Video in Qualitative Research

Video in Qualitative Research

Analysing Social Interaction in Everyday Life

Christian Heath
Jon Hindmarsh
Paul Luff

Los Angeles | London | New Delhi
Singapore | Washington DC

SAGE Publications Ltd
1 Oliver's Yard
55 City Road
London EC1Y 1SP

SAGE Publications Inc.
2455 Teller Road
Thousand Oaks, California 91320

SAGE Publications India Pvt Ltd
B 1/I 1 Mohan Cooperative Industrial Area
Mathura Road, Post Bag 7
New Delhi 110 044

SAGE Publications Asia-Pacific Pte Ltd
33 Pekin Street #02-01
Far East Square
Singapore 048763

Library of Congress Control Number: 2009928042

British Library Cataloguing in Publication data

A catalogue record for this book is available from the British Library

ISBN 978-1-4129-2942-4
ISBN 978-1-4129-2943-1 (pbk)

Typeset by C&M Digitals (P) Ltd, Chennai, India
Printed in Great Britain by CPI Antony Rowe, Chippenham, Wiltshire
Printed on paper from sustainable resources

Mixed Sources
Product group from well-managed
forests and other controlled sources
www.fsc.org Cert no. SGS-COC-002953
© 1996 Forest Stewardship Council

FSC

Contents

Preface

Video provides unprecedented opportunities for research in the social sciences. It offers new and highly distinctive ways of collecting data and building records of human culture and activities and enables new forms of analysis, presentation and publication. It is increasingly used in research in a range of disciplines including sociology, social anthropology, education, communications and linguistics. It forms the basis to more applied studies and interventions, including communication skills training, the design of new technology, and methods for evaluation and assessment. However, despite the growing importance of video, there remain few introductory texts that address the ways in which this cheap and accessible technology can be used in social science research.

Video raises a series of questions and problems that may not necessarily arise using more traditional materials and methods in the social sciences. These include how to gain access to undertake video recording and how to deal with the moral and ethical issues that occur when collecting permanent records of what people say and do. They also include issues concerning the character and quality of the data and how they resonate with more conventional materials used in qualitative research, such as field notes or responses to questions in interviews. Perhaps most fundamentally, video raises important questions concerning analysis and the ways in which recordings can be subject to detailed and systematic inspection. In turn, using video for research inevitably transforms the possibilities that arise in presenting and publishing findings, and sets new demands on the ways in which to enable the reader, or audience, to gain insights into the material and its analysis. The aim of this textbook is to address these and the other issues and to provide practical guidance for using video in qualitative research.

This book is based on research that we have undertaken over the past few decades. Our work has involved video-based studies of a wide range of organisational environments both in the UK and abroad, including general practice consultations and operating theatres, the control rooms of London Underground, the news rooms of the BBC and Reuters, operation centres for international telecommunications companies, design and architectural practices, and national and international auctions of fine art and antiques. It also includes studies of less formal, more public settings including street markets, museums, galleries and science centres. All of these studies are primarily qualitative, drawing on ethnomethodology and conversation analysis.

We have also undertaken more 'experimental' and applied research concerned with analysing communication through advanced media spaces, developing interactive exhibits for museums and galleries, and contributing to the design of a range of new technologies from virtual reality through to interactive paper. Throughout the book we use our experiences in undertaking these studies to animate our discussions of the practical and methodological issues and problems that arise in undertaking video-based research in the social sciences. Rather than repeatedly cite these studies, we have collated key references in Appendix 4.

The range of these studies points to the remarkable support and cooperation that we have received from people throughout the organisations we have studied; people who have willingly and kindly enabled us to record and examine their everyday activities. Despite the popular assumption that it is difficult, if not impossible, to use video to examine certain settings, we have rarely had significant problems gaining access. This points to the extraordinary openness of people and their organisations. We are also grateful to the funding bodies and research councils that have provided support for our studies. These projects include Mixed Media Grid (ESRC, RES-149-25-0033), Communicating Science Through Novel Exhibits and Exhibitions (ESRC, RES-151-25-0047), Utiforo (EPSRC, EP/D07696X/1), Prismatica (EU, G2RD-CT-2000-10601) and PaperWorks (EU, IST-516895).

We have greatly benefited from the enthusiasm and commitment of the students and the research staff who have worked on the projects we have undertaken over the years. These include numerous undergraduates who have demonstrated a willingness and energy to throw themselves wholeheartedly into fieldwork and video analysis, undertaking studies of activities and organisations that one would have thought inaccessible to social science research. We have learnt much from their experience and insights. We should also mention a number of outstanding doctoral students and research assistants who have brought pleasure and interest to projects in the Work, Interaction and Technology Research Group, and who have also helped us to recognise and address many of the issues that arise when undertaking video-based research. In this regard, Katie Best, David Lin, Simon Love, Robin Meisner, Anthony Morris, Menisha Patel, Karola Pitsch, Marcus Sanchez Svensson, Ella Tallyn and Dylan Tutt deserve particular mention. One particular colleague, Dirk vom Lehn, has remained a stalwart of the research group and has helped us to work through many of the ideas and materials discussed in this book.

Without the encouragement and support of David Silverman and Hubert Knoblauch we would have not written this textbook. In their very different ways they both persuaded us that a book on the use of video for social science research was necessary. They read the draft manuscript and with Tim Dant provided highly insightful and critical comments. We hope that we have been able to go some way to justify the commitment that all three had for a textbook on video analysis. Patrick Brindle has proved remarkably patient and provided strong support throughout the project and it is not unfair to say that without his enthusiasm and commitment it is unlikely that the book would have been written. We are also very grateful for Ian Antcliff's hard work, care and patience in supporting the production process. We have also benefited from a number of colleagues in the field who have kindly given us permission to use images and transcripts from their published work. This has undoubtedly enriched the text and we thank them. Finally, we should mention our colleagues within the wider academic community and with whom we have worked on numerous projects; without their support and encouragement it would have proved a far more difficult and less enjoyable task to have prepared and written this book.

Christian Heath
Jon Hindmarsh
Paul Luff

1

VIDEO, ANALYSIS AND THE SOCIAL SCIENCES

Contents

1.1 Introduction

The aim of this textbook is quite simple; the subject matter is rather more complex. We wish to provide an introduction to using video for social research, particularly the use of audio-visual recordings, to support the analysis of everyday social activities. The book addresses and provides guidance on the range of practical, methodological and conceptual issues that arise in using video at different stages of undertaking a study, from preliminary planning through data collection to the presentation of findings. Unlike many introductory monographs to qualitative research, we place particular emphasis on the analysis of data, including matters of transcription, observation, conception and the like. Analysis of audio-visual materials is particularly difficult given the extraordinary detail found even within a few moments of a video of everyday action. Like many other forms of data analysis, our own approach draws on a specific methodological framework, a framework that prioritises the situated and interactional accomplishment of practical action. Throughout the book however, we provide guidance, advice and recommendations that are of relevance to various types of video-based research drawing from other methodological and theoretical standpoints.

While audio-visual recordings provide unique access to the details of social action, they are relatively under-utilised in the social sciences despite their significant

potential; that was recognised almost as soon as technologies emerged for recording visible behaviour. In this chapter we provide a little background to the uses of audio–visual recordings within the social sciences and review some of their distinctive qualities. We note how it is only in recent years that we have begun to find significant and widespread interest in using video, especially digital video, as an analytic resource. We summarise the problems and challenges that arise at every stage of the research process when using video to analyse social action.

1.2 Background: revealing elusive phenomena

It has long been recognised that visual media, including photography, film, and more recently video, provide unprecedented opportunities for social science research. Consider video, for example: here is a cheap and reliable technology that enables us to record naturally occurring activities as they arise in ordinary habitats, such as the home, the workplace or the classroom. These records can be subject to detailed scrutiny. They can be repeatedly analysed and they enable access to the fine details of conduct and interaction that are unavailable to more traditional social science methods. These records can be shown and shared with others, not only fellow researchers, but participants themselves, or those with a more practical or applied interest in the activities and their organisation. Unlike many forms of qualitative data, video can form an archive, a corpus of data that can be subject to a range of analytic interests and theoretical commitments, providing flexible resources for future research and collaboration. Video can also enable us to reconsider the ways in which we present the findings of social science research, not only to academic colleagues but more generally to the wider public.

Despite the enormous potential of video, even greater than one suspects of film and photography, the social sciences have been slow in responding to the opportunities it affords. Some decades ago, for example, Margaret Mead, who with Gregory Bateson helped pioneer the use of visual media in the social sciences, bemoaned 'the criminal neglect of film':

> … research project after research project fail to include filming and insist on continuing the hopelessly inadequate note-taking of an earlier age, while the behaviour that film could have caught and preserved for centuries … (… for illumination of future generations of human scientists) disappears – disappears right in front of everybody's eyes. Why? What has gone wrong? (1995 (1974): 4–5)

Some 30 years later, we have witnessed the flourishing of documentary film in social anthropology and the emergence of more self-conscious, subjective and reflective approaches to the use of visual media more generally within the social sciences. However the use of video as an 'investigative tool', to inform the analysis of human activity, remains neglected within qualitative research. This may seem all the more surprising when one considers not simply the widespread availability of the technology, but the long-standing commitment to prioritising the participants' perspective(s) in naturalistic research. If the key principle of qualitative research is taking the participant's perspective seriously and prioritising the resources on which people rely

in accomplishing their everyday actions and activities, then a technology that enables the repeated, fine-grained scrutiny of moments of social life and sociability would seem to provide, at worst, a complement to the more conventional techniques for gathering 'scientific' information, at best, a profound realignment in the ways in which we analyse human activity; a realignment akin to the effect of the microscope on biology.

The seeming neglect of video and the moving image in the social sciences is particularly curious when we consider that soon after the development of instantaneous photography in the 1830s, implications for the analysis of human and behavioural sciences were recognised. The neurologist Guillaume-Benjamin Duchenne de Boulogne (1862), for example, used photographs to analyse facial expression and the 'méchanisme de la physionomie humaine'. These photographs provided Charles Darwin (1872) with a critical resource for his treatise on the expression of emotions in man and animals. In the 1870s Eadweard Muybridge, with support and encouragement from Leland Stanford (the founder of the University), first developed the possibility of combining a series of images to capture a sequence of action, developing the technology initially to resolve debates concerning how horses galloped (Prodger, 2003). Muybridge recognised the scientific potential of the technology, a technology that could reveal and enable scrutiny of 'elusive phenomena'. His publications, *Attitudes of Animals in Motion* (1881) and *Animal Locomotion* (1887), uniquely revealed aspects of the structure of movement and activity, both for certain species of animal as well as human beings. The discovery of the structure of a galloping horse by virtue of the use of photography is well known, but Muybridge also opened up for scrutiny such diverse human activities as standing, leaping, lifting a ball, fencing, and a woman with multiple sclerosis, walking.

In turn, these initiatives led to Etienne-Jules Marey's (1895) laboratory studies of a range of human activities such as walking, and Braune and Fisher's (1895) research on the bio-physical attributes of human movement. These early initiatives proved less influential on the emerging social sciences than might be imagined, but within social anthropology it was soon recognised that instantaneous photography, and the emergence of film, might be a distinctive and important resource for research.

Felix-Louis Regnault (Lajard and Regnault, 1985) produced an ethnographic film in the 1890s of a Wolof woman making pottery, but it is Alfred C. Haddon who is most frequently credited with first using film in fieldwork as part of the Torres Straight expedition in 1898. Haddon's initiatives had an important influence

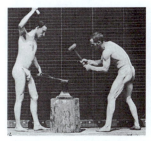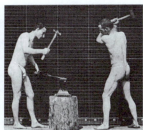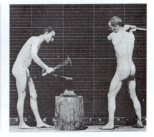

FIGURE 1.1 *Still pictures from Eadweard Muybridge's* The Body in Motion (reproduced by permission of the Collection of the University of Pennsylvania Archives)

on the use of film in anthropological fieldwork. They led, for example, to the substantial body of photographs and film recorded by Baldwin Spencer and Francis Gillen during their many years studying the Australian Aborigines (1899) and to Rudolf Pöch's (1907) use of film on his field trips to New Guinea.

Haddon recognised the analytic potential of moving images to capture everyday life and as a resource for the analysis and presentation of cultural practices. As Howard Morphy and Marcus Banks (1997) suggest however, this early enthusiasm for the role of film in fieldwork was not sustained, at least within Europe, during the first few decades of the twentieth century. They argue that film became tainted by its association with evolutionary anthropology and, with the rise of structural functionalism, 'photography and film, as tools for the anthropological method, suffered the same fate as did art and material culture, tarred by the evolutionary brush they were left out of fieldwork revolution' (1997: 9). In North America it was rather different; film remained of some significance in anthropology, though largely it has to be said as a method of illustration, sometimes entertainment, rather than a resource to enrich analysis.

However, there were important exceptions. For example, in the 1930s, Gregory Bateson and Margaret Mead used sequences of photographs to illustrate children's play and Mead, in particular, recognised the importance of a medium that enabled human behaviour and practice to be re-analysable by others. Indeed, Bateson and Mead were keen to differentiate their use of film from the documentary:

> We tried to use the still and the moving picture cameras to get a record of Balinese behaviour, and this is a very different matter from the preparations of a 'documentary' film or photographs. We tried to shoot what happened normally and spontaneously, rather than to decide upon the norms and then get the Balinese to go through these behaviours in suitable lighting. (Bateson and Mead, 1942: 49)

In rather a different vein, David Efron (1941), a student of Franz Boas, used frame by frame analysis to compare and contrast the gestures of immigrant groups in New York City and to delineate the communicative and cultural significance of these bodily movements in contrast to the idea that they are genetically determined.

Since these early beginnings, photography, film and now video, have become key elements of social anthropology (see Hockings, 1995 (1974)). They form an important subsection of the American Anthropological Association and there is a significant commitment to using film and video as data to support various forms analysis, augmented, for example, by fieldwork. There have been some highly original initiatives to use images to reveal complex sequences of action and interaction (consider, for example, Asch, 1975). Nevertheless, as Morphy and Banks (1997: 4) point out, 'the ethnographic film has tended to dominate the sub-discipline' which, they continue, 'encourages a view of visual anthropology as an "optional extra" – an entertaining introduction to the real business in hand'. One suspects that with the widespread commitment to a 'reflexive' anthropology that challenges conventional distinctions between subject and observer (exemplified in the work of Jay Ruby, 1982) and more generally the so called 'crisis of representation' in the social sciences, the analytic contribution of film and video has become overshadowed by a more self-conscious, dialogical form of film-making.

In comparison, sociology has shown less interest in exploring the opportunities afforded by photography, film and video. This was not always the case. Douglas Harper (1988) notes, for example, that between 1896 and 1916 there were 31 articles that used visual images published in the *American Journal of Sociology*, but by 1920 the use of such materials had all but disappeared. This may come as some surprise when one considers the long-standing and growing ethnographic tradition within sociology, and the commitment, at least within qualitative research, to take meaning, interpretation and practice seriously. There are important exceptions, though these are not necessarily associated with the forms of research that one would expect. For example, Jack H. Prost (1974) argues that the much-maligned Frederick W. Taylor 'laid the groundwork' to the detailed film-based study of the skills involved in performing various work tasks undertaken by Frank Gilbreth (1911).

In rather a different vein, and now more associated with psychology than sociology, Lewin (1932) used film to reveal the life of a child in an urban setting, a film that is said to have had a profound impact on theories of intelligence and learning (cf. Marrow, 1969). To a large extent, however, these latter experiments with the use of film for research, like the material gathered for Mass Observation, were largely used as documentary record and illustration rather than as a resource for the analysis of human conduct and interaction.

Notwithstanding these slow beginnings, and a post-war period in which sociology largely neglected film and the emergence of video, over the last decade or two we have witnessed a burgeoning body of research that has begun to take visual media seriously, and to use the technology as part of studies of situated practical action and interaction. It is important at this stage, as Hubert Knoblauch and colleagues (2006) suggest, to differentiate the wide-ranging interest in the 'visual' in sociology and cognate disciplines, which has formed the subject of many texts (see, for example, Banks, 2001; Pink, 2006; Rose, 2004), from research that uses video to analyse conduct and interaction in 'naturally occurring' day-to-day settings. It is the latter with which we are primarily concerned.

There is now a growing corpus of qualitative research – research which has emerged within various disciplines in the social and human sciences – that uses audio-visual recordings as an analytic resource with which to explore, discover and explicate the practices and reasoning, the cultures and competencies, the social organisations on which people rely to accomplish their ordinary, daily activities. This textbook is concerned with introducing the ways of working, the assumptions and the methodological resources that underpin these studies. These studies are first and foremost concerned with using video, in many cases augmented by fieldwork, to examine the social and interactional organisation of everyday actions and activities, the familiar and in some cases the unusual, wherever they may arise, to help reveal and enable us to analyse the 'elusive phenomena' of everyday life.

1.3 Qualities of video

Video captures a version of an event as it happens. It provides opportunities to record aspects of social activities in real-time: talk, visible conduct, and the use of

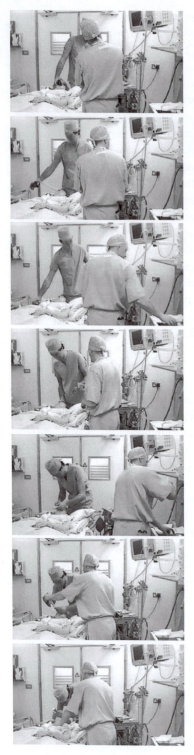

FIGURE 1.2 *Work in a hospital anaesthestic room*

tools, technologies, objects and artefacts. It also resists, at least in the first instance, reduction to categories or codes and thus preserves the original record for repeated scrutiny. Unlike other forms of social scientific data, there are opportunities for 'time-out', to play back in order to re-frame, re-focus and re-evaluate the analytic gaze. These are very powerful opportunities for the researcher. They allow for multiple takes on the data – to explore different issues on different occasions, or to consider the same issue from multiple standpoints.

To illustrate, consider Figure 1.2 which features a sequence of images taken from a recording of everyday work in a hospital anaesthetic room – a space where patients are anaesthetised immediately prior to surgery. There are three participants in view – an anaesthetist, an 'operating department assistant' (ODA) and lying prone on the bed, a patient. The anaesthetist is on the left as we look at it, at the head of the patient, and the ODA is to the right. The monitor displaying various patient readings is visible in the top right hand corner of the images; underneath that there is an anaesthetic ventilator (essentially a machine to inflate the patient's lungs at regular intervals). There is a trolley with a set of medical instruments just visible in the bottom right hand corner of the images.

Within this short sequence, lasting 15 seconds or so, the activities of the anaesthetist, the ODA or both, include: checking the readings on the monitor; removing the gas mask from the patient's face; picking up a 'laryngoscope' (a tool for looking at the patient's windpipe, or 'trachea') from the trolley; handing over the laryngoscope; re-positioning the patient's head using the laryngoscope; picking up a 'tracheal tube' from the trolley; handing over the tracheal tube; inserting the tracheal tube in the patient's trachea; attaching an extension to the tracheal tube; disconnecting the anaesthetic ventilator from the mask; connecting the anaesthetic ventilator to the extension of the tracheal tube; and securing the position of the tracheal tube in the patient's mouth. Aside from a quiet 'okay' from the anaesthetist, this is all completed

without talk. The resources that the participants have to coordinate this range of actions are related to each other's embodied and embedded conduct coupled with their experience of work in anaesthetic rooms.

Not all of these actions are retrievable from the stills, but the original video recording allows for repeated viewing of these moments to enable an analyst to unpack the detailed production of the activities of the participants. In this regard the video record allows the analyst to consider the resources that participants bring to bear in making sense of, and participating in, the conduct of others, to take a particular interest in the real-time production of social order. Video can also enable the analyst to consider the ways in which different aspects of the setting feature in the unfolding organisation of conduct. These aspects include not only the talk of participants, but their visible conduct, whether in terms of gaze, gesture, facial expression, or bodily comportment. Furthermore, video data enable the analyst to consider how the local ecology of objects, artefacts, texts, tools and technologies feature in and impact on the action and activity under scrutiny.

The permanence of video also allows data to be shared with colleagues and peers in different ways. Digital video, in particular, provides flexible ways of manipulating, presenting and distributing social scientific data. Even relatively basic computer software packages enable straightforward and speedy access to fairly complex ways of reproducing, enhancing and juxtaposing images. Indeed, commercially available video-editing software, even simple applications provided free for domestic use, can allow researchers to digitally 'zoom in' on interesting phenomena, 'spotlight' relevant conduct or create picture-in-picture videos to assist with analysis or presentation. Furthermore, Internet-based technologies provide a range of ways of sharing, distributing and disseminating video data and increasingly, through electronic journals, allowing digital video to be incorporated within scholarly articles.

The value of showing and sharing data with colleagues and peers should not be underestimated. A long-standing criticism of ethnography concerns the lack of its 'transparency'; critics highlight the difficulties of recovering what the researcher saw and experienced undermining the ability of fellow scholars to form an independent judgment of the quality of the analysis. With video there is the potential for the data on which analysis is based to be made available and examined during a presentation or within a published account of the research. However, video enables colleagues, students and supervisors to work on the materials together. It can support close collaborative analytic work as well as providing others with the opportunity to scrutinise tentative observations and discuss findings with respect to the data on which they are based.

1.4 Emerging fields of video-based research

To give a sense of the potential of using video in social research, it may be worthwhile providing a brief overview of one of two contemporary fields that have benefited from the use of audio-visual technologies. Consider, for example, the study of work and occupations, which has been informed by qualitative research since the inception of the social sciences in the nineteenth century. Most notable in this regard

is the corpus of ethnographic studies that emerged from the 1940s onwards concerned with culture, practice and the organisation of workplace activities (see, for example, Barley and Kunda, 2001; E.C. Hughes, 1958; Silverman, 1970). However, in recent years we have witnessed video-based research that has developed and re-specified some of the key concerns and concepts that informed these more traditional ethnographies. They have come to be known as 'workplace studies' and include the analysis of organisational activities in a diverse range of settings, such as surgical operations, control centres, surveillance rooms, medical consultations and financial trading rooms (see, for example, Engeström and Middleton, 1996; Luff et al., 2000b).

Video recordings of work and interaction in these settings, augmented by field-work, enable researchers to address a range of phenomena, topics and issues that previously remained largely unexplicated. So, for example, studies address how tools and technologies, ranging from highly complex computer systems through to conventional artefacts such as paper documents, feature in the moment-by-moment accomplishment of workplace activities. These studies delineate, in fine detail, how participants constitute the occasioned, organisational sense and significance of particular displays, information sources and the like (see, for example, Goodwin and Goodwin, 1996; Mondada, 2007; Suchman, 1996). These studies also enable close examination of more traditional issues in organisation analysis, such as how teams work. They reveal how, for example in command and control centres or surgical operations, collaboration relies upon the ability of personnel with differing responsibilities and skills to selectively monitor each other's conduct and to render particular features of activities momentarily 'visible' or available (e.g. Heath and Luff, 2000a).

Workplace studies also enable us to recast our understanding of familiar kinds of organisational interaction, such as the service encounter and the professional–client consultation. For example, studies of call centres reveal the ways in which communication between callers and clients is systematically and contingently shaped with regard to various organisational requirements, in particular the need to complete documents, both paper and electronic (Greatbatch et al., 2005; Whalen, 1995a; Whalen and Vinkhuyzen, 2000). Such video-based, workplace studies address many of the key themes that underpin more traditional ethnographies, and yet provide a powerful and distinctive body of insights that enable us to reconsider key concepts concerning the social organisation of work.

Audio-visual recordings are increasingly used to support research that examines the situated activities and interactional organisation through which knowledge, skills and practice are shared and disseminated. These initiatives draw upon the corpus of research concerned with talk and interaction in the classroom that arose two or three decades ago (McDermott, 1976; Mehan, 1979). Video helps reveal how it is critical to understand visible conduct, material artefacts and features of the local environment within more formal educational environments (see, for example, Erickson and Schultz, 1982; Hester and Francis, 2000; Rendle-Short, 2006).

In part driven by the turn towards situated and peripheral learning (Lave and Wenger, 1991), there has been burgeoning interest in using video to also examine the ways in which knowledge is revealed, shared and embodied in non-institutional or informal settings. This rich body of work is highly varied and it is not possible

to do it justice within a few sentences. However, some examples may give a flavour of the topics considered. Barbara Rogoff (2003) considers the cultural variations in problem-solving by mothers and toddlers. In rather a different vein, Marjorie Goodwin (1990; 2006) develops a highly sophisticated analysis of children playing games. There is also a growing corpus of video-based research concerned with the interactional and contingent organisation of learning in settings such as museums, galleries and science centres (Ash, 2007; Callanan et al., 2007; Meisner et al., 2007), and in more complex organisational environments, including studies of how surgical training is accomplished in operating theatres (Koschmann et al., 2007; Mondada, 2007).

Film, and more recently video, have also been used in the analysis of interpersonal communication, in particular the non-verbal or visible aspects of human behaviour. Although within the fields of psychology and social psychology such research typically took place in experimental settings and laboratories, the emergence of robust and portable video equipment made it possible to undertake more naturalistic studies. An important interdisciplinary project in this regard emerged in the early 1950s at the Institute of Advanced Study at Stanford University and is known as 'Natural History of the Interview' (see Leeds-Hurwitz, 1987). This project, initiated by Frieda Fromm-Reichmann (and also involving Gregory Bateson, Henry Brosin, Charles Hockett, Norman McQuown and Ray Birdwhistell), gave rise to a highly distinctive approach to the study of human interaction, an approach that has come to be known as 'Context Analysis'. This formed the background to a range of extraordinary studies, including those by Birdwhistell (1970) of bodily motion and conduct (see, for example, his wonderful descriptions of smoking a cigarette or hitching a lift), and Albert Scheflen's (1973) analysis of psychotherapy sessions, and directly influenced a range of fine grained studies of human behaviour including the analysis of mother–infant interaction (e.g. Condon and Ogston, 1966).

Building on these foundations, Adam Kendon (1990) has developed a wide-ranging body of film and video-based naturalistic studies of social interaction that has had a profound influence on the analysis of visual communication and gesture. His studies demonstrate how visible behaviours, such as facial expressions, gaze orientation, and bodily comportment, are not simply manifestations of inner cognitive states or emotional dispositions, but serve in the complex coordination of human behaviour. From these insights, research has emerged that systematically delineates the social and interactional accomplishment and foundations of gesture (see, in rather different ways, Haviland, 1993; McNeill, 1992; Streeck, 1993). Such studies have led to a reconsideration of the relationship between talk and bodily conduct. They suggest breaking away from the idea that communication consists of distinctive channels for the verbal and the non-verbal, to demonstrate the ways in which social action and interaction involve the interplay of talk, visible and material conduct.

Alongside these academic contributions, there is also growing interest in using video-based research to address more practical problems and to contribute to policy and practice in a broad range of domains, both in the public and private sector. For example, video and video-based studies are used in communications skills training,

to inform the design of advanced technologies and to unpack consumer behaviour in shops, supermarkets and even in the home. The distinctive access that video provides to human activities as they are accomplished in everyday settings, and the ability of video to reveal to others the complexity and character of the mundane, can prove highly insightful and persuasive for practitioners, and help to address a range of distinctive problems that people face in the performance of their everyday activities.

1.5 The challenges of using video for social research

The burgeoning body of video-based qualitative research within various disciplines reflects the growing recognition that the medium offers important analytic opportunities and ways of (re)addressing long-standing topics and issues within social science and the humanities. Despite the growing interest in using video for research, it remains, as Margaret Mead might suggest, 'criminally neglected', perhaps most curiously in qualitative research and, in particular, ethnography. This may not be as surprising as it first seems. Video-based, qualitative research does pose a number of important practical, ethical, methodological and analytic problems and yet, as Knoblauch and colleagues (2006) suggest, despite a significant corpus of studies that use video as data there are few guides or guidelines on how to undertake video-based research.

 Even before any research is undertaken difficulties may arise. Ethics committees can become concerned at simply the suggestion that cameras and microphones will be used to record naturally occurring activities. There are also common practical problems that arise when trying to record using video equipment. But perhaps the most significant problem is that audio-visual recordings of everyday activities, as data, do not necessarily resonate with the theories, concepts and themes that inform dominant approaches to research in the social sciences. In consequence, and unlike field observations, in-depth interviews and focus groups, it proves difficult to link video-based research into more conventional approaches within the social sciences.

 This textbook is concerned with providing guidance to those who are planning, hoping to start or are beginning to use video to support their research. This advice is intended not only to be practical but also help address more academic concerns. As some readers might be intending to use video for the first time it may be helpful to review some of the main issues and problems that can emerge. They are best summarised firstly in terms of issues that arise in undertaking data collection, secondly, in terms of problems that arise in undertaking the analysis of materials, and thirdly, in terms of challenges associated with the presentation of insights, observations and findings deriving from the analysis of video.

Collecting data

High-quality equipment is now readily available at a reasonable cost and many leading researchers gather useable data using high-end domestic video cameras coupled in some cases with separate microphones. There are, however, long-standing

debates as to how best to access and record scenes, activities and events. Some of the questions and queries that arise include the following:

- How can you gain access and permission to record in a setting? (See Chapter 2)
- How do you address the moral and ethical issues that arise when planning to video record naturally occurring events? In particular how do you obtain consent from the participants you will be recording? (See Chapter 2)
- Is it best to gather materials in one intense period of data collection or undertake this in successive phases? (See Chapters 2 and 3)
- Where should the camera be placed and what focus and framing should be used to capture key events? How much recorded data should be collected? (See Chapter 3)
- Should you focus on collecting video or try to make field observations at the same time? If you do both, what sorts of observations are useful? (See Chapter 3)
- Is it possible to assess the 'influence' of the camera on the participants in the scene? Are there ways in which the presence of the camera and the researcher can be made less obtrusive? (See Chapter 3)

These questions and queries are by no means new. Similar problems and issues arose when film was originally used in the human and behavioural sciences, and they have served to generate discussion and debate over the last century or so. More importantly perhaps, these are not simply practical problems to be overcome, but rather derive from important methodological debates. For example, how does one determine the field of view of the camera during data collection? Even the duration of recording during a single session will depend upon a decision concerning what constitutes the context of action and the analytic framework that will be brought to bear on the data. If, for instance, one is interested in addressing the role of facial expressions during interpersonal communication then it will be important to capture close-up images of the face. If, on the other hand, the guiding methodological focus is with the collaborative and contingent accomplishment of activity, then it will be critical to encompass the contributions – visible, material and spoken – of the all participants who contribute to its production. Methodological assumptions and presuppositions about such matters as context, agency, participation, action and the like have a profound influence on how we resolve the problems and issues that arise in data collection. These methodological commitments also underpin how we resolve some of the analytic problems and issues that arise in using video as data.

Analysing audio-visual recordings

The analysis of audio-visual recordings of naturally occurring activities and events has proved a significant challenge to the social sciences. Indeed it may not be surprising that there is a trend in social anthropology and elsewhere, to use video and film for illustrative and documentary purposes rather than as a form of data. The following covers some of the practical and methodological questions that arise when undertaking video analysis.

- Where do you begin? Is it necessary to review the whole data corpus? If so, how do you identify, select and categorise actions and events? (See Chapter 4)
- How can you begin to identify particular phenomena, understand the organisation of an activity and analyse particular actions and activities? (See Chapters 4 and 5)
- How do you build a case – an argument – for an analysis? Is it helpful to build collections of extracts to enable more detailed comparison? (See Chapter 4 and 5)
- What role does transcription have in analytic work? Should all data be transcribed? How can you transcribe the visible as well as the vocal aspects of conduct? (See Chapters 4 and 5)
- How do you consider and address the context in analysing social action and inter-action? (See Chapters 4 and 5)
- What is the relationship between different forms of data that are gathered? For instance, how should field observations be used to inform the analysis of the video recordings? (See Chapter 5)

Presenting and disseminating findings

Aside from questions that arise in data collection and data analysis, there are a range of issues and problems associated with presenting and publishing video-based studies. It is interesting to note that in other areas of qualitative research that are based on the analysis of recorded data, such as in discourse and conversation analysis, it is relatively rare for scholars to play the actual recorded material – they largely rely on presenting transcripts of the original data. The publication and presentation of video-based studies are constrained by the conventions and conventional media through which academic research is disseminated. Notwithstanding the recent emergence of innovative technologies for dissemination, it is likely that we will have to continue to work, at least in part, within the limitations of text-based media.

Issues that emerge when presenting and publishing data include the following:

- Given the fleeting nature of many of the 'elusive phenomena' that are addressed in video-based studies, how is it best to guide a live audience through an analysis? (See Chapter 6)
- How can you present fragments of action drawn from an audio-visual recording in publications and reports where, to a large extent, it is not possible to accom-pany text with CDs, DVDs or other ways of displaying moving images? (See Chapter 6)
- How have video-based studies contributed to the core issues and debates in the fields of sociology, psychology, education and cognate disciplines? (See Chapter 7)
- How can video-based studies of everyday action and interaction be shown to be relevant for those in the world of business, social policy or for the participants in the studies? (See Chapter 7)

1.6 Appreciating everyday life

This textbook addresses the key issues and challenges in working with video recorded data in social research. While many of the issues we discuss are common

to many, if not all, social scientists working with such data, we will inevitably be emphasising our particular methodological orientations and interests. This will be most evident when we discuss analysis (Chapters 4 and 5) and reflects our own interest in exploring and revealing how everyday conduct and interaction is accomplished. A secondary aim of the book, therefore, is to foster an aesthetic of the everyday (see Silverman, 1997), an analytic appreciation of the taken-for-granted complexities of social interaction. These aspects of conduct are subtle, fleeting and readily overlooked and yet they underpin the organisation of social and institutional life. We aim to show the fundamental significance of these minutiae of human conduct for those with an interest in understanding sociability, interaction and social organisation.

Key points

- There is a long and diverse history in using film and video for research in the social and behavioural sciences.
- Video can be subject to a diverse range of methodological and analytic interests and provides new and distinctive ways of presenting culture, practice and social organisation.
- Video creates unique opportunities for the analysis of social action and interaction in everyday settings and can help provide distinctive contributions to observation, method and theory.
- Video-based research of everyday life poses significant challenges to more traditional approaches to gaining access, data collection, analysis and the presentation and publication of materials.

RECOMMENDED READING

- Paul Hockings's edited collection (2003) first published in the 1970s. It features papers that exemplify a broad range of approaches to using film and video in anthropology. It draws out some of the principle methodological and theoretical problems and issues of using these media.
- Hubert Knoblauch et al. (2006) provides a wide-ranging exposition of qualitative video analysis built around a series of empirical studies adopting different approaches and techniques.
- Goodwin (1981) is an exemplary and highly detailed video-based study of social interaction.

EXERCISE

Chose a particular event or activity – for example, a medical consultation, political debate, or dinner party – and discuss three different approaches to using video to explore and examine its social organisation.

2

ACCESS, ETHICS AND PROJECT PLANNING

Contents

2.1 Introduction

It has long been recognised that qualitative research can pose significant challenges to gaining access, securing consent and planning projects. Video can exacerbate these difficulties and, unless carefully managed, can undermine the possibility of undertaking the research. In this chapter, we address the problems and issues that arise when seeking to gain access to undertake video-based research and consider how these difficulties can be addressed and in many cases avoided. We also discuss research ethics and, in particular, the ways in which formal ethical approval can be secured in order to undertake video-based research. In discussing access we draw on our own experience in undertaking three particular projects: a study of team work, collaboration and new technology in London Underground; the use of documents by children in classrooms; and the conduct of visitors in museums and galleries. Each of these projects and the settings in which they were undertaken pose distinct challenges to data collection and yet they demonstrate that with the

right approach it is possible to gain permission to undertake video-based research even in seemingly 'sensitive' environments. We conclude by considering how issues of access and ethics fit within the planning of video-based research projects more generally.

2.2 Gaining access and agreement to record

One reason that is often raised for not using video in qualitative research is that it will be impossible to gain permission from participants, or more generally, an organisation to make recordings. Surprisingly perhaps, gaining access to undertake video recording rarely proves a major difficulty, as long as you are sensitive to the demands of the setting and address the concerns of the participants themselves. In recent years, video-based studies have been undertaken in such diverse settings and activities as medical consultations, management consultancy, counselling interviews, banking and financial management, surgical operations, air traffic control, hairdressing, surveillance, nursing, television and radio production, home life, shops and business meetings. Each of these settings poses distinct challenges for data collection and demands different techniques for securing consent. However, there are a number of common problems and issues that arise.

For example, many research settings, including schools, hospitals, businesses and the like, are 'closed access groups' (Hornsby-Smith, 1993) in that there are barriers to physically entering the setting as well as to undertaking the research. Different kinds of access have to be negotiated. In such cases it is necessary to establish trust and a working arrangement with participants themselves in addition to their managers and sometimes to other key stakeholders in the setting. To consider these different kinds of access it is useful to draw on the distinction between 'getting in' to a setting and 'getting on' with the participants (Cassell, 1998). It should be noted that the people with whom you negotiate physical access to the setting are unlikely to be the people that you film. Both need to agree to the research for it to progress.

'Getting in': Gaining physical access to the setting

Organisations may turn down requests for access for a range of reasons. For instance, they may not be keen to engage in additional voluntary tasks (additional meetings, introductions, reading reports, etc.) or they may worry about the potential sensitivity of the topic or the confidentiality of the research. It is critical therefore to talk to participants and those responsible for the setting, and sometimes give short presentations about the proposed research and the background to the project. These preliminary meetings with members of the organisation allow you to understand some of their more general concerns and become sensitive to the different views and perspectives they hold.

In these meetings it is critical to provide a clear account of the project and why you wish to undertake the research. It is worthwhile also exploring how your own interests might resonate with those of the organisation. Organisations will

often be more willing to grant access if they can see how they might benefit from the project. Indeed one of the important contributions that a researcher can make to an organisation is to provide a brief report of their observations and findings that is tailored to the key concerns of the people involved. It is also important to establish your credibility by demonstrating your experience or knowledge of undertaking research and, if possible, research of similar organisations where video has been used. This can be done by discussing previous projects you have undertaken or by referring to studies undertaken by others in the field. It is important to assure the relevant 'gatekeepers' that the aim of the research is not to develop a critical analysis of the participants or the organisation, but rather to analyse their skills and practices; and more generally to understand the world from the perspective of the participants themselves. Finally they will need to be given a clear account of how the data will be analysed and disseminated and the extent to which they will be able to retain some control over access to data as well as, in some cases, to the findings of research themselves.

'Getting on': Establishing trust and participation in the setting

It can be a mistake to believe that once you have gained physical access to a setting then video recording can be undertaken without regard to the cooperation of the actual participants and the circumstances at hand. However, access is ordinarily an ongoing concern. An illustration of this comes in the film *Kitchen Stories* (2003, Director: Bent Hamer), which depicts a charming fictional account of observational research in the home. It centres on one researcher who gains physical access to a single man's house to study his use of the kitchen. Soon after the study commences the man becomes uncomfortable with the presence of the researcher and ends up cooking in his bedroom, rendering the study worthless. This is an extreme example, but without proper communication with participants they may in various ways resist involvement. They may avoid the view of the camera, they may have conversations away from the microphone, or in other ways avoid being filmed. To ensure the data is of good quality (as opposed to simply 'data'), the participants must be willing to participate fully.

So even in cases where you might have secured more formal permission from senior management in an organisation, access may well remain a continuing concern. In order to develop the trust necessary for collecting video it is usual to initially visit the proposed research setting on several occasions. Before recording takes place, a period of fieldwork is useful to discuss the project with core participants, to clarify any distinctive challenges relevant to the setting, to identify any key concerns and so forth. On these occasions, the fieldwork will give you a much clearer idea of the practicalities of recording in the setting and will also provide an opportunity to learn more about the specific concerns or reservations of the participants. In this way, they will get to know you before they encounter your camera.

It may be tempting to only seek permission from key members of an organisation for undertaking your research, but it is important to make sure that the range of people who may be affected by your research are willing to cooperate

if you want to avoid problems and difficulties. In our experience we have found little concern from participants in our undertaking video recording *as long as they have been properly informed*. In part this may be due to the methodological orienta-tion we adopt; one that is primarily concerned with the analysis of the participants' practices, the knowledge, reasoning and procedures on which they rely to accom-plish their activities. Concerns may arise when a researcher adopts a stance that is more at odds with the participants and tries, for example, to uncover mistakes, errors and failings. Clarification of your interests and approach can serve to allay these concerns. (See Appendix 2 for an example letter seeking access to record.)

Once you have become more familiar with the setting, and the participants have a clearer idea of the aims and scope of the research, then it will be easier to introduce a camera for recording. In almost all the projects that we have under-taken, we discuss with the participants themselves as well as key stakeholders: (i) the advantages of recording for the analysis of the activities and taking the participants' conduct seriously; (ii) the importance of recording remaining as unobtrusive as practically possible; (iii) that data will only be used for research (and in some cases teaching); (iv) that copies will not be available for those outside the research team; and (v) that in no circumstances will the data be broadcast, appear on the web or be used for commercial gain. We also emphasise that at any point before, during or following data collection, the participants can refuse to be recorded or have materials destroyed. We often propose that, in the first instance, we will collect one or two hours of data and participants can then judge for them-selves whether they are happy to cooperate further. In other words, even in cases where permission is granted to undertake recording, we provide the participants with successive opportunities to discuss their reservations or concerns. This helps to develop trust and a working relationship with the participants.

Informed consent

The principle of informed consent is paramount for ethical approval bodies and so it is increasingly important to establish formal consent for undertaking video recording. For qualitative research this typically requires written consent from all participants (see Box 2.1). This is normally obtained by providing participants with an information sheet about the research and then, after being given suitable time to read and discuss it, they are asked to sign a form confirming their permis-sion and participation. Participants should not be placed under pressure to pro-vide their consent and they should have the time and opportunity to raise questions and issues that may come to mind. Furthermore the consent form high-lights their right to withdraw from the research at any stage.

In many circumstances, gaining written permission to undertake video record-ing is unproblematic. If the setting is clearly bounded and does not involve large numbers of individuals or rapidly changing personnel, then obtaining written consent can be relatively straightforward. For example, settings such as control centres, design practices and offices that involve a small and stable population of participants readily lend themselves to the use of information sheets and consent forms. Nevertheless it is important to be aware that the widespread deployment

of CCTV cameras can mean that participants may have become a little blasé about the differences between CCTV and video recordings made for research, where recordings capture sound as well as images. It is critical that the researcher assumes responsibility for clearly explaining how data is collected and the subsequent use of the materials for research and teaching.

In other situations it may be inappropriate or even impossible to gain written permission from all participants. Gathering data in public and semi-public environments, such as the concourse of stations, city streets, cafes, and museums and galleries, raises additional challenges with regard to informed consent. Even when recording more circumscribed domains, people, from whom written permission has not been secured, may happen to visit. If the researcher is unaware of new people entering the scene and is not on site at the time of recording, it may prove difficult subsequently to establish informed consent in the conventional way.

Researchers can use various techniques to inform those who enter a particular environment that recording is taking place, provide people with the opportunity of finding out more about the research and whether they wish to not participate or have any recordings of them destroyed. These ordinarily require that the researcher be on hand to answer questions, switch off cameras and even to erase parts of a recording. It is also important that any information provided is in such a form that even those rapidly passing through a domain can know what is happening and are provided with the opportunity to withhold consent – to 'opt out' of the study.

Box 2.1 Informed consent

Informed consent is a basic ethical tenet of scientific research on human populations.

ASA Code of Ethics, 1999: 12

Informed – all pertinent aspects of what is to occur and what might occur are disclosed to the subject and that subject should be able to comprehend this information.
Consent – the subject is competent to make a rational and mature judgment and agreement should be voluntary, free from coercion and influence.

(Homan, 1991: 71)

2.3 Access in practice

Although there are general concerns to be addressed when seeking permission and consent to record, some issues arise that are related to the particular settings in which the research is undertaken. To discuss some of these specific matters we will review three cases where video-based field studies posed very different challenges in securing access and consent: a study of a complex organisation; a study involving children; and a study in a public, or at least, semi-public, setting.

Case 1: London Underground – Researching an organisation

As part of a programme of research concerned with the deployment of advanced technologies we were keen to study a command and control environment that was subject to technological change. The research was supported in part by Rank Xerox Research Laboratories, so it involved potential commercial conflicts of interest. Colleagues in Paris had recently undertaken ethnographic studies of station control on the Paris Metro (Joseph, 1998), and we were keen to complement and extend that research in London. Therefore we contacted London Underground and arranged to meet to discuss potential collaboration (Heath and Luff, 2000).

We held successive meetings with the technology strategy manager and his colleagues and they responded positively to the proposal for a study of technological change. At that stage we left open the question of how the study might be undertaken. They suggested that it would be interesting to consider the introduction of a computerised signalling system into the operation of a number of principal lines, beginning with the Bakerloo Line. Since Rank Xerox were not involved in the design or supply of command and control systems we were able to assure staff that there was no conflict of interest.

A meeting was arranged with senior management on the Bakerloo Line. We presented the general themes that informed our research and why we would like to undertake a preliminary study with London Underground. We stressed that, in the first instance, we would simply undertake a pilot project, just two or three days, involving field observation and, where practical, informal interviews with staff. We would then report back to management and then they could decide whether the research was worthwhile taking further. On this condition they provisionally agreed, but required the agreement of the Unions and personnel in the Line Control Room. Staff and the Unions accepted the proposal of a pilot project and we began the study. Video recording had not been mentioned at this stage.

The first few days of fieldwork were spent largely in the control room before the introduction of the new signalling system. It not only proved fascinating, but we realised that personnel had major concerns about both the new technology that was to be introduced and its implications for their roles and responsibilities. Our preliminary fieldwork provided us with the opportunity to learn of the quite reasonable worries of staff concerning the new system. In our report to senior management we were able to discuss a number of those problems and raise one or two issues concerning the introduction of the new system and its potential consequences.

Management were convinced that it was worthwhile looking at these issues in more detail. Since our concerns reflected many of the worries of personnel, they were keen that we should undertake further research as well. Even at that stage, it was clear that the research was beginning to reveal the complexity of the skills required by staff to manage traffic on the network and the range of events and problems that they faced day-to-day – it was a period in which the Irish Republic Army (IRA) was active in London, which heightened the security measures that were put in place. The complexity of the work enabled us to introduce the idea that it would be of great benefit to video record activities in the Line Control Room. Staff and management happily agreed, with various provisos on access to and use of the data.

After a short period, we realised that we needed multiple cameras to examine communication and collaboration in the control room. Staff and management agreed and we undertook a further phase of data collection in which we used four interlinked cameras. This enabled us to record participants and their screens and diagrams. When we showed video fragments to staff within the control room to discuss the initial findings, they then suggested that it might be worthwhile comparing the Bakerloo Line control room with other control centres on the network. Two of these happened to be located in the same building. They arranged for access, we secured consent from personnel and management and then undertook brief phases of video-recording in these other control centres. Access and data collection continued to progressively evolve so that after a few months we had access to almost all the line control rooms on London Underground and then to station operations rooms, train drivers, surveillance centres and more. The culmination of this developing process of gaining access and consent perhaps was when staff and management agreed to the BBC recording a programme based on the research.

Two points are worth highlighting. Firstly, approval for access was achieved incrementally, allowing time to develop the involvement and trust of relevant stakeholders. Secondly, access was made easier since the interests of the research team resonated with the more practical concerns of the organisation and staff.

Box 2.2 Some ways to foster trust

- **Take the process of gaining access in stages**
 Develop your understanding of the concerns of the participants to gradually obtain incremental access to the setting.
- **Do not blindly follow ethical guidelines**
 Make sure that they are appropriate for the study and show how you can deal with the specific requirements of video recording.
- **Present video clips and provide reports from previous studies to the participants, to show the kinds of data you will be collecting and the issues that you will be exploring**
 You may find it useful to take a laptop computer, portable video-player (or camcorder) so that you can easily show people clips from previous research.
- **Emphasise your interests in the participants' practices and knowledge**
 You may wish to reiterate that unlike some documentaries and television programmes you are not concerned with the unusual or dramatic but with the ordinary and routine.
- **Emphasise the right to withdraw from a study at any time**
 Participants should be aware that they may request that recordings be erased at anytime. This should be mentioned in the information sheets you provide, but it is worth reiterating.
- **Provide individuals and organisations with copies of reports and papers written about the study**
 It is usually the case that through your research you consider issues that may be relevant to the organisation you are studying. It is often helpful to offer to provide a report or make a presentation that specifically addresses

these more practical or applied issues. At the very least it seems reasonable to disseminate papers based on the research to your hosts.

- **Make it easy for individuals and organisations to contact you**
 Provide all participants with a way to contact you to discuss the research. This could be via your official phone, email account or mobile.
- **Offer to meet again to discuss the research**
 You should always be available to discuss matters further. You can make progress in small steps by first suggesting a brief pilot study or a convenient time when you could collect a small amount of video, so the participants can see what is involved.

Case 2: Schools – Recording children

Video has been widely used for educational research (Goldman et al., 2007), for example, to explore the interaction between pupils and teachers. Gathering video data involving children, or members of any potentially vulnerable group, raises additional issues. In many countries there are special provisions in legislation and in official ethical guidelines regarding research involving young people. It is important, if you are intending to collect video recordings of children, to be aware of local legislation, guidelines and practice.

Obtaining consent can prove difficult if the children are very young or considered too immature to make a judgment. In these cases a researcher cannot only rely on securing the consent of 'gatekeepers' such as teachers, head teachers and the parents of the children (Homan, 1991) but, as most recent guidelines emphasise (including the UN Convention on the Rights of the Child), it is necessary to explain what you are doing even to the youngest of children in language that they can understand. You need to check that they are willing to be recorded, although with younger children the extent to which they are truly 'informed' may prove problematic (Flewitt, 2006). In this regard, gaining consent to video record classroom activities can be time-consuming especially if you wish to record a whole class of children. Permission may well have to be sought from a large and disparate collection of people, including parents, teachers and classroom assistants. It is likely that many will be hard to contact, may not initially respond to your enquiries, and some may give permission whilst others will not.

Box 2.3 Issues to consider when making video recordings of young people

- **Be inclusive about who you involve**
 Try to involve the children, teachers and other carers and parents as much as possible in discussions about your research.
- **Find out if procedures already exist that you can draw upon**
 Many educational institutions have established policies for recording. Also, most teachers and teaching professionals will be familiar with video from their training, so may have useful tips or experiences from which you can learn.

(Continued)

- **Develop materials to support your discussions**
 These will include letters, information sheets and consent forms written in appropriate styles for teachers, parents and pupils. Note that teaching professionals may be more interested in the methods you are using, whereas parents may be concerned about the potential disruption to teaching and how the data will be disseminated.
- **Consider who should collect the data**
 Researching children requires care. If you are unsure about whether you have the experience necessary to deal with the issues that might arise, consider gaining the support of an educational professional or someone with specific skills with children to assist you.
- **Think about the potential consequences of your study**
 Existing guidelines on research involving children offer much that it is useful, but these are not a substitute for properly considering the potential hazards and risks.

In a recent study we were interested in how students used paper, books and computer systems in classrooms (Luff et al., 2007). We identified a number of local schools that might be willing to participate in the research and discussed our ideas with the teachers and head teachers at each. Following these discussions it was agreed that we should focus on classes of children aged 9 to 10 years old. We then had further discussions with the teachers of the children and found volunteers who would be happy for recordings to take place in their classrooms. We then obtained formal permission to commence the study from the head teacher on the understanding that we would gain consent from teachers, students and the parents of those children. We discussed with the relevant teachers how this could best be done and they helped prepare the information sheets for parents, the consent forms and the covering letters. It was agreed the letters would be sent to each parent individually from the teacher of the child in question and reflect the usual way teachers informed parents of school activities.

Box 2.4 Example consent letter for parents

<school address>

Dear <parent's name supplied by school>
I am writing to ask whether you would be willing for your child to participate in a research project being conducted by <researcher's institution>.

The aim of the research project is to explore how children use books and computers for learning. It is hoped that these studies will inform educational practice, provide design recommendations for new technologies, and contribute to social scientific research concerning child interaction. The project is part of a wider initiative investigating new technologies to support educational activities and is funded by <research funding body>.

To carry out this research, <researcher's institution> would like to video a class of children conducting their normal activities during lessons. For example, the video might focus on children working on a computer or a group of children working with books. It would not involve children taking part in any extra activities. This video will allow the researchers at <researcher's institution> to look closely at how children use books and computers in order to complete their tasks. The children are not being measured or tested in any way.

Initially the video will only be viewed by the small team of researchers directly involved in the project. If any of the video is to be shown to a wider research audience then the identities of the children will be protected (their real names will not be used and their faces will be blurred).

The videoing would take place on two or three days for around 1–2 hours on each day, and should not disrupt their school day. The researcher from <researcher's institution> who will video the work is <researcher's name>, who can be contacted at <researcher's address, email and phone number>.

Please feel free to contact me or <researcher's name> with any worries or questions about the video or the research.

If you are willing for your child to participate I would be grateful if you could sign and return the section at the bottom of this letter. If you do not wish your child to participate, they will be able to take part in their lessons as normal but will not be included in the video.

Yours

<teacher's name>

...

I am willing for my child to be videoed during their lessons at school for a research project being conducted by <researcher's institution>

Signed...

A number of parents replied to give consent. However, their children did not correspond to the standard groups into which they were divided for classroom activities. We were only interested in focusing on small groups of three to four students working together at a time. As these working groups were not 'fixed', the teachers were willing to re-organise the groups so that students with completed consent forms could work together.

Prior to the first day of recording we visited the school to discuss the research with all the students. At this stage we obtained explicit consent from those that might be recorded. Given possible absences from class, we could only make the final selection on the day of recording. We focused on one desk of four children and arranged the camera angle so that other children in the class were not in view. Data were edited if children without consent forms entered the scene. As we only required short, maybe 30-second, extracts to develop the analysis, these arrangements proved unproblematic. As there was frequent movement around the class and talk between classmates, analyses of learning activities of longer duration, or involving more students, may have required additional procedures for gaining consent.

The case highlights the special care that needs to be taken when seeking permission to record potentially vulnerable people, and the importance of involving all stakeholders in discussions and negotiations about access. It also shows the significance of carefully designing information sheets and consent forms with regard to the needs of particular stakeholders.

Case 3: Museums – Research in public environments

It is widely recognised that strictures used to secure informed consent are difficult to follow in undertaking studies of public and semi-public settings. Indeed, the British Psychological Society and the American Sociological Association specify that informed consent is not usually required in public settings (see Box 2.5).

Box 2.5　Informed consent in public settings

Unless informed consent has been obtained, restrict research based upon observations of public behaviour to those situations in which persons being studied would reasonably expect to be observed by strangers, with reference to local cultural values and to the privacy of persons who, even while in a public space, may believe they are unobserved.

BPS Code of Ethics and Conduct, 2006: 13

Sociologists obtain informed consent from research participants, students, employees, clients, or others prior to videotaping, filming, or recording them in any form, unless these activities involve simply naturalistic observations in public places and it is not anticipated that the recording will be used in a manner that could cause personal identification or harm.

ASA Code of Ethics, 1999: 14

Although the guidelines are more relaxed, it remains the responsibility of the researcher to be sensitive to the concerns of participants. Even if you plan to record in a public setting where people take photos and video recordings – for example at tourist sites – information about the research should be made available to participants and they should still have the opportunity to decline to participate.

In a series of recent studies of conduct and interaction amongst visitors in museums, galleries and science centres (Heath and vom Lehn, 2004; vom Lehn et al., 2001), it was impossible to gain written permission from the thousands of people who pass through the doors of each museum on a daily basis. Curators, museum directors and education officers were also concerned that the more conventional methods for gaining informed consent would be intrusive and would undermine visitors' experiences. After discussion with visitors, as well as museum staff, it was agreed that we should use an 'opt-out' model of consent (Homan, 1991).

We decided to undertake data collection in only one of the many galleries of the particular museum at any one time. Signs were mounted at the entrance(s) to the gallery, providing information about the research and the recording taking place (see Box 2.6). If visitors had any questions or reservations, the signs invited them to talk to a researcher who was available throughout the period. The signs were mounted on stands that preserved the overall aesthetic of the exhibition but could not be confused with the labels and signs used by the museum.

Box 2.6 Example sign for use in a museum

<address of research institute>

We are currently undertaking a research project looking at the behaviour of people in museums. We are particularly interested in the ways in which people look at and discuss paintings in <museum>. The project involves close collaboration between researchers at <research institute> and the staff and associates at <museum>.

In order to undertake this study we are currently video- and audio-recording in parts of <name of gallery>. If you have any concerns about being recorded, please inform our researcher or a member of the <museum> staff and the camera will be switched off immediately. If you have been recorded but decide that you would prefer that the recording was destroyed, again, please inform us, and the tape will be wiped.

The material will be used for research and teaching purposes only.

<names and contact details of principal researchers>

Throughout the study a number of visitors approached us, either because of the signs or seeing the cameras, the microphones or the researcher. Many were interested in the research and wanted to find out more. However, we had very few visitors who were concerned about the recording or who asked for data featuring them to be destroyed (see also Gutwill, 2003).

It is difficult to anticipate all the questions and concerns members of the public will have when recording in more accessible environments. It is important to remain available – often close to the camera during recording – and willing to discuss the research and allay any concerns. One issue that is often overlooked in public settings is to make people aware that the recordings also capture sound and, most importantly, talk. It is not always apparent to participants that you might be recording what they say. It should be added that in these studies we took care to discuss the research with museum staff, not just senior management but also guides and security guards. It was important that staff were also aware they might be recorded and were happy that this should take place.

There are two points worth highlighting. Firstly, that the conventional model of informed consent is not appropriate to all settings, and secondly, it is important to discuss with members of the relevant organisations how best to inform people about the research.

2.4 Obtaining ethical approval

To undertake research involving people, or 'human subjects', most universities and research institutions require researchers to obtain formal approval from an ethics committee, institutional review board (IRB) or similar. The process typically requires a written proposal reviewed by a committee. In some universities the process applies to all research projects, whether they are carried out by undergraduate students or by experienced research staff, whether they are funded or not, and irrespective of whether they take a few weeks or many years.

Approval is normally granted for a specific duration and if the project runs over that period an extension has to be secured. The formal approval process is intended to ensure that before any research is carried out by members of the institution, that ethical matters have been considered and addressed, that the research is safe and that it respects the autonomy and privacy of the participants. In some cases, for example, in undertaking research in health care organisations, it can also prove necessary to submit a formal application to the institution in question or an overarching body to secure ethical approval for the research. Even if your own institution or the organisation that oversees the research site does not have an explicit policy on ethics, it is important to consider the ethical issues that might arise.

Box 2.7 Internet links to ethical guidelines and procedures

- British Psychological Society (2006):
 http://www.bps.org.uk/the-society/code-of-conduct/code-of-conduct_home.cfm
- British Sociological Association: Visual Sociology statement of ethical practice (2006):
 http://www.visualsociology.org.uk/about/ethical_statement.php
- Economic & Social Research Council 'Research Ethics Framework' (2005):
 www.esrcsocietytoday.ac.uk/ESRCInfoCentre/Images/ESRC_Re_Ethics_Frame_tcm6-11291.pdf
- American Sociological Association Code of Ethics (1999):
 http://www2.asanet.org/members/ecoderev.html
- General Medical Council *Making and Using Visual and Audio Recordings of Patients* (2002):
 http://www.gmc-uk.org/guidance/current/library/making_audiovisual.asp
- Market Research Society Code of Conduct (2005):
 http://www.mrs.org.uk/standards/codeconduct.htm
- Social Research Association 'Ethical Guidelines' (2003):
 http://www.the-sra.org.uk/ethical.htm
- UK Data Protection Act (1998):
 http://www.opsi.gov.uk/ACTS/acts1998/19980029.htm
- UN Convention on the rights of the child:
 http://www.unicef.org/crc/
- Wellcome Trust Guidelines on Good Research Practice (2005):
 http://www.wellcome.ac.uk/About-us/Policy/Policy-and-position-statements/WTD002757.htm

See also the International Compilation of Human Subject Research Protections document which has been compiled by the Office for Human Research Protections, United States Department of Health and Human Services and gives listings for Research Ethics Committees in 72 countries (http://www.hhs.gov/ohrp/).

Research ethics committees may consist of members of your department or discipline, but increasingly they also include academics from other fields and in some cases lay members drawn from the general public. It is important therefore that your methods and approach are clear to a non-expert and that the reasons for using video are convincing. In many cases, ethics committees will not be familiar with research that uses video and it will be necessary to provide background to the approach and examples of video-based studies, preferably in the same field of application. The approval process often allows supplementary materials to be provided with the application including, for example, your original research proposal, information sheets you will give to participants and sample consent forms and these can provide an opportunity to clarify your approach. The professional associations for psychologists, sociologists, anthropologists, for educational, social or medical researchers all specify ethical codes and principles (see Box 2.7). These can be an invaluable resource in choosing and legitimising your approach with regard to issues of ethics.

A number of the questions that arise in conventional application forms used by ethics committees will not necessarily be relevant to your research, but the use of video does raise issues that may need to be addressed. These include the following:

- *Does the study involve potentially vulnerable participants or those unable to give informed consent? As well as children this includes people with learning difficulties, your own students, over-researched groups or people in care.* In all these cases consider how you can obtain consent without subjecting participants to undue pressure, for example, it may be worth considering the use of intermediaries, including gatekeepers or carers, or providing additional time for people to reflect on and withdraw from your study.
- *Will participants take part in the study without their consent or knowledge or will deception of any sort be involved (this might, for example, be the covert observation of people in non-public places)?* The normal principle is that informed consent is obtained from all participants prior to the study. Deception should not be used without very good reason. If some form of informed consent cannot be secured prior to recording, then consider how you can provide information following data collection and, if relevant, provide the opportunity for participants to have materials destroyed.
- *Does the study involve the discussion of sensitive topics affecting individual respondents (e.g. sexual activity, drug use, death or illegal activities)?* The confidentiality and privacy of the participants needs to be strictly maintained and you should ensure that members of the research team have the skills and experience to deal with sensitive topics that might arise. Prior to undertaking any study you should consider how you might deal with materials that concern illegal or improper activities by participants. These matters are of common concern to ethics committees and guidelines are available.

- *Could the study induce stress or anxiety, or produce humiliation, cause harm or negative consequences beyond the risks encountered in normal life?* If, as part of the research, participants undertake particular tasks or discuss matters that could prove potentially humiliating to themselves or others (for example, their friends, family or colleagues) then clear strictures are required that might further constrain access to and use of the data.

Although ethical procedures differ from committee to committee, some questions recur for those collecting and using video recordings. The following might be useful to consider when completing an ethical approval form.

Legal and organisational considerations

You may need to state who has rights to the data. This could include the researcher, funding body, academic institution, host setting, a collaborating organisation and the participants. Normally it is the researcher. However, you should be wary if others, like funders or management within the participating organisations, request the right to access the recordings. The funding body, for example, may hold a data archive that requires principal investigators to submit materials and use by the broader research community. Or, for example, senior management of the organisation in which you are undertaking the research may request copies of recordings, if only for running a training session or giving a presentation. It can be difficult to envisage all the circumstances where you might be asked to provide copies of your video recordings but in establishing access and securing ethical approval you have to avoid possibilities of being subject to unreasonable requests in the future.

It will often prove necessary to refuse requests to provide copies of your video recordings. For example, we receive numerous requests to provide other researchers with copies of our substantial corpus of materials, where the original agreement stipulates that copies will not be made available to people outside the research team. In this regard, it is worth being careful when making presentations of your research. It is not unusual for people to request permission to record a talk or receive copies of the slides and associated video data (this is discussed further in Chapter 6). In some circumstances it may seem churlish not to respond positively to a request for material, for example, in a case where there is genuine commitment to use the data for the benefit of members of the organisation (an organisation that may have generously given you access). However, first and foremost it is critical to re-seek permission from participants, that they are happy for the selected materials to be made available. Also carefully review the material in question to ensure that there is nothing untoward or potentially embarrassing. This may include jokes or discussions about fellow members of the organisation, or about unexpected visitors. In one case we inadvertently collected personal comments concerning a senior minister of the government who had attended an event at London Underground. This was deleted.

Storage, access and archiving

In securing ethical approval you may well be required to specify how long the data will be kept. These strictures can undermine one of the significant advantages

of video recordings, namely the ways in which they can be re-used and subject to a range of analytic interests. Care needs to be taken therefore in preparing an application to an ethics committee to stress the possibility that the data will be used to address a range of substantive and analytic concerns. In certain circumstances, it is possible to secure permission to continue to use the data beyond the duration of the initial project arguing that it will be used to further develop analysis and prepare papers and publications. In other circumstances, you may need to reapply to the relevant ethics committee to continue to use the data. If you are considering using the data beyond the period of the project then you should make sure you have agreement from participants when you initially collect your data, since it can prove difficult to re-establish contact after a period away from the setting.

In cases where you use the recordings for a longer duration, particularly if the material is to form part of an historic archive, it is worthwhile discussing copyright approval with the participants. You might wish to refer to the guidelines offered to oral historians when considering archives of personal materials (Ward, 2003) or the experiences of the Qualidata archive in relation to consent agreements for archiving qualitative data (Corti et al., 2000).

Box 2.8 Guidelines for storing and distributing data

- Always make copies of all your original recordings and store them in a separate location.
- Store all data and collections in a secure location. If they are on computer they should be password protected.
- Do not place data on public websites unless you have explicit agreement from all the participants.
- Only provide copies of data to those who are authorised to use it as specified in the original agreements.
- If you have agreement to present fragments to research audiences, this may not include presentations being made available on stored media or websites. Be careful when distributing copies of your presentation material.
- Similarly, be careful when requests are made by others, like data archives, for your material; ensure that this does not contravene your agreements with participants.

Confidentiality of Data <sample answer for an ethical approval form>

The data are only to be used for teaching and research purposes, and are kept locked in a cupboard at all times. Data on the computer are guarded by password access and are wiped from the hard drive as soon as they are no longer needed. Video data that are collected will be kept for seven years in a secure location and then destroyed.

Preserving privacy and the anonymity of participants

Video presents distinctive challenges for ensuring the privacy not only of the individuals that may be recorded but also for any organisations that may be involved. The names of individuals or organisations may be voiced, people will be recognisable, institutional logos may be visible, and confidential information may well be recorded. You may also, even inadvertently, record personal phone conversations, gossip, discussions of an organisation's strategy and the like – material that it may be critical to anonymise or even remove.

In some cases it can be difficult to ensure that participants or settings cannot be identified from the materials that are published. For example, in our studies of auctions, the name of the auction house is sometimes written in large letters on the rostrum from which the auctioneer conducts the sale. Also given the relatively small number of companies that are selling pictures worth more than two million dollars, even if the name of the auction house is concealed, it is not difficult to identify the organisation that might be involved. In our studies of control centres on London Underground, we realised early on that it would be impossible to conceal the identity of the organisation or even the particular control rooms that we studied. In these circumstances it is important to make it clear to participants and the organisation that it may not be possible to preserve their anonymity.

In many cases, however, preserving the anonymity of the setting or organisation will be unproblematic and it is unlikely that individual participants will be familiar to people who see the data. Nevertheless there remains a 'duty of care', to avoid showing or sharing material that might, however inadvertently, threaten the privacy of individuals or prove invidious or embarrassing.

For publication, there are conventional ways to anonymise transcripts and references to people, places and organisations through the use of pseudonyms. There are also various techniques that can be employed to modify images. Standard software packages can be used to blur or pixellate faces, logos and the like (see Chapter 6 for ways of doing this). Alternatively, the images can be replaced with tracings or drawings that selectively exclude elements that might enable recognition of particular individuals. Where practical, it is often best to discuss these issues with the participants and together come up with a procedure that they will be happy with.

However, these procedures can severely constrain research. It would be difficult, for example, to present an analysis of visible orientation in a medical consultation if it is required that actions of interest are obscured in order to preserve the anonymity of the participants. It is critical, therefore, that in securing consent, you recognise the implications for the type of analysis you can undertake and for the ways in which your observations and findings can be presented and published.

Many participants will allow researchers to record and even make copies of the documents that they use and will grant permission to record what is displayed on computer screens. It is important to be aware that in collecting such materials it is possible that you will have access to personal data of clients, customers or other people associated with the organisation; data that in some cases, you may well have not expected to collect. It remains the investigator's responsibility to secure agreement on the use of all private information and to make sure that data are stored securely

and cannot be accessed by anyone outside the immediate research team. If in doubt, discuss the matter with the participants and other relevant members of the organisation.

Given changes in organisations and personnel, it can be difficult to renegotiate consent to participate in your research, so it is unwise to assume that once you have gained consent to record you will be able to relax any conditions you have previously set. It may be more appropriate to make participants aware of the nature of your analysis and secure explicit agreement to present particular materials. Rather than collecting data that you will later find to be unusable, it is better to collect a small amount of usable data that you can present and publish. You will need to provide information concerning the management of these issues in your application to an ethics committee.

Anonymity of Participants <sample answer for an ethical approval form>

Participant's identities are anonymised in the data records whenever they are published. At the earliest possible stage, names on any transcripts are transformed into pseudonyms. Where possible, all reference to particular institutions and organisations will be anonymised. Where complete anonymity of the institution is not practical, agreement from relevant participants and members of the respective organisation(s) will be secured.

Dissemination and presentation

One of the advantages of video, particularly digital video, is that it can be easily copied – often with no loss of quality. Copies can be made on a variety of formats including CD-ROMs, DVDs, portable disks and quite easily uploaded to websites. This makes it relatively simple to share data with other researchers. The flip side of this is that it is easy to lose control over who has access to your data (see Hindmarsh, 2008). If you make copies of data available to others then they can similarly copy the data for distribution. It is unlikely, however, that they will know the details of the agreement you made with the participants, and may well be unaware of the informal, tacit assumptions that enabled data collection to proceed. Despite the temptation to share material and show generosity to fellow researchers and the broader research community, it is advisable to be careful when making copies, even for the closest of colleagues. If copies are made, and are part of the original agreement, then it is critical to make sure that colleagues are clearly aware of the agreements that apply to the data and its reproduction.

In this regard uploading data to public websites is particularly problematic, since there is no effective control over who may then obtain copies of recordings from such websites. Even if not intended for public use it is important to use passwords to protect access to websites that include data collections. More generally, if you intend to distribute or publish CD-ROMs, DVDs or share data, make it clear in your agreement with your participants. If you are in doubt as to

who will be able to access data and whether it can be subsequently copied, it is best not to make it available. This may run contrary to the interests of your fellow researchers, students, or funding bodies, but your agreement with participants is your principal responsibility.

On the other hand, it is important to secure an agreement that will not undermine your ability to analyse the recordings and present and publish your findings. You should be concerned with the privacy of the individuals and the organisations you study, but make sure that this does not restrict your own obligation to present and publish your findings. As with any research, you should be sensitive to any agreement with an organisation that requires their consent prior to publication. It is good practice to distribute to organisations material that you wish to publish and ask for their comments and feedback. This can help correct inaccuracies and errors, but you need to consider carefully giving them the right to stop publication or to enforce changes. We always find it best at the outset of the project to state that it will be necessary to present at least brief video fragments to the research community, for example, at conferences and colloquia, and to students in lectures and classes.

2.5 Project planning

Many of the issues and problems that arise in planning video-based studies are not unlike those that arise more generally with qualitative research. It is important to identify clear aims, objectives and research questions and to consider how best to divide the project into discrete stages or phases. Furthermore, it is useful to establish key milestones, to clarify the criteria that will be used to assess the final outcomes of the project and to consider how the research might contribute to theory, method and practice. Many texts on research methods discuss these issues and funding bodies usually encourage them in their guidelines for research grant applications (see for example ESRC, NSF). There are, however, aspects of video-based research that raise distinctive issues and challenges and that require special attention.

The approach to gaining access that we described earlier in this chapter is somewhat idiomatic of the broader approach to video-based studies. That is to say, it is useful to undertake data collection incrementally, in a series of small steps or phases. As discussed, it might be necessary to build from fieldwork towards video recording to develop the trust of individuals and organisations and that this should be done in stages. Also, and as we shall discuss in Chapter 3, it is useful to experiment with different camera angles, camera combinations, microphones and the like. This again requires an incremental approach. Also, and maybe most importantly, progressing in an incremental, step-by-step manner suits the qualitative approach that underpins this use of video recordings.

For instance, it is tempting to start to make notes on all that has been recorded, to transcribe the data and then begin some kind of categorisation and identification of themes. However, even when making brief notes and rough transcripts it is likely that an hour of material could take at least three to five hours; it is time-consuming and needs to be taken into account when planning a project. Indeed, rather than adopt a conventional model of research in which data collection is followed by data

analysis, video is more suited to an iterative approach where data is collected in brief phases – maybe one to three days at a time – and then subjected to transcription and systematic review. Preliminary observations and insights that derive from these early phases of analysis can provide the resources with which to decide what further data should be collected and what form that data should take: the timing, framing and focus of the recording. So, rather than undertake a single period of data collection followed by data analysis, it is worthwhile undertaking successive phases of data collection interdispersed with analysis. In this way, data collection can be sensitive to analytic themes and issues that emerge during the course of the research as well as maximising the quality and relevance of the recordings.

This more iterative approach to data collection also facilitates the involvement of colleagues at early stages of the research. Unlike more conventional fieldwork where individual researchers are expected to spend extended periods of time in the field before reporting on and discussing their observations and findings, video provides the resources with which to review and discuss the project from the earliest of stages. Data analysis workshops, informal presentations, simply showing fragments of data to colleagues, supervisors and members of the research community can support serious discussion of the research, which fields of inquiry might be pursued, the advantages or disadvantages of other ways of gathering data (or other settings that might be relevant) and even the analytic issues that might form the focus of further research.

So rather than being segmented in terms of project development, data collection followed by analysis, we suggest that it may be more appropriate to interdisperse analysis with successive stages of data collection. For example:

Preliminary: Prepare project proposal, secure access and apply for ethical approval.
Outcome: *Final project proposal, access secured and ethical approval.*
First stage: Prepare for data collection, undertake preliminary fieldwork and a brief period of audio-visual recording.
Outcome: *A preliminary corpus of data, an evaluation of the material, preliminary observations and a strategy for further data collection that may include further fieldwork as well as audio-visual recording.*
Second stage: Review of data, selection of fragments and transcription and analysis of particular activities.
Outcome: *A preliminary catalogue of key events and activities in the data, a corpus of transcripts and a report documenting the analysis of particular actions and activities.*
Third stage: Collect further data, where relevant, transcribe data, undertake review of new materials, develop and refine analysis.
Outcome: *Catalogue data and develop the corpus of transcripts. More thorough analytic report showing refined analysis of fragments with increasing and developing sophistication of argument and analysis, tied to issues in the recent literature and reflections on the implications that can be derived for the study.*
Fourth stage: Final writing, dissemination and presentation of analyses.
Outcome: *Articles, presentations and discussion of methodological, conceptual and practical implications.*

Box 2.9 Example project timetable

A video-based study of design practice:
Duration of the project: 30 months.

1. Stage I: Preparation (months 1–3)

- Undertake a brief review of related studies of design to assess themes and issues that have been addressed, particularly focusing on those that have adopted a naturalistic approach and used video.
- Establish contact with design companies and meet to clarify the approach with participants and secure agreement and dates for initial data collection.
- Also, undertake a brief survey of the design practices to assess where to begin collecting video and any special requirements for equipment.
- Acquire video-recording equipment and gain familiarity with it.

2. Stage II: Preliminary fieldwork and data collection (months 3–9)

- Begin fieldwork in principal site, initially through field observations and interviews with members of the design practice.
- As soon as practical, commence recording, including capturing general shots of the site (work areas, technologies, example documents and resources) and collect sample recording of a focused collaboration (say one hour).
- Discuss recording (camera positions, sound levels) and initial observations with research team. Return to setting for two to three days' recording, selecting several locations and design teams, and gather recordings of design discussions.
- Review recordings, select fragments and discuss fragments with research colleagues.

Data Workshop I: report initial fieldwork and data collection to close research colleagues. Gather suggestions for further relevant data collection and to support initial development of typology of activities (month 4).

- Repeat short periods of recording, selecting and transcribing fragments of design discussions, and writing reports of preliminary analysis.
- Extended literature review given themes emerging from analysis.
- Undertake some recordings of other work activities in the design practice (e.g. presentations to clients, project-planning activities, mark-up of detailed design changes and using computer systems).

Data Workshop II: propose and discuss initial themes for analysis with wider research team. Gather suggestions for other issues to focus on and materials to collect (month 9).

3. Stage III: detailed investigation (months 10–24)

- Principal fieldwork and data collection – again through successive short periods of recording.
- In-depth analysis of selected video recordings and associated data. Detailed transcription of fragments.
- Reports of extended analysis of collections on particular themes and issues, related to literature and practical concerns of the project.

- Further comparative or exploratory fieldwork (say, of other design practices, clients or collaboration with other organisations and professionals).

Data Workshops III–VI: to present analysis of fragments and refine analysis, to discuss analysis with key participants and colleagues outside the research team (months 15, 18, 24).

4. Stage IV: Dissemination (months 20–30)

- Preparation of reports, papers, and draft publications.

Data Workshop VII: Present analysis to external parties (e.g. practitioners, external researchers and other organisations) (month 28).

The problems and issues that arise in undertaking projects that use video data make this kind of structure advisable, and the particular qualities of video make it possible. While it may not be the conventional way in which research projects are organised in the social sciences, it would not be unfamiliar in a number of other disciplines. Nevertheless, in any project proposal it will require some explanation (see also, Sandelowski and Barroso, 2003).

Key points

- Gaining access normally requires the cooperation and agreement of a range of people – not only participants themselves, but also key stakeholders in particular organisations or institutions.
- Consider the concerns of participants when undertaking data collection and when presenting and publishing research based on video recordings.
- Gaining and maintaining ethical approval often remains relevant throughout the lifecycle of your research.
- Consult the ethical guidelines of the professional bodies and associations that relate to your research.
- Consent needs to be carefully tailored with regard to the characteristics of the setting and the concerns of the participants themselves.
- Where possible and appropriate organise your research through successive phases of data collection interdispersed with analysis.

RECOMMENDED READING

- Michael Hornsby-Smith (1993) provides a useful overview of general issues and problems of access in social research, and Mark Saunders et al. (2007, Chapter 6) consider a range of useful strategies for negotiating access to firms and organisations.

(Continued)

- Roger Homan (1991) and Melanie Mauthier et al. (2002) provide thorough reviews of ethical issues in social research.
- Sharon Derry (2007) and Rosie Flewitt (2006) include useful discussions of the distinctive problems and concerns of undertaking video-based research in classrooms.
- Margarete Sandelowski and Julie Barroso (2003) present an informative piece on the distinctive challenges of writing proposals for qualitative research. They annotate one of their successful funding applications and draw out some broad principles.

EXERCISE

Write a three-page project proposal for a three-month video-based study of your choice. It should be divided into 5 sections:

1. *Aims and objectives*
2. *Background*
3. *Methods*
4. *Approach*
5. *Intended outcomes and dissemination*

3

COLLECTING AUDIO-VISUAL DATA

3.1 Introduction

All forms of data are selective and video recordings are no exception. Where you position and how you focus the camera, the number of cameras you use, whether you attempt to follow the action or use a fixed frame, and how you record sounds, all have an impact on the data you collect and the analysis you are able to undertake. So it is important to have a clear sense of what is required of the data before you begin to record. As you make decisions about data collection it becomes apparent that they are tightly interrelated and even the most trivial of decisions, such as whether to use a tripod or not, reflects the broader analytic commitments of the research.

Even with a clear understanding of the form of data required, few researchers are able to gather good quality audio-visual data when first entering a setting and even highly experienced researchers will often encounter difficulties. Indeed, if there is one important lesson to be drawn from the outset, it is that each and every setting poses distinctive challenges for recording. In consequence, data collection will normally require successive attempts before high quality, researchable materials are secured.

In this chapter, we address a number of the more significant challenges that arise and introduce some strategies for dealing with these problems and issues. If one considers that video studies have explored settings ranging from cars to control centres, operating theatres to kitchens, then there is no reason to believe that ethical or practical constraints will preclude research in almost any setting. This chapter considers both the general methodological issues as well as a number of more specific practical matters that arise when undertaking video-based research. These include the following:

- Deciding whether to set the camera in a fixed position or adopt a more active role when recording.
- How to select and frame the image to capture what is required.
- Understanding the impact of video recording on the activities of participants in the setting.
- Identifying the range of supplementary forms of data that may be necessary or helpful in analysing the recordings.
- Maximising the quality of the sound as well as the picture.

3.2 Observer roles and camera positions

One of the key issues in video-based research is whether or not to fix the position of the camera in the setting. In turn this raises a broader set of issues regarding the role of the field researcher and their relationship to the participants. These roles in part reflect the significance that recorded data holds for analysis, whether, for example, it is illustrative and reveals observations largely generated through field-work or, in contrast, it is treated as the principal form of data on which insights and findings are based. For example, the dominant trend in visual anthropology is towards using the camera to create ethnographic films co-produced with the participants (see Banks, 2001), whereas in, say, Conversation Analysis, where the focus is on the details of social interaction, a fixed camera is ordinarily used to encompass all active participants in the scene. It is worthwhile considering examples of different ways the camera is used and how researchers define their own role in the research process.

The roving camera

Some researchers use camcorders to record their conversations with participants. In these cases, the camera may be used to film the interviewee directly or it may

not even point at anything in particular. Alternatively the camera may be used to enable the researcher to document aspects of the scene that are referred to in the course of the interview. For instance, the visual anthropologist Sarah Pink (2004) interviewed people about the design and organisation of their homes. These interviews took the form of 'video tours' in which the interviewees guided the researcher around their home answering questions and reflecting on the environment and its design and characteristics. The recording can be seen as a collaborative production between people in their home and the researcher, and provided a rich and insightful resource with which to consider the ways in which the participants discussed their domestic environment.

This approach can be taken further by following participants as they actively engage in mobile activities. This way of using video has been termed 'guerrilla-style filming' (Shrum et al., 2005) where the camera serves as a roving eye recording events as they unfold. Highly mobile activities may demand this approach. For example, in studies of people playing 'mixed reality' games, the researchers literally had to run alongside the players carrying their cameras to document the action (Benford et al., 2006). In a rather different way, Monika Büscher (2005) has undertaken a series of studies of the work of landscape architects and recorded their activities in the office, in cars, as they visit sites and discuss plans with colleagues and clients (see Figure 3.1). To capture aspects of these activities and the range of resources on which they rely – plans, sketches, photographs, the surrounding environment, etc. – demanded a roving camera.

Here, the researcher has to be close to the action. So the distinction between recording events, undertaking fieldwork, and even interviewing participants can become more blurred. Furthermore, the subtle and timely use of a camera can prove highly demanding and in many cases relies upon an established familiarity with the activities to enable the researcher to anticipate where the action will arise at certain moments. It is an approach that is used widely

FIGURE 3.1 *Monika's Büscher's video-based study of landscape architects in the studio (top left) and out in the field (top right and bottom). Reproduced courtesy of Monika Büscher*

within social anthropology but as Douglas MacBeth (1999) notes, the researcher is often 'following the action', trying to capture activities that may well have begun as the camera is turned towards the relevant scene of action. In consequence, it becomes difficult to analyse the structure of an activity from the recorded material. Indeed Eric Laurier and Chris Philo (2006: 182) have gone so far to suggest that 'the anthropologist's camera sweeps inelegantly until it finally catches up with [an activity] already in progress'.

The fixed camera

An alternative approach is to place the camera in a fixed position using a single viewpoint. In this approach the researcher adopts the role of observer rather than cameraperson. Fieldwork maybe undertaken alongside recording and can be designed in support of the analysis of the video recordings, rather than the video illustrating or augmenting fieldwork.

Recording in this way has many advantages. If the camera is positioned appropriately it enables the researcher to record activities without having to anticipate events and it provides a consistent view of the stream of action. It also allows the researcher to remain relatively unobtrusive and avoid, as far as possible, participating in the scene or drawing attention to the camera by continually looking through the viewfinder. It can enable the researcher to undertake fieldwork alongside recording and note aspects of events and activities that arise that may be not be intuitively available in the recording. In certain circumstances it also allows researchers to leave the scene and build up a substantial corpus of recordings with the assistance of participants who may be willing to change tapes and the like.

Certain activities and settings lend themselves to using a fixed position and a single viewpoint (see Figure 3.2). These include more formal environments where a small number of participants largely remain in a set position, for example, a medical consultation, a counselling session, a job interview, and so forth, where the ecology of action is relatively circumscribed. It can also include more informal activities such as when families are gathered in a kitchen, having dinner parties or watching television. Even in quite complex environments such as control centres, operating theatres, shops and the like, specific activities can often be adequately recorded using a single camera in a fixed position. However, these settings can begin to prove highly demanding when activities arise in different locations, even within the same room, and may well require the use of multiple fixed cameras. Preliminary fieldwork can provide the resources to identify the requirements for recording, including the position, alignment and focus of cameras.

Choosing between fixed and handheld camera positions

Debates as to how best to film in the field are not new. Gregory Bateson and Margaret Mead – two of the pioneers of the use of film in anthropology – were recorded in conversation over 30 years ago regarding their alternate perspectives

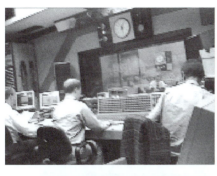

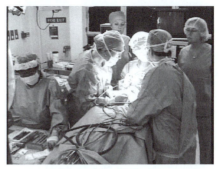

FIGURE 3.2 *A selection of fixed camera images (clockwise from top left): A news studio, a control room, an operating theatre, a design meeting*

on the use of cameras and tripods (see Box 3.1). Bateson considered it critical to follow the action with the camera while Mead saw it as best to record 'long runs' from one perspective.

The role or standpoint that you adopt in gathering data will depend upon two key factors: (i) the type of data needed, and (ii) the practical constraints of the setting. If there are no practical or access constraints, it is often helpful to gather at least initial data in a setting using a fixed camera position. It is simpler, less demanding on the participants, and allows you to capture a run of events at the early stage of data collection. However, you may begin with an idea that a fixed camera will provide the most useful corpus of data only to find that the practicalities of the activity require more flexible access to the domain. In a recent study of car mechanics, Tim Dant (2004) discusses how he changed his initial recording plans.

> Initially we had planned to set up the video camera on the tripod at some distance from the work but [the researcher] rapidly realised that this meant we would miss most of the action; even though cars are large objects, many of the bits are small and the very inaccessibility of components quickly emerged as an issue in the work. (Dant, 2004: 44)

The difficulties in finding a view on the work of the mechanics demanded that they move with the mechanics around and under the cars and in that way were able to record the principal but shifting field of action.

Box 3.1 Bateson and Mead debating the use of tripods

[An extract of a conversation between Gregory Bateson (B), Margaret Mead (M) with Stewart Brand. The full conversation can be found in Brand, 1976.]

B: By the way, I don't like cameras on tripods, just grinding.
 ... it should be off the tripod.
M: So you run around.
B: Yes.
M: And therefore you've introduced a variation into it that is unnecessary.
B: I therefore got the information out that I thought was relevant at the time.
M: That's right. And therefore what do you see later?
B: If you put the damn thing on a tripod, you don't get any relevance.
M: No, you get what happened.
B: It isn't what happened.
 ...

M: Well, what's the leaping around for?
B: To get what's happening.
M: What you think is happening.
B: If Stewart reached behind his back to scratch himself, I would like to be over there at that moment.
M: If you were over there at that moment you wouldn't see him kicking the cat under the table. So that just doesn't hold as an argument.
B: Of the things that happen, the camera is only going to record one percent anyway.
M: That's right.
B: I want one percent on the whole to tell.
M: Look, I've worked with these things that were done by artistic film makers, and the result is you can't do anything with them.
B: They're bad artists, then.
M: No, they're not. I mean an artistic film maker can make a beautiful notion of what he thinks is there, and you can't do any subsequent analysis with it of any kind. That's been the trouble with anthropology, because they had to trust us. If we were good enough instruments, and we said the people in this culture did something more than the ones in that, if they trusted us, they used it. But there was no way of probing further material. So we gradually developed the idea of film and tapes.
B: There's never going to be any way of probing further into the material.
M: What are you talking about, Gregory? I don't know what you're talking about. Certainly, when we showed that Balinese stuff that first summer there were different things identified – the limpness that Marion Stranahan identified, the place on the chest and its point in child development that Erik Erikson identified. I can go back over it, and show you what they got out of those films. They didn't get it out of your head, and they didn't get it out of the way you were pointing the camera. They got it because it was a long enough run so they could see what was happening.
 ...
B: I'm talking about having control of a camera. You're talking about putting a dead camera on top of a bloody tripod. It sees nothing.

3.3 Fixed cameras: Selecting a viewpoint

Prior to filming it is critical to become familiar with the setting – to scout it out – which involves a short period of traditional fieldwork. As suggested in Chapter 2, this also helps to build trust with the participants. Indeed Dant (2004) argues that the roving camera approach adopted in his study of car mechanics required the researcher to build good rapport with the participants for it to be at all successful. In addition, it is helpful in developing a sense of where to place the camera to capture the action. Choices made at this stage can have significant impact on the analysis that is possible. There are three key issues: 'finding the action', 'avoiding the action' and 'framing the action'.

Finding the action

It is important to try to locate some part of the domain or some activity in the setting that the recording (and the research) can focus on. This is particularly problematic in environments that involve numerous participants or where the activities of particular individuals are dispersed across the setting; settings such as control rooms, newsrooms and open plan offices. For example, in our study of a large telecommunications control centre which involved numerous participants based at various consoles, preliminary fieldwork revealed that staff tended to cluster around one particular desk for long periods. We placed a camcorder on a tripod to the side of that desk to record a view along it (see Figure 3.3). Here we could focus on the work of the staff as they sought to deal with the problems that emerged on the telecommunications network, particularly those that were related to the screens in front of them.

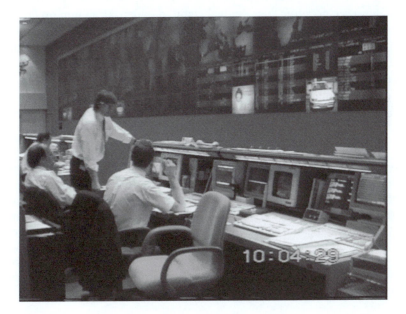

FIGURE 3.3 *One desk in the Restoration Control Office (RCO)*

Finding the action can depend on a range of factors, only some of which are with regard to the organisation of the socio-physical environment. For example, the time of day, the day of the week and even the season, can have an impact on the data that one is able to collect. In our museum studies, we found that filming in certain areas of the Science Museum in London was almost impossible during school holidays since large numbers of children would obstruct the view of certain exhibits. On the other hand, Monday morning in particular areas of the Victoria & Albert Museum (London) would have very few visitors, so there was little point in trying to gather data. Aside from fieldwork, it is worthwhile asking staff or participants about when to collect data, as it is often a practical concern for them as to when it is busy, when it is quiet and when interesting incidents are likely to occur.

Avoiding the action

While it is important to maximise the quality of data, the decision of where to place cameras and microphones should be made in close consultation with participants. Given the need to maintain the cooperation of participants, it is critical not to unduly disrupt their activities. In our studies of pre-operative anaesthesia we routinely discussed camera positions with staff and made sure that we were not using any electrical sockets that would be needed by others. Similarly, when recording in museums and galleries, we had to be sure that the curators were happy that our positioning of cameras and microphones did not disrupt the aesthetics of the display, constrain visitors' access to an exhibit or breach the health and safety regulations, for example, by blocking emergency exits.

If you remain in the setting during recording, it is important to consider how your presence may affect the action, in particular if you remain near the camera. Ordinarily it is best to remain out of view of the camera and range of the microphone, however, occasionally it can be helpful to undertake an impromptu interview so it can seen as well as heard. The danger however, especially if you remain near the camera, is that conversations that you happen to have with participants or even fellow researchers are recorded on the tape and undermine your ability to analyse an activity later. In other words, in recording you need to consider both how you position the equipment and yourself and how those decisions influence the data that you will gather.

Tip: Locating the camera

If the setting allows, position the camera next to a wall or some kind of boundary. This can help to avoid trailing leads across the setting. You should also try to position yourself so that you can see the camera and monitor the filming whilst not having your own conduct and conversation interfere with the recording. Moreover, where possible, avoid being seen by the participants to be actively recording their activities – it will simply draw their attention to filming and make it more difficult for participants to disregard data collection.

Framing the action

Once again, how you frame the action with the camera will depend upon your analytic commitments as well as the practical constraints of the setting. It can be tempting, especially if you are unfamiliar with a setting, to record the widest angle possible using a wide-angle lens. However, doing this runs the danger of losing the detail required to undertake analyses of visual orientation, gesture and the like. Wide-angle lenses and adapters can distort the appearance of an image, often making it difficult to see where people are looking. Settings which involve large numbers of participants, such as classrooms, can prove particularly difficult in this regard since the more you attempt to encompass the action, the more you lose access to the details of their conduct.

Multiple cameras can help to overcome some of these difficulties, but it is also important to consider how you can record the actions of the principal participants, even though certain episodes or features of an activity may not always remain in view. In this and other ways, recording always involves a compromise; a balance between encompassing participation and accessing the details of conduct. As far as our own research is concerned, it proves highly frustrating when, after having collected some recordings, we find that the conduct of a participant that is critical to the accomplishment of an activity is inaccessible.

It can take a number of attempts before you manage to record useable data. As we have suggested, it is important to review materials early on in the process in order to identify and rectify any limitations. Moreover, as analysis develops and you become interested in particular issues or activities, it may prove necessary to change the approach and viewpoint again. For example, in our studies of architectural design, we became increasingly interested in the ways in which people manipulate and inscribe documents such as plans. Therefore we recorded sections of data using an additional camera to focus on the surface of the desk including the participants' hands (see Figure 3.4).

FIGURE 3.4 *Capturing hands in design work*

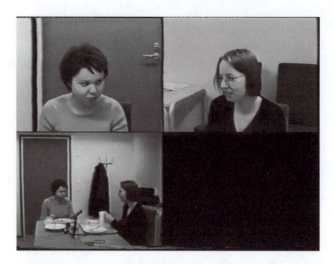

FIGURE 3.5 *Recording facial expressions and emotions using multiple cameras (Peräkylä & Ruusuvuori, 2006). Reproduced with kind permission from Anssi Peräkylä and Johanna Ruusuvuori*

In a recent study concerned with the expression of emotion, Anssi Peräkylä and Joanna Ruusuvuori (2006) used three cameras to record conversations (see Figure 3.5). Two cameras provided a close-up of the face of the participants and the third provided a more general view of the scene. More generally, there is a long-standing tradition in social psychology of experiments that involve the simultaneous recording of multiple images of the participants' bodily movement and expression.

It may not just be the interests of the researcher that dictate how to frame the action: the physical or practical constraints of the setting may exclude some combinations. In a study of social interaction in cars, Eric Laurier and colleagues (2008) were interested in the conversations between drivers and passengers and how these related to the sights and scenes visible through the windscreen. They found that, given the tight space constraints, the only solution was to place two cameras by the windscreen using a severe wide-angle lens for each (see Figure 3.6). One camera faced into the car, the other faced out. We will return to the issue of using multiple cameras later.

Tip: Using the autofocus

When using a tripod, avoid using the autofocus facility that – the default on many camcorders. If there are regular movements in the scene, or someone quickly crosses in front of the view, the camcorder will attempt to adjust and re-adjust. It is better to position the camcorder and manually focus the image on the fixed point of interest, e.g. the desk the participants are working at. Even when using a roving camera, it is important to make relatively stable recordings, as rapid 'panning' and 'zooming' can be 'vertiginous to watch and so blurred to be useless' (Dant, 2004: 48).

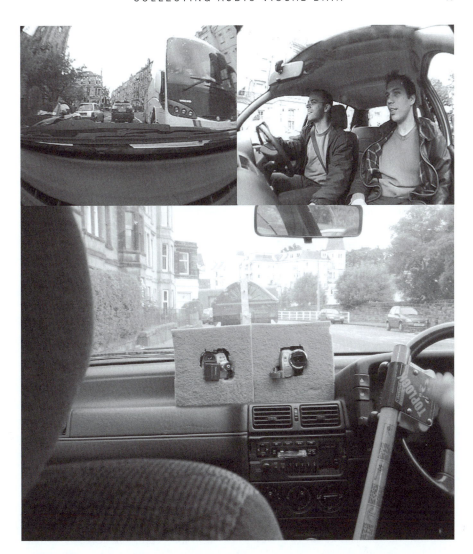

FIGURE 3.6 *These images show the camera set-up used by Eric Laurier and his colleagues to record in-car conversations. Two camcorders are embedded in foam cubes one pointing inwards and one outwards. This produced images of the participants and their view through the windscreen. Reproduced courtesy of Eric Laurier*

3.4 The reaction of participants

It is common for researchers to regard the presence of a recording device as something which renders problematic the normalcy, naturalness and authenticity of the data collected. Such device-induced effects are deemed to distort the object of analysis and lead to potentially invalid results. (Speer and Hutchby, 2003: 333)

As Susan Speer and Ian Hutchby suggest, there is a common assumption in the social sciences that the presence of the camera influences the conduct of those being recorded. If a roving camera is used and participants are asked questions or

asked to describe what they are doing (e.g. to provide a verbal protocol), then the recording process is likely to have a significant impact on the participants and their activities. However, it is often assumed that fixed cameras also affect the conduct of participants and undermine the quality of data. We would suggest that this issue of 'reactivity' is often exaggerated.

Rather than assuming an *a priori*, all-pervasive influence of the recording process on the participants, it is worthwhile addressing the problem empirically. For any data you collect, examine the materials to find evidence of the participants orientating to the filming and if instances are found then consider how they arise and why. In other words, we need to demonstrate an orientation by the participants themselves in the production of their action to some aspect of the recording equipment.

While almost everyone will agree that there is a need to reflect on the impact of a camera and recording on the conduct of the participants, the actual influence is highly variable and will depend upon a range of practicalities and contingencies. For example, it is not unusual to find that when a new participant enters a room, then the presence of the camera is remarked upon. Or, we have noticed that during slack moments, tea breaks, moments of gossip and the like, participants may point to the camera and start discussing the recording. At such moments some participants may even joke and 'play up' to the camera. In one study we undertook with colleagues on financial dealing rooms (Jirotka et al., 1993), the market traders knew that we were interested in their gestures, so in a period of unusually low activity in the market, two of them began to act out strange gestures and comment on how it might influence our findings. However, as soon as the financial markets picked up they once again became immersed in the demands of their work.

More generally, there are often moments when jokes are made, moments when a curious glance is given to the camera, moments when a comment is designed for the camera or for the researcher. In their study of café life, Laurier and Philo reflected on these aspects and the more general influence of the camera:

> Customers and staff at the cafés made visual jokes on camera with an orientation to their recognisability and reception as such … In making jokes like this they did not of course contaminate the entire record any more than a joke on a ballot paper spoils the entire election. They created something easily see-able on the record that for observational documentary would be consigned to the digital trash bin for deletion… (Laurier and Philo, 2006: 185–6)

These 'jokes' and glances are passing moments and it would be wrong to assume that participants remain preoccupied with the presence of the camera throughout data collection. Moreover these occasional moments of awareness do not impact on the quality of the data corpus as a whole. In work settings participants have a job of work to do, and have to accomplish their various responsibilities in routine and recognisable ways. The level of detail that we are interested in would be extraordinarily difficult to transform without making a topic of the transformation or rendering actions unintelligible to others.

Interestingly there are occasions when participants in the setting find it very useful to have a camera and a researcher present. For instance, Colin Clark and Trevor Pinch (1995) recorded sellers in street markets and they would comment on this during their work with phrases like 'We'll be on television from now till

Christmas!'. By incorporating the recording into their sales patter they hoped to generate interest and to attract potential customers. Furthermore, in our own studies of auctions, the camera has been used by auctioneers to draw attention to the importance of a particular lot or to encourage participants to show their hand clearly so that they can 'appear properly on television'. In another case, Helen Lomax and Neil Casey (1998) discuss how midwives used the presence of the camera and the researcher in their study of home visits in order to build an informal atmosphere before getting down to the business of the encounter.

On such occasions the video camera (and the researcher) has an impact on what is being recorded, but its presence does not continue to pervade the action. Throughout our studies – of a diverse range of settings and activities, from the highly sensitive through to public domains – we found that within a short time, the camera is 'made at home'. It rarely receives notice or attention and there is little empirical evidence that it has transformed the ways in which participants accomplish actions.

There are cases when it can seem particularly awkward to record video data, even if agreement has been obtained from all participants. For example, in small one-to-one encounters if the researcher is present they can often feel pressure to participate or alternatively to leave the setting (Lomax and Casey, 1998). It can seem unusual for a researcher to be seen as 'doing nothing' so having a notebook with you when videoing can be very useful both for writing notes when collecting data as well as for deflecting unwanted attention. Indeed it is often the researcher rather than the camera that has the greatest impact on the interaction, as Charles Goodwin suggests:

> The tool that a participant-observer would use to observe the gaze of others – his own gaze – is itself a relevant event in the interaction in which he is participating ... The camera, though intrusive and perhaps disruptive in other ways, does not focus attention on the gaze of either party ... and is not itself an oriented-to feature of the process under observation. (Goodwin, 1981: 45)

It remains important to reflect upon how data collection might alter the behaviour of participants, in part to be able to address this issue when it arises in presentations and publications. In this regard, consider two standard practices. Firstly, if you are present during data collection, make a note of any occasions in which the participants appear to notice or attend to the camera, even if it appears of little significance at the time. In certain circumstances it may even be possible to discuss these occasions with the participants after recording is complete. Secondly, in reviewing the data, note any occasions in which the participants (appear to) orient to the camera and spend time analysing those occasions and reflecting why they arose when they did. This will not only give you insight into the extent to which recording impacts on the action but also may enable you to minimise the effect of the camera on future occasions.

3.5 Fieldwork in video-based research

In some cases video is used to augment field research, but even when video is the principal source of data for analysis, fieldwork is invaluable. As we have suggested, fieldwork early on in the process can help you to develop a familiarity with the

characteristics of the setting that may be critical in deciding when and how to record, where to position equipment and how to deal with problems that might arise in securing a clear visual image and good quality sound. In addition, for studies of highly complex organisational environments, fieldwork can be essential to enable you to become familiar with the basic features of the setting and the activities involved. Even in settings that seem utterly familiar – schools, homes, museums, and the like – it can also encourage reflection on the activities that arise, the participants involved and the various material, and increasingly digital, resources on which people rely.

In our experience it is more helpful to undertake intensive and successive periods of fieldwork interspersed with analysis rather than the more traditional time of, say, some weeks or months in the field. As the project develops, the fieldwork will become increasingly focused on specific issues and features of activity but it is worthwhile addressing at least the following issues when starting the study – they can be useful in unpacking the sense and significance of different sequences of interaction:

- *What documents, tools and technologies do people use and rely upon in the setting?*
 These not only include more formal organisational resources such as computer applications and records, paper forms, log books and the like, but also informal resources such as note books, post-it notes, whiteboards, etc. Where possible, collect examples, copies or at least images of these.
- *Are there specialist terms or jargon that people use?*
 This may take the forms of specialist terminology, organisational acronyms, euphemisms, slang, and the like – it will be important to reflect on how these terms and expressions are used and for what purposes.
- *What are the general tasks and activities in which participants are engaged?*
 This will also include consideration of how activities are interrelated and coordinated and the extent to which they relate to formal organisational procedures or conventions.
- *Is there a formal or working division of labour in the setting?*
 Who is responsible for what and are these organisationally prescribed roles or more informal roles? How many people carry out each role at any one time?
- *Can routine patterns of action be identified?*
 For example, are there routine problems or difficulties that people face in accomplishing their activities and how are they resolved?
- *Do unusual events arise during filming?*
 Are there any events that you need to take note of in order to analyse in more depth in the recordings?

Tip: Keeping records of your video data

Most camcorders have a date or time stamp facility that can be recorded with the image. This can be very useful when reviewing discs or data and trying to find events you have made a note of. It also should be noted that this is a permanent part of the image and can be intrusive when you are analysing or later

presenting materials. As most digital systems provide alternative ways of showing time position, it is worth considering avoiding the use of this facility. Either way, it is good practice to label every tape (not just the tape box) and to keep a list of tape, disc or DVD timing and numbers in your notebook. Most researchers use a simple indexing scheme which numbers each tape, disc or DVD (and when recording multiple cameras, label each camera 'A', 'B' etc.) and also records location, time and date of the recording. Also, once you have recorded a tape, remember to switch the recording tab to 'save' or 'lock'.

In some cases it is possible to undertake fieldwork in close collaboration with colleagues. For example, in one study of London Underground, the three of us gathered data in different parts of the transport network at the same time. This enabled us to explore the ways in which information is distributed across the organisation. So on one occasion Heath was in the line control room at Baker Street, Luff in Leicester Square station operations room and Hindmarsh was riding with train drivers up and down the Bakerloo Line. During one afternoon a person fell under a train at Waterloo on the Bakerloo Line. The field notes, as well as the data we collected, provided very different perspectives on the ways in which this information was disseminated and acted upon throughout the network.

To organise collaborative fieldwork, prior to each day we would agree who would record where, so that each researcher recorded data in different locations. We would also arrange to meet up with each other at least twice a day. This allowed us to exchange notes and ideas and to identify further materials and information that we needed to collect. Also, because we all noted the times of critical events in our locations, we could track how the materials we collected related to each other.

Tip: Collecting images of the scene

To help yourself and colleagues to understand the setting, it is worthwhile collecting a series of general images that illustrate the layout of the setting and the location of different participants. Slowly panning the room with the video camera can prove very useful. It is worthwhile taking photographs (or stable video) of equipment, tools and technologies, including screen shots and documents. Alongside these images and recordings, it is useful to prepare detailed diagrams of the setting so that you can easily recall the precise layout of the scene and the relative positioning of different features.

3.6 Informal interviews and video-based research

Undertaking fieldwork at the same time as video recording provides an opportunity to talk to the participants and discuss events that might have arisen or aspects of the material environment. Extensive advice on interviewing 'in the field' can

be found in a number of texts on ethnographic fieldwork (e.g. Hammersley and
Atkinson, 1983; or Wolcott, 1995). However, it is worth briefly raising two issues
about informal interviews: who to talk to and what sorts of questions to ask.

Who to talk to

Within any work group or social group there will be certain individuals who are
more interested in discussing the nature of their activities or with whom a researcher
will develop a stronger rapport. These 'key informants' are often keen to talk to the
researcher and one or two individuals can provide substantial information very
quickly. However, it is important to try to talk to a range of participants and elicit
different views on particular matters and explore the extent to which the 'pop-
ular opinion' discussed by one person is actually shared by others.

Rather than plan a formal occasion on which to speak to individuals, it is often
more appropriate to find a time when things are quiet to ask questions. For exam-
ple, in our studies of general practice we found that short breaks between patients
often provided an opportunity to raise certain matters with the doctor. The period
following the morning rush hour in London Underground proved an invaluable
time to talk more generally to staff in operations and control rooms. In our
study of a telecommunications control room, there was always one member of
staff assigned as 'back-up', who would therefore have more flexibility to dis-
cuss the nature of the work. Another strategy that we have used is to take staff
for a drink after work or to go for lunch with them to discuss their job in
more detail. However, even in busier periods there are often pauses in the
activity that can be exploited to ask a quick and pertinent question about
what is going on.

What sorts of questions to ask

In complex technological environments it is useful to ask participants to describe
the texts, tools and technologies that they use and to provide a basic account of
how they use them and what they use them for. This is a nice concrete topic that
works well to get participants to begin talking. It often allows the researcher
opportunities to find out a great deal about how the job in general is done and
enables the researcher to spin out numerous discussion topics from this central
one. If possible this should be done so that it is recorded, freeing up the researcher
to talk to the participant rather than to make notes.

As fieldwork progresses events will arise that will puzzle, confuse or intrigue
the researcher: what happened then? why did they get angry? why did they make
that phone call? what was amusing? what did they enter into the log book then?
At opportune moments it is useful to get participants to describe their reasoning
about events. In all cases it is important to talk less and listen more.

Preliminary analysis of video data routinely generates further questions about
the setting and the activities observed. Some of these can be dealt with by simply
asking the relevant participants straight out. In other cases, especially in complex
work settings, it is useful to take a small video player or laptop computer into the

setting to play back puzzling video clips and to ask the participants what was going on, and the reasoning that might have informed their actions. They are unlikely to recall all the details that informed their activities, but they will be able to explain jargon that is used, standard procedures and the like. These 'video review sessions' can be helpful in developing an understanding of a specific video fragment, and they can also engender more wide-ranging discussions about the activity or the workplace.

3.7 Using multiple cameras

In many cases a single video camera will suffice. Indeed, multiple cameras tend to complicate data collection and analysis. However, there are settings and activities that demand the use of more than one camera, especially where a single view severely constrains or even undermines the ability to analyse the activity of interest. For example, it may be relevant to include images of different parties to the encounter. In examining auctions we became increasingly interested in the interaction between auctioneers and buyers and it proved necessary to use multiple cameras so that we could capture views of the audience as well as the auctioneer.

In certain circumstances, it may be necessary to simultaneously record the activities of participants in different physical locations. For example, in their in-depth study of high-street copy shops, a research group at Palo Alto Research Center (PARC) distributed a number of cameras in key locations throughout the shops so that they could follow the flow of orders through the store (Whalen et al., 2004).

> **Tip: Recording data from computer screens**
>
> With most modern (LCD) computer screens it is possible to collect data from screens quite easily. However, recording the screens of conventional television sets and older (cathode ray – CRT) monitors can result in bars moving across the image, which makes the data difficult to review. If this is the case you should try to use a video camera with a variable scan rate and experiment with it to find the settings that deliver the best image. Even when it is possible to capture a high quality image of the screen it may be necessary to investigate other ways of gathering these data. In many settings it is difficult to collect screen data which is not obscured by the people using the technology. If this is the case and data of the screen are critical to the analysis, it may be necessary to consider running a separate monitor from the computer system and record from that. This is more likely to be feasible in an office setting than, say, a control room where there are likely to be strict regulations about rewiring the technologies in use.

Even when an activity takes place in a relatively confined area, additional cameras are sometimes essential to make sense of the activity. For instance, it can be useful to

use more than one camera when it is important to capture close-up views of a screen, a document or some other artefact. In their studies of operating theatres, Tim Koschmann and colleagues (2007) were studying endoscopic surgery and found that no single view was adequate for analysing work practice and collaboration. As the surgical team were used to recordings being produced for teaching purposes, it was relatively unproblematic for the researchers to use multiple cameras to capture three different views: the hands of the surgeon over the body (captured using a mini-camera mounted on the head of the surgeon); the image of the operation from within the body that the surgeons were using to do their work and a general external view of the participants working around the body. This combination of images made it easier to piece together what the participants were talking about and how their conduct interrelated.

Apart from managing more equipment and an additional stream of data, the principal difficulties with using multiple cameras emerge when you come to analyse the material. There are practical problems of synchronising the recordings after the event, as well as transcribing and analysing actions that are distributed across three or four distinct images. In our own experience, it has proved useful to undertake initial transcription and analysis using one of the recordings, often the most wide-ranging view, and then successively integrating parallel views to inform the analysis.

There are a variety of ways of trying to synchronise recordings from different cameras, usually by some way of mixing (or multiplexing images and sound). This can be done either whilst you record or after you have gathered your data. In some settings, and with the right equipment, it is possible to capture mixed images in real-time as you record. So, with a field mixer you can combine images from more than one source and record the result on a separate tape. Usually this needs quite a bit of preparation.

Tip: Mixing images from multiple camcorders

When using a field mixer, consider carefully the configuration of images you are recording. To retain the quality and detail in the images it is best that you keep recordings from the individual cameras as well as the mixed image. When you mix two images you will either need to use a picture-in-picture configuration or change the aspect ratio (height–width proportions). The former is best if one image is the principal view and within it an area can be defined that is not important and can be overlaid with the secondary image. The latter will result in some of the image recorded by the cameras being lost in the mixed image and you will need to frame your shots carefully to take account of this.

In many settings, using a mixer and running cables across the room is not practical and therefore recordings have to be synchronised after the event. Precise post-synchronisation is difficult. Even if you are careful about setting the time and date on each, there can be slight differences in the clock speeds of camcorders

(and how the tape mechanism works); in consequence synchronisation becomes less reliable when performed over long durations. It is often more practical to produce synchronised versions just of short fragments of interest. This is not straight-forward but there are ways to make it easier. One is to make sure that there is some overlap between what is recorded on each tape – this could be through the sound or some part of the visual image. In the auction data, for example, the striking of the gavel proved a useful resource for synchronising images. The synchronisation problem demonstrates why the simple clapper-board is so important to professional film production.

Tip: Synchronising images from multiple cameras

Synchronising video data from multiple recordings can be complicated, requiring the use of packages like Final Cut, Adobe Premiere and the like. For these you will need to find a place where both streams are synchronised and then find a suitable video effect that mixes the streams (e.g. 'picture-in-picture'). Even with fast computer processing the effect can take some time. The recent version of Apple's iMovie (iMovie '09) has a very simple Advanced Tool where all you need to do is place one clip over another, select a 'Picture-in-Picture' option and then fine tune where it should appear.

3.8 Recording good quality sound

In trying to capture good quality images it is often easy to neglect the importance of sound. For many activities, talk and other sounds are critical. Conventional camcorders produce high quality images even in conditions of poor light, but the way in which they record sound can mean that the audio quality is poor. A common problem arises from the necessity in many settings to record from a distance and use the zoom to focus in on a particular area. The image may be clear but the in-built microphone will only record sound close to the camera so it will usually be difficult to hear what people are saying.

Tip: Testing sound levels in the field

Always take an earphone or headphones when collecting data so that you can check the sound levels are adequate.

A standard solution is to use an external microphone that can be positioned in front of the participants and connected to the camera by an audio cable. The kind of microphone you use will depend on what you wish to capture. A simple stereo microphone will pick up two or three participants nearby and you can change the

angle of coverage to help you to identify who is speaking. These microphones are good at masking other sounds in the setting. This is useful for avoiding background noise but might not capture the voices of other important participants or activities. That is why it can be preferable to choose an omni-directional (or flat-plate) microphone.

In our studies of the line control rooms on London Underground we used an omni-directional microphone that was placed in the centre of the console between the controllers. It not only recorded what they said, but also what colleagues at another desk said and even both sides of some radio and phone calls. In the quieter environment of an architects' practice the same microphone was placed at the centre of a large desk around which four architects would sit and work. However, it was hard to hear the architects due to the rustling noise from the paper plans placed near the microphone. As the architects would often cluster around one side of the desk, a stereo microphone pointing to that side usually provided better results.

Tip: Preparing for the field

It is critical to practise setting up and using all your equipment prior to entering the setting. It is useful to work out how everything fits together and where the key controls are. Every camera is slightly different so it is necessary to do this every time new equipment is used. The time and date should be set on all camcorders in advance even if you do not record this on the tape. Also, all camcorder batteries should be charged and new microphone batteries should replace old ones. Given that in many settings there is little time to set up, it is important to be prepared and not add any unnecessary delays by not knowing how to operate your equipment. It also helps to display your competence to undertake the research you are carrying out.

In most settings you will need to experiment with a range of solutions before securing adequate sound.

In our research on pre-operative anaesthesia, the ideal solution would have been to place an omni-directional microphone on the body of the patient, as medical staff worked on all sides of the patient and tended to look down towards the body. This was of course not sensible, so we mounted a shotgun microphone onto the camcorder. As the room was fairly quiet the recordings were good enough to hear all that was said.

When we discussed our problems of recording sound in museums and galleries with sound engineers they argued that we would have to hang a series of large shotgun microphones from the ceiling above the action. Aside from the expense of such a solution, it was unlikely that curators of our museums would be happy with the idea of transforming the aesthetics of their galleries. We did, however, find a more simple and unobtrusive solution. We were able to position small wireless microphones close to the exhibits, which successfully transmitted to the camera

the sound of people talking. In other cases, when we were interested in the navigation of people through an exhibition, we secured the cooperation of visitors to wear wireless microphones.

Box 3.2 Equipment checklist

While the video-equipment market is constantly in flux there are a set of issues to bear in mind when preparing to collect audio-visual research data.

Camcorders:
It is possible to gather excellent data with inexpensive camcorders, although it is not advisable to use the very cheapest ones on the market as they tend not to be very robust and lack some key features. The range of good quality and affordable video cameras and camcorders is continually changing. Since 1990 formats have changed from analogue formats such as VHS, Video8 and Hi8, to digital (e.g. MiniDV, microDV, CD and DVD) and High Definition Digital Video (HDDV). Beyond tape, the latest hard disk camcorders provide quality recordings without the need for individual tapes. Each upgrade in format demands new investment not only in camcorders, but players as well. Whichever format you are using, there are certain requirements of the camcorder to bear in mind:

- Is it small and light? You will have to carry it to and from the research site and you will want it to be as unobtrusive as possible.
- If using tape, is the tape ejection door to the side of the camcorder? If so this enables easy access to change tapes when the camera is mounted on a tripod.
- Does it have a colour LCD screen? While a small viewfinder can be adequate, larger LCD screens provide a clearer guide to the shot you are recording and also they can usually swivel, allowing you to check the shot even when the camcorder is in an awkward position.
- Does it have separate external microphone and headphone sockets? If not then it is impossible to use an external microphone or to check the quality of the audio you have recorded. It is becoming increasingly common for one of these options to not be available on domestic camcorders.
- How much can be recorded in a session? You should try to record at the highest resolution possible, but with some formats this might mean changing tapes or disks every hour or half hour, which may cause difficulties in some settings. Recent developments in hard disk camcorders can allow you to record many hours at a time, but make sure you will have enough space to record all you need. Without a very large capacity, there might not be time to transfer your data from the camcorder before your next session. So if you are recording for several days in a row, check the practicalities of how you will manage your recordings.
- Does it have sockets to enable you to connect to your computer (e.g. Firewire, i.Link IEEE 1394, USB 2.0)? This is essential in order to transfer the video to a computer for analysis and presentation.

(Continued)

Tripods/Clamps:

To collect stable images you can use standard lightweight but robust tripods. However, for more demanding locations you may need to use very small desk tripods or use mini-clamps that you can attach to shelves or ceiling supports. Manfrotto Bogen make excellent lighting supports that can be also be used for camcorders. Their magic arm and super clamp can be attached to doors, shelves, desks, etc. and if floor-space is restricted then their autopole system has a very small footprint and can be secured from floor to ceiling.

Microphones:

As you are likely to position the camcorder a few metres away from the action in order to secure a good view, the internal microphone is rarely adequate. Sennheiser have a large selection of good quality microphones. The choice depends on the setting but options include the following:

• Radio or wireless microphones – are good if most of the action involves one person and you can ask them to wear a small microphone on their lapel. These can also be used to record in discrete locations (attached to a museum exhibit or on a cluttered desk, for example). If you need to avoid trailing wires, then radio microphones can allow you to record sound a distance away from where the camcorder is located.
• Basic omni-directional microphones – are good for placing on a desk or meeting table when voices need to be picked up from all directions.
• Shotgun microphones – if mounted on the camcorder itself they can collect better sound than an internal microphone. They are most suitable when using a roving camera.
• Stereo microphones – provide a simple option which can be good to record and distinguish two voices in circumscribed settings (e.g. interviews).
• Two microphones – can be used together and mixed in real-time using a dual microphone input adaptor (e.g. the DXA-6 produced by BeachTek).

Headphones:

Basic, light but robust headphones are useful for checking sound quality on site.

Extension lead:

It is preferable to use mains power and, if an electric socket is not where you need it, a multi-socket extension lead can be invaluable. If you ask permission you can also use it to share an outlet.

Batteries:

It is critical to have long-life batteries for the camcorder in case an electric socket is not available. Also spare microphone batteries are essential.

Duct tape:

To secure any loose cables – you want to avoid people tripping over your cables.

Equipment bag:

Something sturdy with lots of pockets – a rucksack or shoulder bag such as the large Barbour fishing bag. Specialised camera bags often have many useful features including places to attach tripods.

3.9 How much video data is enough?

The predictable answer to this question is that 'it depends'. It depends on the nature and demands of the setting, the actions and activities that are being addressed and of course, most fundamentally, the methodological commitments that inform the collection and analysis of data. It is worthwhile bearing in mind that many settings involve the repeated production of particular events or tasks (e.g. auctions). While each event is unique to the occasion in which it is accomplished, it is possible to begin to identify some potentially generic features of an activity on the basis of a detailed analysis of a seemingly 'small' amount of data. In other settings, the activities that may form the analytic focus may be relatively rare (e.g. visitor conduct in museums with few visitors), so preliminary data will need to be collected over days or even weeks before enough useful and useable examples are found. However, as video materials are a very rich data source, even small amounts can deliver an endless array of issues and questions. The video rewind mechanism facilitates what Michael Agar considers a 'critical way of seeing' for ethnographic inquiry more generally, that 'comes out of numerous cycles through a little bit of data, massive amounts of thinking about that data' (Agar, 1991: 93).

Key points

- Data collection will be governed by the analytic orientation adopted by the researcher and the practical constraints imposed by the setting.
- It is important to reflect on how the act of collecting data may impact on the organisation of activities in the setting.
- Traditional fieldwork is an essential and valuable component of video-based research.
- Begin with a simple recording arrangement, review materials that have been collected and if necessary revise the way in which you are recording images and sound.
- Pay careful attention to the quality of the sound recording as well as the image; because you need to have data where you can clearly hear what the participants are saying as well as see what they are doing.

RECOMMENDED READING

- Charles Goodwin (1993) provides one of the few practical guides to doing video-based research. Whilst the equipment he discusses is now dated, his guidelines for doing research are excellent.
- Tim Dant (2004) includes an insightful description of the issues and challenges faced in collecting data in a video-based study of car mechanics.
- Rogers Hall (2000) considers different ways of framing views on a scene and their implications for subsequent analysis.
- Eric Laurier and Chris Philo (2006) provide a considered account of issues of reactivity and the nature of 'naturally occurring' data.

EXERCISE

Initial data collection in a new setting rarely produces the best quality audio-visual recordings. Therefore select a new setting and record an hour or so of naturally occurring activities. Try a number of positions for the camera and, if possible, different ways of recording sound. Review the material and reflect on the advantages and disadvantages of the different recordings. Consider why some are better than others and how particular viewpoints and ways of recording sound may influence the type of analysis that can brought to bear on the material. In the light of your conclusions undertake a further period of data collection and reflect on whether the new recordings provide significant advantages over the original data. If you are working in a group, split into sub-groups and collect data in similar settings – compare and contrast the data and consider how to improve the material.

4

ANALYSING VIDEO: DEVELOPING PRELIMINARY OBSERVATIONS

Contents

4.1 Introduction

In this and the following chapter we provide an overview of the ways in which we can begin to subject video recordings of naturally occurring activities to detailed scrutiny. Any form of scientific or social scientific analysis derives from a particular methodological standpoint and reflects various assumptions and presuppositions. Our own approach draws on analytic developments within sociology, namely ethnomethodology and conversation analysis. These analytic developments have proved highly successful in generating a substantial corpus of naturalistic studies of the organisation of everyday activities. Perhaps the most impressive contribution of studies of this kind has been the way in which they reveal the methodic foundations of social interaction, in particular of talk-in-interaction. In more recent years these developments have increasingly underpinned a burgeoning body of video-based studies that have addressed the interplay of talk and visible conduct in social

interaction, including the ways in which people use texts, tools and technologies in accomplishing everyday practical activities.

In this chapter we explore the ways in which social interaction can provide the resources to examine how participants themselves orient to and accomplish social actions. We consider how sequence and sequentiality provide both a topic for investigation and a resource for analysis and how they direct attention towards the situated production of everyday activities. We reveal the importance of transcription to analysis, and explore the ways in which visible conduct, talk and the use of material artefacts inform the accomplishment of activities. These methodological issues and observations are developed with regard to a brief analysis of two fragments of data. To begin with however, we wish to briefly consider how to work through the hours of data that may be recorded in a research project.

4.2 Reviewing data

One of the advantages of video recordings over other forms of social science data is that the same material can be considered with a range of very different interests and analytic commitments. As a study develops, certain phenomena, or aspects of social organisation, are revealed and one can return to the original corpus of data to find further examples or variations of those practices. It is likely that the principal data, the recordings, will be reviewed a number of times during the course of the project, where each of those reviews will be focused in rather different ways. As they in some ways correspond to different stages of a study, it is helpful to differentiate the distinct ways in which the data corpus may be reviewed. For convenience we can refer to these in the following way:

> Preliminary review – cataloguing the data corpus.
> Substantive review of the data corpus.
> Analytic review of the data corpus.

Preliminary review – cataloguing the data corpus

In undertaking a preliminary review of the corpus it is important to catalogue some basic aspects of the activities and events that have been recorded. Where possible, it is worthwhile doing this review as soon as possible after data collection. Cataloguing and reviewing data should not detract from undertaking more detailed analysis, so preliminary reviews should involve no more than a simple description and classification of the materials. Preliminary catalogues can be written on paper or using a standard word processor, as long as they are easy to find and review. Alternatively, and especially with larger datasets, it may be more appropriate to use dedicated software for cataloguing data (see Tip on p. 64). The form of the catalogues will be similar regardless of the medium.

Figure 4.1 shows a catalogue generated during the preliminary review of data collected as part of a project concerned with communication in primary health care

General Practice

Preliminary Review

Westfield Health Centre

20/3/92

Dr A. Erickson Surgery (9–11.25)

26 Consultations

GP AE 1/1/07 Tape 1

Time	Patient	N/R	Problem	Treatment	Notes	
09:02–09:09	P. Hall	N	Bronchitis	Antibiotics return	Chest exam Discuss side effects	n 3
09:13–09:20	C.Byrne	R	Bruising/fall	ref nurse	Child/M pain/crying	n 4
...						

FIGURE 4.1 *A preliminary catalogue of video data collected for a study of general practice consultations*

consultations. Each consultation typically lasts less than ten minutes, and one follows immediately after the prior. Each tape held up to nine consultations. The initial catalogue lists in a number of columns the basic features of each recorded consultation; where, on the tape, each consultation starts and concludes (the time displayed on the tape was set so that it showed the correct time of day), the name of the patient, whether it was new or a return appointment, the symptoms or the problem reported by the patient followed by the diagnosis or assessment. A column on the right contains brief notes concerning any phenomena or features that are of interest, particularly for future analysis. This includes references to page numbers in field notes and to any documents that have been collected which are associated with the consultation.

Figure 4.2 shows a preliminary catalogue developed for a very different data set, namely recordings of visitors to exhibits in a museum.

With these data, interaction that arises at the exhibits is more intermittent and it is useful to know exactly when the recordings include people and when these people leave the scene. In this case we document the times when people (distinguishing men, women and children) were in the vicinity of the exhibits, the exhibits they visited, and whether they were alone or with others. We also make a simple record of the kind of interaction that arises at the exhibit, for example, whether they press a button or whether talk arises. Once again, we have a column for brief notes concerning potential phenomena and activities that might be of interest after future analysis, including references to related materials, such as field notes, and information associated with the exhibits, like labels.

Even producing these simple catalogues can be time-consuming, but they can provide useful vehicles when returning to the corpus to identify where events occur or when looking for particular phenomena.

Museum & Science Centres

Preliminary Review

Science Museum London: Materials

28/11/06

SM M 28/11/06 Tape 2 (11:04:00–12:02:49)

Position	People	Exhibit	Interaction	Notes	
11:13:42–11:15:21	M, 2xC	Glass Tank	Buttons/Talk	Beckons child/ order button turns reconfigure bodily arrangement	n 4
11:46:05–11:54:09	M, C	Magnet	Buttons/Talk	M instructs C/explains exhibit coordinate button press	n 5

...

FIGURE 4.2 *A preliminary catalogue of video data collected for a study of visitors to a science centre*

Tip: Using software to catalogue data sets

For small data sets it is probably easiest simply to use paper or a simple word processor. However, for large data sets this becomes unsustainable. In these cases a programme such as CatDV is useful for managing, cataloguing and indexing large corpora of digital video. CatDV was originally developed to support video editing and production but as with other products these tools can be valuable for social science research. One particular benefit of using this software is that 'collections' of similar instances can be created without the need to create multiple versions of the clips. This saves substantial hard disk space.

Substantive review of the data corpus

Subsequent reviews of the data should be more focused and arise in the light of the initial analysis of data extracts or 'fragments'. They are performed to find further instances of events or phenomena, so as to enable comparison and to delineate aspects of interactional organisation. For example, a more focused, substantive review of data can be found in Figure 4.3. The data in question consisted of video recordings, using four simultaneous cameras, of a control room on London Underground. Following preliminary analysis of the data, we became interested in the ways in which a member of the control room staff issued public announcements and the relationship between those announcements and other activities in the control room and events that arose on the network. In this case we catalogued, from one of the tapes, all instances of public announcements. We also noted details

Bakerloo Line Control Room

BLCR 7.1..93: Tape 2a (7:53), 2b (7:55), 2c (7:57), 2d (7:53), 2e (7:58) composite

Position	Announcement Account	Addressed	Preceding Concurrent Event(s)	Notes
8:10:26	Delay Pass. Alarm	Picc	RC: Driver – DCM OC: Driver	
8:12:10	Delay Pass. Alarm	CX	OCL All Drivers	n 16
8:12:55	Pass. Alarm Delay	Emb	OC: DCM	

FIGURE 4.3 *A substantive catalogue of public announcements made in a London Underground Control Room*

including: the topic addressed by the announcement; basic features of its structure; the source of information that prefigured the announcement; and any immediate consequences it had for the actions of other personnel within the control room.

In this case, we recorded details of announcements (e.g. about a delay), whether they included an explanation (e.g. a passenger alarm being activated) and to whom they were addressed (e.g. passengers at 'Picc', Piccadilly Circus; 'CX', Charing Cross; or 'Emb', Embankment). We also kept a brief summary of immediately preceding or concurrent events such as 'RC Driver' (a call received from the train driver), and 'OC DCM' (an outgoing call to the Duty Crew Manager). This classification was useful to identify other potential instances of events that we were investigating.

Analytic search of the data corpus

As a study progresses and it becomes necessary to refine the analysis, it is not uncommon to undertake repeated searches of the data corpus. In some cases this will involve the review of related data sets in order to find examples of actions that appear to reflect similar characteristics.

In undertaking these analytic reviews it is helpful to gather candidate instances of the particular phenomena, actions or organisation under scrutiny. We say 'candidate', since until you have undertaken detailed analysis of the fragments it is unlikely that you will have a robust sense of their character and organisation. If you use a computer to store your fragments then you can put copies associated with different phenomena in different collections (see previous Tip). These collections will often become the principal data used during analysis and, as we will see, enable you to compare and contrast the organisation of activities in different occasions and circumstances.

It is tempting to devote substantial effort to reviewing, sorting, cataloguing and categorising video materials, effort that may not, in the end, contribute to the

analysis. It should always be borne in mind that the reason for doing these activities is to support analysis and it is important to recognise that an extensive and wide-ranging review of data can undermine the time you have to analyse the materials. If you feel that you are spending too much time cataloguing or reviewing it can be useful to undertake a brief preliminary analysis of a fragment; indeed we find that it is not unusual to begin to devote extended time to analysis during the preliminary review of the data. This can help to refine how you are reviewing your data when you return to the materials.

4.3 Where to begin: Selecting a fragment of video

When reviewing data, a video recording of social interaction, its extraordinary detail and complexity soon become apparent. In moving beyond initial classifications, and progressing the analysis, it is rarely practical, or fruitful, to try to deal with the whole recording even if it is of a single event that lasts only a few minutes. Inevitably, the researcher has to be selective. The initial selection of episodes or fragments of data on which to focus could be based on a range of interests and concerns. It might be influenced by the overall aims and objectives of the project or by seeking to contribute to the understanding of a pre-established topic or issue. More likely, it will emerge from the initial review of the materials, even from the fieldwork that may have preceded or accompanied the recording, where particular activities or events will have been seen to recur or just happen to look interesting and worthy of further attention.

Take a brief episode or 'fragment' of interaction found in the data which lasts no more than ten seconds or so, and simply spend time repeatedly viewing the fragment, transcribing the action and developing observations. Aside from selecting a fragment in which there is interaction between participants, and where you can clearly hear what people say and see what they do, it does not matter that much, at this stage, what you chose. If you have not worked on video before, you will be surprised by the detail that begins to emerge from repeated viewings of the data and you may well be impressed by the complexity revealed in the participants' actions. Conduct will also become evident that has previously passed unnoticed. As Sacks (1992) demonstrates, the orderliness of the activities undertaken by the participants will become apparent; an orderliness that is found in the fine details of human conduct and which suggests that participants themselves are drawing on a flexible social organisation that enables activities to be accomplished in a systematic and concerted fashion.

It is worth repeating the exercise with a number of short fragments drawn from the data. In this way, you will begin to develop your observational skills that enable you to examine fine details of the actions and activities of the participants. It will also provide a range of preliminary insights into the actions or activities that you found in the data that in turn can form the basis for further investigation. You will find that you have to play and replay the fragment a significant number of times, perhaps 50 or 60 times, before you can begin to gain a sense of the action and delineate features of the participants' conduct.

4.4 How to begin: Transcribing talk

In order to help show how observations can be developed from video materials it is worthwhile presenting and discussing one or two examples. Since we are unable to accompany this book with copies of recordings, we will present examples using a mixture of simplified transcripts and images. The first example is drawn from the beginning of a medical consultation. It is less than 25 seconds long and we will come to pay most attention to just five or six seconds of the fragment.

Fragment 4.1 **Transcript 1**

 Knock
 Dr: Come: in:
 (4.6) ((P. enters the consulting room)
 Dr: Do sit down::
 (5.5)
 Dr: What's up?
 (4.8)
 P: I've had a bad eye::: (.) °in there=
 Dr: =Oh: yeah
 (0.8)
 P: Bit of fat flew up er a fortnight ago.
 Dr: Yeah.

Like many activities that arise in both formal as well as informal environments it is accomplished at least in part through talk. To begin to undertake close, detailed inspection of the fragment it is necessary to transcribe talk. Transcription is not simply a way of representing aspects of the activity, but provides an important resource in developing observations and getting to grips with the characteristics and organisation of the actions in which the participants engage. The transcription system that we use to transcribe talk, and which is widely used, was developed by Gail Jefferson (1984). Details of the transcription system can be found in Appendix 1 and, with minor variations, can be found in various monographs and edited collections of papers (see, for example, Atkinson and Heritage, 1984; Drew and Heritage, 1992; ten Have, 1999). It is worth briefly mentioning here a few of the features of the system. The length of pauses or silences (in tenths of a second) are given in brackets – as in (4.6) in the example above, when a word or part of a word is emphasised it is underlined, and when a sound is stretched or elongated it is extended by a number of colons (the number of colons capturing the length of the sound), as in 'down::'.

Fragment 4.1 consists of some preliminary exchanges between the patient and the doctor followed by a discussion of the patient's difficulty, namely a 'bad eye'. The first two utterances in the transcript would appear in large part concerned with establishing an appropriate socio-spatial environment to enable the consultation

to take place. The patient is invited to enter and to sit down. Given that no further discussion or clarification takes place, we can assume that the patient produces appropriate physical actions, namely entering and sitting down.

The patient's description of his problem, his reason for seeking medical help, is occasioned by, or responsive to, the doctor's query or utterance, 'What's up?' – a euphemistic way of asking the patient what is wrong. The doctor's query and the patient's response provide the principal vehicles through which the participants progress from the preliminaries to the business at hand. The patient's response provides the doctor with an initial description of the difficulty and the resources through which the doctor can gain further information concerning the problem and thereby produce an assessment and some form of management of the difficulty. The response, 'I've had a bad eye::: (.) °in there' also provides ways in which we can discern how the patient himself is orienting to the doctor's utterance 'What's up?'. It is treated as the start of business at hand, the consultation proper. Similarly the doctor's reply 'Oh: yeah' enables us to see how the patient's disclosure is responded to by the doctor and the way in which it serves to encourage the patient to provide further information about the problem and its history.

4.5 Sequence and sequentiality

The beginning of the consultation appears to be organised by virtue of successive packages or sequences of action. The doctor's 'Come: in:' is responsive to the patient knocking on the door, and by sitting down, the patient displays his orientation to the doctor's request, 'Do sit down::'. As we have suggested above, the patient's disclosure of his problem is occasioned by the question or invitation to describe his reason for seeking medical help. In various ways therefore we can see how particular actions are responsive to prior actions of the co-participant, and in turn they provide the basis to subsequent action and activity.

In this regard, the patient's description of his difficulty is elicited by, and responsive to, the doctor's question. The doctor's subsequent response ('Oh: yeah') would appear to stand rather differently in relation to the patient's action, in that it is not demanded or elicited, but it is intelligible, at least in part, by virtue of its position immediately following the problem description. So the interaction between the participants does not simply emerge step-by-step, moving like the hands of a clock, but rather the participants' actions are *sequentially* organised. They are designed with regard to, and occasioned by, prior actions and they form the foundation to subsequent actions. Sequential organisation provides the principal vehicle through which almost all actions that arise within conversation, and more generally mutually focused social interaction, are accomplished (Schegloff, 2007).

The position or location of an action within the emerging course of actions is central to the ways in which it is understood. As suggested, the doctor's 'Oh: yeah' serves to acknowledge the patient's problem and display his recognition of the difficulty by virtue of its position immediately following the initial description. This turn enables the patient then to describe its cause rather than provide further description of the difficulty for example. Moreover, as the patient describes the

problem, the doctor moves towards and appears to take a closer look at the eye. His visual alignment works with the 'Oh: yeah' to display that he sees the problem through their placement in immediate juxtaposition with the disclosure. So, the intelligibility and significance of an action for the participants themselves is at least partly achieved by virtue of its position within the developing course of action. In this regard, in his discussion of the sequential character of talk, Heritage (1984) refers to the ways in which an utterance or turn at talk is both context sensitive and context renewing.

> A speaker's action is *context shaped* in that its contribution to an on-going sequence of actions cannot be adequately understood without reference to the context – including, especially, the immediately preceding configuration of actions – in which it participates. (Heritage, 1984: 24)

The patient and doctor progressively move from the preliminaries to the business at hand through successive sequences of actions. These sequences consist of an action that projects or implicates a relevant next action, or one of a range of actions. The subsequent action is produced by the co-participant, and produced in juxtaposition with the first action. In other words, the first action implicates, or makes sequentially relevant a subsequent action, and the subsequent action can, and is, treated as responsive to the prior. The patient's initial problem description is responsive to the question from the doctor and displays the patient's analysis of what is required in producing a relevant response; a response that can form the foundation to subsequent enquires and eventually diagnosis and assessment. By 'relevant' we refer to the relevancies of the participants themselves. If the patient failed to enter on being told to 'Come: in:', the implicated second action does not occur, so it is 'noticeably absent' and can form the basis to inquiries and repair – perhaps the doctor calling more loudly for the patient to enter (see, for example, Schegloff and Sacks, 1973).

One of the most pervasive and strongest forms of sequential implicativeness is known as the adjacency pair: these consist of two utterances, produced by different speakers, in adjacent positions, arranged in terms of first and second pair parts, where the first projects and makes sequentially relevant a second or one of two alternative second actions (see Schegloff, 2007). Question and answers, greetings and their response, invitations and their acceptance or refusal, all reflect these organisational characteristics. However, different actions are treated as having different sorts of sequential implicativeness. It is worthwhile reflecting on the very different relations that pertain between the opening query, 'What's up?' and the patient's reply 'I've had a bad eye', compared with the relations between this reply and the doctor's subsequent response, 'Oh: yeah'. There are highly variable sequential relations between actions even within a seemingly similar sequence type, and they provide different opportunities and constraints on action.

Sequential organisation is the vehicle through which participants produce and make sense of each other's actions and activities. It enables the routine and ordinary character of everyday activities and events to be accomplished by participants themselves in concert and in collaboration with each other. With this is mind, sequence and sequentiality form the basis to the analytic approach that we discuss in these chapters.

4.6 Transcribing visible conduct

The beginning of the consultation involves the participants establishing an appropriate bodily and socio-physical arrangement to enable the business at hand to begin. The patient enters, crosses the room and sits down. The doctor selects, reads and dates the medical record card before the start of the consultation. It is clear that these visible actions and activities are integral features of the beginning of the consultation.

If we consider a small part of this fragment, such as when the patient sits down and awaits the beginning of the consultation, we find that the participants engage in a range of visible activities before proceeding to discuss the problem at hand. Along with talk, these actions enable the participants to progress from the pre-liminaries to the business, providing the opportunity for the patient to describe why he is seeking help and for the doctor to make further enquiries. To understand how the participants accomplish the start of the consultation and the proper progression into the discussion of the problem, we need a practical way of transcribing the visible, as well as the vocal aspects of the participants' conduct. Given the sequential character of interaction, it is critical that a transcription

Transcript 2 of Fragment 4.1

creases pages and withdraws hand

Dr	*glances to the*	*turns from*
reads records	*top of the page*	*records to patient*
↓	↓	↓

Dr: What's up?--------,--------,--------,--------,--------

P: I've had a bad eye:::-in there

 ↑ ↑ ↑

patient glances *glances at the doctor* *turns to doctor*
at the doctor *takes in-breath*

patient sits and lands in chair *patient points at eye*

system enables us to identify conduct with regard to its location within the immediate framework of action and activity.

Not withstanding a number of attempts to develop orthographies of human behaviour (see, for example, Birdwhistell, 1970) there is no generally accepted method for transcribing visible conduct. However, a technique that we and others have developed over some years involves mapping out the details of the participants' visible conduct in relation to their talk (see Appendix 1 for a description). Rather than being presented vertically, turn by turn, as in a conventional transcript, the transcribed talk is laid out horizontally across the page. Ordinarily a line is dedicated to the talk of each participant. To represent pauses and silences a single dash is used to capture each tenth of a second. So, for example, a half of a second is transcribed with five dashes. Graph paper is very useful when transcribing the visible aspects of the participants' conduct since it provides a way to lay out, spatially, the actions and activities you observe.

If we take part of Fragment 4.1 above, between, say, the doctor's query and the patient's response, then the talk will be laid across the page as on the previous page. Commas are used following every tenth dash to make each second visible.

We begin by mapping the visual orientation or gaze of the participants using a system developed by Goodwin (1981), which is written on the lines surrounding the talk. In this case the doctor's orientation is transcribed above his talk, and the patient's below. A continuous line indicates that the participant is looking at the co-participant, a series of dots ('.....') that one party is turning towards another, and a series of commas (',,,,,') indicates that one party is turning away from the other. We have used a series of dashes in this example to show that the doctor is looking at the medical records rather than the patient. We then map the start and completion of other visible actions of the participants with regard to where they occur within the talk and if necessary indicate where other features of their production occur. The following is a simplified version of the original map. To aid clarity we have included brief descriptions of particular actions and continue to do so throughout the next couple of chapters. We suggest, however, that in practice it is important to transcribe and map the fragments without adding vernacular descriptions, at least initially, since how you eventually describe or characterise the actions of the participants will depend upon analysis of the data.

Transcribing and mapping the participants' conduct in this way enables the researcher to begin to determine the position of particular actions to explore their potential relationship to preceding, concurrent and subsequent conduct, both vocal and visible, of all the participants. It also provides a way of discovering aspects of the action that might otherwise pass unnoticed and to document observations and insights. Indeed it is useful to include a large margin on one side of the page where observations can be recorded alongside the transcript itself. In some cases, it can also help to accompany the transcript with a series of still images.

FIGURE 4.4 *A copy of an original transcript of Fragment 4.1*

Transcripts are used to accompany and illuminate rather than replace the data. They provide a fundamental vehicle for developing analytic insights into the organisation of a particular episode of action or activity. These maps are a critical resource for the individual researcher. However, they rarely, if ever, accompany a presentation or even published paper as they are too complex to be easily interpreted and are often incomprehensible without regard to the original data; for example, Figure 4.4 shows a copy of one of the original transcripts of Fragment 4.1. It is more common, therefore, to include a simplified mapping of only selected features of the original transcript (see Chapter 6 for further details).

Returning to the fragment, we can use the new transcript to examine the interplay of visible and vocal conduct in more detail. As we have seen, there are more than four seconds of silence before the patient replies to the doctor and the consultation properly begins. As the patient begins to sit, the doctor asks 'What's up?' and begins to read the medical records. The patient comes to rest in the chair roughly a second into the pause following the question and momentarily glances towards the doctor. He does not reply. Four and half seconds into the pause the doctor looks up from the records and turns to the patient. At that moment, the patient begins to speak and as he replies to the doctor, he gestures towards his left eye.

The patient's reply to the doctor's query, therefore, is not simply responsive to the question or invitation but appears to be co-ordinated with the doctor's re-orientation from the records to the patient. It is at this moment that the patient chooses to respond, as if waiting for an indication that the doctor is ready and willing to listen.

The re-orientation of the doctor, from the records to the patient, gains its significance by virtue of the patient withholding a sequentially appropriate response – the reply. By turning from the records to the patient, we might suggest that the doctor displays that he is ready and willing to listen to the patient's reason for seeking medical help.

The fragment begins to reveal not simply the interdependence of talk and bodily conduct, but interconnected sequential relations that enable the participants to accomplish the smooth transition from the preliminaries to the business at hand. The patient produces a description of his illness with regard to the invitation to disclose his reason for seeking medical help, and within that sequence we find the doctor's shift in orientation encourages the production of the reply.

> **Tip: Developing a transcript**
>
> It is helpful to begin by first transcribing the talk that arises in a fragment and then to overlay other elements of visual and material conduct.

4.7 Analysing talk and visible conduct

As we begin to look more closely at this fragment of data, we can consider a second methodological commitment that underpins many of the analytic orientations towards qualitative research, namely the 'participants' perspective'. The way in which interaction is accomplished by participants, producing 'next' actions with regard to the prior, provides an analytic resource to enable us to examine how participants themselves are orienting to the actions of others. This methodological resource is most apparent perhaps when we consider talk and the turn-taking organisation of conversation. Sacks et al. (1974), in their seminal paper concerned with a systematics for turn-taking in conversation, succinctly summarise the double-edged character of the organization of talk-in-interaction and its methodological implications:

[It] is a systematic consequence of the turn-taking organisation of conversation that it obliges its participants to display to each other, in a turn's talk, their understanding of the other turn's talk. More generally, a turn's talk will be heard as directed to a prior turn's talk, unless special techniques are used to locate some other talk to which it is directed... But while understandings of other turns' talk are displayed to co-participants, they are available as well to professional analysts, who are thereby provided a proof criterion (and a search procedure) for the analysis of what a turn's talk is occupied with. Since it is the parties' understandings of prior turns' talk that is relevant to their construction of next turns, it is their understandings that are wanted for analysis. The display of those understandings in the talk in subsequent turns affords a resource for the analysis of prior turns, and a proof procedure for professional analyses of prior turns, resources intrinsic to the data themselves. (Sacks et al., 1974: 728–9)

Unlike talk, bodily conduct is not necessarily structured in terms of distinct turns, but the location of a particular movement within the emerging interaction remains critical to the ways in which an action, whether spoken, visible or a combination of both, is produced and understood by participants themselves. For example, we can see that the significance of the doctor's realignment of orientation from the records to the patient serves to display his readiness to listen to the patient by virtue of the action's location with regard to his invitation and the absence of an immediate reply. The patient's reply can then be seen as sensitive to the doctor's visual realignment. And, as we have suggested, the doctor's inspection of the eye, with his accompanying 'Oh yeah', displays his orientation to the patient's description; indeed it serves to display that the doctor has not only looked at, but seen and recognised the problem. The sequential organisation of interaction therefore provides an analytic resource with which to inspect and discover how participants themselves orient to each others' action(s) and a way of providing evidence for the interpretation and analysis of particular actions, activities and the resources that inform their accomplishment.

Let us return to the brief pause before the patient responds to 'What's up?'. Up until now we have glossed over the fact that the doctor looks at the records before the patient sits down and responds. We have also made various suggestions concerning the patient's sensitivity to the orientation of the doctor and the ways in which it occasions withholding a response. It is worthwhile looking a little more carefully at the participant's conduct during the pause, where the patient appears to wait until the doctor is ready and willing to listen. It is helpful to provide some pictures with the transcript.

Transcript 3 of Fragment 4.1.

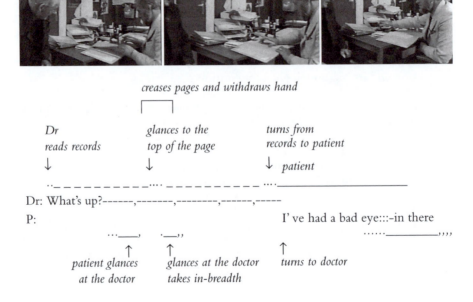

As the patient sits down, he glances briefly at the doctor and then looks down to one side where his orientation remains for a few moments. The doctor is looking at the medical records. He then uses his right hand to flatten the margin of the open record following the path of his hand with his eyes. As his hand reaches the top of the page, the doctor begins to look up. At this moment the patient turns towards the doctor, opens his mouth and breathes in as if inhaling air in readiness to talk. However, rather than turning towards the patient, the doctor turns back to the records. As the doctor looks down, the patient turns away, licks his lips, and closes his mouth. A few moments later, the doctor looks up from the page, turns to the patient and the patient produces his reply.

The patient's actions would suggest that he is sensitive to the conduct of the doctor during this pause. He seems to attempt to determine when it might be appropriate to begin his reply. The query from the doctor places the patient under an obligation to respond. His monitoring of the doctor's conduct can be seen as oriented to producing the sequentially appropriate next action, namely disclosing his reason for seeking medical help. We can see how the patient assesses the doctor's actions with regard to his obligation to produce a response, attempting to determine the upcoming completion of the activity with the records. In other words, the sequential environment encourages the patient to scrutinise the doctor's conduct with regard to its relevance for beginning to disclose his reason for seeking help, while enabling the doctor to complete the activity at hand. In one sense we might suggest that these delicate moments of interaction reveal the patient's defer-ence to the doctor and demonstrate perhaps his awareness that the records play an important role in the consultation. So until they have been read it may be a mistake to begin.

It is worthwhile raising one or two further methodological issues that will resonate with some of the points we made earlier. Firstly, the patient's actions during the pause show the significance of anticipation or, more technically, *projection,* to the production and intelligibility of action(s) in interaction. The doctor's question or invitation projects a sequentially appro-priate response and creates obligation for the patient to produce that response in juxtaposition with the question. The interactional relevance of that response informs the ways in which the patient monitors the actions of the doctor, prior to delivering the reply, just as one suspects that the doctor is sensitive, in the course of looking at the records, to the absence of an immediate response from the patient. So we can see how actions may be read, or indeed misread, by virtue of their location, as prefiguring the start of a particular activity. The ways in which actions project subsequent actions are important aspects of the ways in which we determine the significance of each other's conduct.

Secondly, we can see how the use of material artefacts, such as the med-ical record, are relevant to the analysis of the participants' conduct. That in these data we do not know what is written in the records, and the video

provides us with limited access to what the doctor is actually reading or looking at during the pause. It is also unlikely that the patient can see what the doctor is reading, as the record is on the other side of the desk and, for the patient, upside down. Even if he could, the patient might not necessarily be able to make sense of the notes in the records. However, by examining the patient's conduct we can begin to consider what the patient may be orient- ing to when waiting to begin to respond. We have a sense of what he notices and how he responds to the actions he is able to see. In other words, our access to the scene, whilst not equivalent to the patient's, provides us with the resources to enable us to consider how the patient orients towards the conduct of the doctor, just as our access to the doctor can enable us to consider how he might be responding to the conduct of the patient. The video recording provides us with the resources to begin to examine how the participants themselves are orienting towards each other's conduct, to build a case with regard to how they respond to specific actions, and to develop some insights into the complex and organized character of their interaction.

Thirdly, we can begin to consider how the organisational characteristics of the medical consultation are accomplished in and through the fine details of the spoken and visible conduct. We have already noted how it is the doctor that initiates the patient's presentation of the complaint. He subse- quently produces a series of inquiries designed to elicit further information to inform the diagnosis and treatment. We can also note that in withholding a response to the doctor's inquiry, but remaining sensitive to when it might be appropriate to begin to speak, the patient displays a certain deference, enabling the doctor to decide just when the proceedings might properly begin. Moreover, the ways in which the patient presents the complaint, the economy of description and presentation, invites analysis rather than, for example, sympathy. Together they serve to contribute to, and reproduce, char- acteristic features of a medical consultation and interaction between a patient and a doctor. In other words, the roles of doctor and patient, the asymmetries of professional interaction and the character of the event as a medical consul- tation, are contingently and interactionally accomplished. Close inspection of the materials can provide resources to begin to explicate the character- istic features and practices that inform the production of this particular form of institutional arrangement (see, for example, Drew and Heritage, 1992; Heritage and Maynard, 2006). We will return to these matters in the next chapter.

4.8 Analysing visible conduct

Although talk is a pervasive feature of almost all settings, it is not unusual to find activities that are primarily, if not solely, accomplished through bodily conduct.

For example, the behaviour of pedestrians is frequently accomplished without talk, as are the ways visitors navigate museums or department stores even when they are with others. Similarly, many of the activities in which people engage in work or domestic environments are accomplished with regard to the contributions of others, but do not necessarily involve talk.

Notwithstanding the absence of talk, sequence and sequential organisation can be critical to the organisation of conduct and interaction and it provides an important methodological resource to explore how participants themselves produce their own actions and orient to the contributions of others. The absence of talk, however, does pose further challenges for the transcription and analysis of activities. It is worthwhile discussing an example and examining it in some detail. The fragment is drawn from research undertaken in collaboration with Marcus Sanchez Svensson (see, for example, Sanchez Svensson et al., 2007).

The activity we will consider might seem quite simple – an exchange of objects – and yet it forms an important part of a more complex event – a surgical operation. If not performed appropriately, the activity disrupts the surgeon's ability to accomplish the operation.

FIGURE 4.5 *Clip applier and clips used to secure facial skin*

The fragment is drawn from the phase of the operation in which the surgeon is preparing to remove a potentially serious growth from an area around the frontal lobe of the brain, just above the nose of the patient. To gain access to the growth, part of the facial skin is folded back and temporarily fixed using small clips. The clips are secured using clip appliers, which resemble a pair of scissors (see Figure 4.5).

The scrub nurse prepares the appliers by inserting a clip at the end furthest from the handle. She then passes them to the surgeon. The surgeon pins the section of flesh together by closing the handles together. The surgeon then returns the used set. This simple process continues until a portion of flesh has been safely secured.

The images on the left show one in a series of exchanges in which the

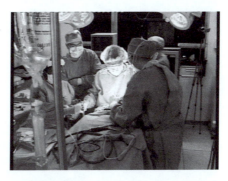

FIGURE 4.6 *The scrub nurse is on the left passing the clip appliers to the surgeon. A surgical assistant stands between them, and another surgical assistant stands to the right. A student is partly visible on the right*

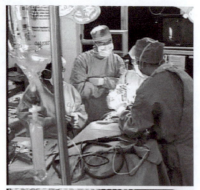

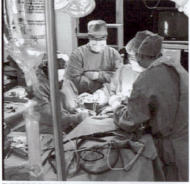

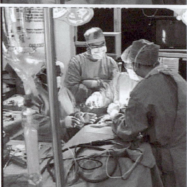

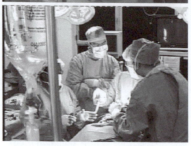

FIGURE 4.7 *The scrub nurse (left of pic-*
ture) passes the clip appliers to
the surgeon (second right)

surgeon returns the used set and the scrub nurse passes the new set of prepared appliers.

There is no talk in this fragment. The exchange of instruments is accomplished through visible conduct by the scrub nurse on the left and the surgeon in the centre of the pictures (partly obscured by an assistant on the right). There is no talk to transcribe and no talk to use as the basis to identify and map out the visible conduct of the participants.

In these cases we normally use a horizontal time line as the basis of the transcript and map each of the participant's conduct in relation to the time line. Once again the time is laid out in tenths of a second with a single dash representing a tenth of a second and vertical lines marking the full seconds. The numbers '24' to '28' in the transcript refer to the time in seconds from the beginning of the fragment on the original tape. In this case, since the exchange primarily consists of the contributions of two principal participants, the surgeon and scrub nurse, we have positioned the time line at the top of the page. Once again, for clarity, the following map is a highly simplified and selective versions of the original. We join the action as the surgeon(s) is oriented towards the site of the operation (Op site). She briefly turns to the scrub nurse, returns to the site of the operation and then looks firstly at the used set of clip appliers (CA1) which she passes to the scrub nurse(s) and then the new set, CA2.

We can then begin to add one or two details concerning the surgeon's passing of the used set of clip appliers; 'r/h' and 'l/h' simply refer to whether the participants are using their left or right hands.

Transcript 1 of Fragment 4.2

Time
24 25 26 27 28

Applying CA1 withdraws held repositions
 CA1 out hand
 ↓ ↓ ↓ ↓
r/h

Op site SN Op site CA1 CA2 Op site
S:
SN:
 Op site CA1 CA2 Instrument
 table
l/h
 ↑ ↑ ↑
 hand thrust takes withdraws left hand
 fingers open CA1

Transcript 2 enables us to begin to identify the position of actions and potential relations between the conduct of the surgeon and the scrub nurse. For instance, as the surgeon withdraws the used clip appliers, the scrub nurse immediately, within less than two tenths of a second, turns towards the instrument and begins to thrust her hand towards it. The movement is progressively aligned

with the hand movement of the surgeon (the hand opening as it nears) and when the surgeon's hand is momentarily held mid-flight, the scrub nurse grasps and removes the used clip appliers.

The fragment suggests a sequential relationship between the actions of the surgeon and the scrub nurse. The movement of the nurse's hand and opening fingers are sensitive to the withdrawal of the clip appliers from the operation site and the ways in which they are positioned with regard to the scrub nurse. The thrust of her hand and opening fingers serve to display to the surgeon that the scrub nurse is ready to receive the clip appliers and enables the surgeon to hold the implement mid-flight, assuming that they will be taken. In other words, the withdrawal of the clip appliers places the co-participant under an obligation to produce a sequentially appropriate next action, and to produce that action in immediate juxtaposition with the first. This enables the smooth exchange of the implement.

The exchange is both more complicated and analytically more interesting than this brief description suggests. The passing of the used clip appliers is undertaken concurrently with the scrub nurse handing the newly prepared set to the surgeon (CA2), an exchange that occurs almost immediately following the transfer of the first set. As the scrub nurse takes the used set, the surgeon moves her hand towards the right hand of the scrub nurse and, placing her two fingers in the rings of the implement, transports the new set to the operation site and, a moment later, applies the clip. In some ways there are two interdependent sequences of action that are produced concurrently by the participants – on the one hand, the passing of the used clip appliers, on the other, the exchange of the new set. The withdrawal of the surgeon's hand from the site of the operation occasions an exchange of implements that enables the next phase of the operation to be accomplished. While we might point to the overall sequential structure of these activities, we can also begin to see how the very accomplishment of passing an implement is a complex interactional achievement. Consider the exchange of the new clip appliers; a brief summary transcript coupled with a series of images may help give a more detailed sense of the action.

As the surgeon withdraws the used clip appliers from the site of the operation, the scrub nurse raises her right hand containing the new set of clip appliers (CA2). They are held, momentarily, mid-flight until the surgeon relinquishes the used set and begins to move her right hand towards the new set. At that moment, the scrub nurse begins to transport the clip appliers towards the right hand of the surgeon, and as the surgeon opens her thumb and forefinger, the nurse aligns the clip appliers until they are raised almost vertically, the surgeon inserting her thumb and forefinger into the loops. Within a sequence of action where one participant simply passes an object to another, we can begin to see how the accomplishment of the activity involves a complex of action in which the participants progressively align their conduct to enable a smooth and unproblematic exchange.

Transcript 2 of Fragment 4.2

Earlier, we remarked on the ways in which actions can serve to project sequentially relevant next actions and how particular sequences of action can serve to foreshadow and implicate subsequent action and activity. In this fragment, we can see how an action may be transformed in the very course of its accomplishment. In handing an object, such as the clip appliers, to a co-participant, the action, from its early beginning, may project a course of action enabling the co-participant to align to that action to receive the object in question. However, the action does not simply project what it might take to be satisfactorily complete (and by implication the conduct it requires from the recipient) but, in the course of its production, it is progressively shaped with regard to the emerging conduct of the co-participant. So, while the sequential import of an action serves to enable the recipient to orient to the course of action, its actual articulation is emergent and contingent – where the principal contingency is the concurrent action(s) of the co-participant, in this case progressive alignment and orientation of the receiving hand.

We can also begin to see that, despite the exchange of instruments being an utterly routine feature of this and many operations, on each occasion the actions are performed slightly differently. For example, the scrub nurse adjusts the ready

position of the prepared clip appliers with regard to small changes in the surgeon's bodily orientation and with regard to which part of the facial flesh is being clipped. The 'circumstances' or 'contingencies' at each successive exchange place different demands on the way in which the same or similar actions are accomplished. The design of conduct is sensitive to these contingencies. So the typicality, regularity and unproblematic production of these seemingly routine actions are a moment-by-moment, concerted and interactional accomplishment.

The exchange raises a further issue. In the production of their actions the participants do not simply respond to the conduct of the other, but rather prospectively envisage the trajectories of each other's actions. Thus they are able to produce a sequentially appropriate action just at the moment it becomes relevant. We have already remarked on the ways in which the scrub nurse has the prepared appliers in hand and in a state of readiness for passing so that as the surgeon's hands begin to move away from the patient's face, one of her hands immediately moves forward to take the used instrument. We can see how the scrub nurse's understanding of the task being undertaken by the surgeon and its boundaries and transitions provides a vehicle for understanding just when it might be relevant to take and pass the clip appliers. So, in the course of their production, actions serve to project not only what it might take for them to be complete, but implicate action that is relevant from others to enable the activity to be successfully accomplished. The understanding of and orientation to trajectories of action is critical to the ways in which co-participants contribute to the collaborative and contingent organisation of activities.

4.9 Key analytic considerations

We have drawn upon a number of analytic considerations to inform the ways in which we analyse these fragments of video data. These considerations reflect broader methodological commitments that underlie a range of qualitative research approaches. Our own methodological commitments draw from a distinctive approach and solution to these analytic issues and problems; commitments that prioritise the endogenous, interactional accomplishment of naturally occurring activities. The focus on the interactional accomplishment of activities is not only concerned with explicating the primary vehicle in and through which most human activities are produced, but also with the ways in which interaction provides a methodological resource for explicating how people orient to each other's conduct in the contingent and emergent production of social action. It is worthwhile perhaps at this stage summarising three of these more general analytic considerations. In the next chapter we will discuss their implications in more detail.

Firstly, the sense and significance of social actions and activities is inextricably embedded within the circumstances in which they arise. The production of an action, its meaning or intelligibility is accomplished with regard to the contributions of others; in particular the immediately preceding actions and activities. Therefore the sense and significance of actions is treated, by the participants themselves, with respect to the circumstances in which the actions arise. In turn those actions contribute and advance those circumstances and form the foundation to

subsequent actions and activities. The occasioned and occasioning character of practical action is referred to in various ways (e.g. the situated, the indexical) and whilst different terms carry different analytic implications, they direct attention towards the local, practical accomplishment of social action.

Secondly, there is no necessary correspondence between a particular physical movement or the lexicon or syntax of a turn at talk and the action it performs. The 'same' physical movement, for example a wave or a smile, can perform very different actions depending on the circumstances in which it occurs. So, as Schegloff and Sacks (1973) suggest, 'Why that now?' is a pervasive question resolved by virtue of an analysis of the immediate configuration of action and in particular the immediately preceding and proceeding actions. This approach stands in marked contrast to traditional research on non-verbal behaviour which explores, for example, the relationship between the psychological or cognitive states of the subject and particular forms of facial expression. Rather than classify conduct in terms of its physical or linguistic characteristics, we are concerned with the analysis of the action it accomplishes then and there within the immediate circumstances of its production and the ways in which it is treated by the co-participant(s).

Thirdly, the practical accomplishment of human activity relies upon a social organisation that enables the production and intelligibility of social action. This social organisation is characterised in terms of practice, procedure, practical reasoning and the like. Each of these terms points towards the methodic character of practical action. These methods or practices inform the production and intelligibility of social action and enable the concerted, situated accomplishment of everyday activities and events. Analysis of fragments therefore is concerned with explicating the practices and reasoning in and through which participants accomplish their activities in concert with others. In this regard, it is worth adding that there is evidence to suggest that these methods or practices may be highly generic, although produced in ways that are highly sensitive to and enable the production of the unique circumstances at hand.

4.10 The analysis of single instances and collections

This chapter has focused on the analysis of single cases. This is entirely apposite given that the analytic approach we are describing considers the production of order to be an inherently local achievement. Nevertheless, there is value to be gained in working with collections of instances. In work that we have done previously we have created 'collections' of topic initiation in medical consultations, referential practice in control centres, public announcements in London Underground and the like. Bringing together collections of similar practices enables one to compare and contrast sequences of action and the ways in which they arise and are organised on different occasions in different circumstances. Thus it may be possible to begin to identify patterns and regularities and to explore how particular practices are accomplished with regard to the contingencies and circumstances at hand. Furthermore, collections of instances of the same candidate activity

or sequence type can also help reveal so called 'deviant' cases – cases that do not appear, at least initially, to resonate with the characteristic organisation of a particular action or sequence.

Evidence, however, remains at the level of the analysis of individual instances. The approach does not attempt to draw on statistical defence of the claims of regularity. Indeed here is where the approach is markedly at odds with many approaches in the social sciences. Whereas the significance or relevance of an analysis in many branches of the social sciences is warranted through the use of statistical tests of one sort or another, very distinctive forms of evidence for relevance are suited to studies of talk in interaction. As Schegloff suggests:

> Even if no quantitative evidence can be mustered for a linkage between that practice of talking and that resultant 'effect', the treatment of the linkage as relevant – by the *parties* on *that* occasion, on which it *was* manifested – remains… And no number of *other* episodes that developed differently will undo the fact that in these cases it went the way it did, with that exhibited understanding… (Schegloff, 1993: 101)

These arguments lead Schegloff (1993: 114) to suggest that 'quantification is no substitute for analysis'. At the heart of the approach is the concern with local, situated evidence for the relevance of the analysis, rather than attempts to make claims of statistical significance.

Key points

- Simple catalogues of the data can be used in the first instance to identify key events and activities. Later, they can form the basis for retrieving fragments of data relevant to emerging analytic concerns.
- Transcription is a critical resource in analysis, enabling the researcher to become more familiar with the data and to develop preliminary observations and insights.
- For any action it is worth addressing the question 'Why that now?', by interrogating the ways in which it might attend to prior conduct and how it might be treated by others in subsequent action.
- The potential relations between actions can be unpacked through careful attention to the sequential organisation that informs their production and intelligibility.
- Candidate collections of practices, sequences or phenomena are valuable to compare and contrast their characteristics and organisation on different occasions and in different circumstances.

RECOMMENDED READING

- Harvey Sacks, Emanuel Schegloff and Gail Jefferson's (1974) paper is a seminal account of the sequential organisation of talk and focuses on the organisation of turns in conversation.

- Emanuel Schegloff (1993) considers the problems with using quantification as evidence in the study of social interaction.
- Ulrike Kissmann (2009) presents a collection of various perspectives on the analysis of video, drawing on leading scholars from linguistic anthropology, conversation analysis, ethnography and phenomenology.

EXERCISE

Select a brief fragment from your video recordings lasting no more than ten seconds and preferably involving both talk as well as visible conduct. Transcribe the talk and then map the visible aspects of the participants' conduct. Examine the possible relations between the participants' conduct and consider the actions that are accomplished. Identify a possible sequential relationship and build a case for the ways in which the participants' actions orient to and build on their respective contributions.

5

MATTERS OF CONTEXT: OBJECTS, PARTICIPATION
AND INSTITUTIONAL PRACTICE

Contents

5.1 Introduction

In this chapter we unpack our methodological considerations further by considering in more detail how situational and contextual characteristics of activities can be addressed within the analysis. We have already discussed the value of interrogating local contexts of action, especially the immediately prior and subsequent conduct. In this chapter we focus on how to take into consideration issues that are normally seen as features of a 'broader context'. In this regard we discuss four main issues.

Firstly, we examine how objects and artefacts and other features of the immediate environment can be encompassed within the analysis. Secondly, we consider 'interactive' artefacts, in particular, computer systems, and discuss how we can transcribe and analyse their use. Thirdly, we explore the ways in which more flexible and variable forms of participation found in many settings can be subject to investigation. Finally, we address the ways in which video-based studies can complement the burgeoning corpus of studies concerned with talk and discourse in institutional and organizational environments. In considering matters of context, it is important to consider how evidence from interviews and field observations relates to the analysis of the video data. So, towards the end of the chapter we reflect on the ways in which these data may be used to augment the analysis.

Context has long been a key issue for the social sciences and continues to pro-
voke debates amongst the proponents of various methodological standpoints. In
the 1930s, for example, Malinowski (1930) argued, in a pioneering chapter, that
the meaning of language, and by implication an action or activity, needs to be
understood with regard to the context of the situation – 'a statement, spoken in
real life is never detached from the situation in which it has been uttered' (1930:
307). Parallel arguments informed the emergence of certain forms of pragmatism,
symbolic interactionism, situated cognition and more generally ethnographic
research. While the emphasis on the importance of the context or the situated
character of action often serves to differentiate certain forms of qualitative
research from more conventional quantitative analysis within the social sciences,
there is significant debate as to how context is brought to bear in the analysis of
social action. To put the problem crudely, for any activity, a broad (if not infinite)
range of features of the context or situation might be said to bear upon the organ-
isation of the action. To make matters worse, these features can be described or
characterised in very different ways. The question, therefore, is how we can legit-
imately demonstrate that particular aspects of context are relevant to the produc-
tion of the activity on some occasion, and relevant not just for the analyst but for
the participants themselves.

5.2 The material environment

The difficulties that arise in presupposing the overarching influence of certain
features of 'context' on action are perhaps best illustrated by the example of the phys-
ical environment. It is sometimes argued that aspects of the physical environment
provide a framework for, shape or even determine, the activities that arise within a
particular setting. In one way it seems reasonable to assume that the environment
may influence the actions and activities that arise within its auspice. Indeed, physical
settings are frequently designed to afford and facilitate particular actions. However,
there is an important distinction to be drawn between 'types' of action occurring
within a certain setting and whether the participants themselves can be seen to
orient to particular features of the environment in the production of the activities.

Rather than presuppose an overarching influence of the physical environment, we
can use video to explore the ways in which participants constitute the occasioned
sense and significance of features of the setting, such as objects, artefacts and the like.
Such an approach would seem to resonate more sympathetically with qualitative
research, prioritising the 'participants' perspective(s)', and enabling us to examine how
the physical environment features in the accomplishment of social action.

There are certain settings that are 'perspicuous' (see Box 5.1) to the study of
how aspects of the physical environment feature in social interaction. Take
museums for example; they consist of large and diverse collections of artefacts
and visitors navigate the space and selectively explore exhibits. There is a sig-
nificant literature that discusses the museum discipline and the ways in which

exhibitions can be designed to organise how visitors navigate around and experience the exhibits on display. Less attention is paid to ways in which visitors themselves select, look at and examine exhibits. While action and interaction at the exhibit face are largely neglected, museums and galleries provide a rich and interesting domain with which to consider how people, in concert and collaboration with others, constitute the occasioned sense and significance of the material environment.

Box 5.1 A definition of 'perspicuous settings'

'Perspicuous settings' are settings that exhibit, as a prominent, routine and recurrent feature, the issue or phenomenon that the analyst is interested in. As Garfinkel describes:

> A perspicuous setting makes available, in that it consists of, material disclosures of practices of local production and natural accountability in technical details *with which to find, examine, elucidate, learn of, show, and teach the organizational object as an* in vivo *work site.* (1992: 181)

FIGURE 5.1 *Visitors to the V & A in London; Freda (to the right) and Annie*

The following fragment is drawn from a leading museum of decorative and applied art in London, namely the Victoria and Albert Museum. In the fragment, two friends, Annie and Freda, approach a cabinet containing a large collection of 18th Century English and Chinese porcelain including teapots, jugs and plates. At the base of the cabinet is a small shelf containing fragments of porcelain that visitors can touch and feel. In the first minute or so, Annie and Freda look at various artefacts in the cabinet, and at one point Freda touches one of the porcelain fragments. The images on the left give a sense of the ways in which they look at the objects in the cabinet.

As they near the cabinet, Annie announces that she is keen on pots and the two friends begin to look at different pieces that are on display. Within a few moments both friends are looking at a small collection of jugs that have grotesque faces; jugs that Freda believes might be called Bellamine jugs.

Transcript 1 of Fragment 5.1 Cardinal Bellamine (Annie and Freda)

A: I am very keen on <u>pot</u>(s). I was te(lling)

F: Yes

A: I would quite like to look at these.

→ F: I was planning(g) to see whether they'd (.) <any of these (0.2) we've
 seen these before called Bella:mine: jugs:
 (.)

F: jugs: ⌐(.) because there was a Cardinal
 ⌊
A: ⌊→I I was

F: Bellamine whose face was meant to be rather like this

A: <u>Oh really</u>::

A: But they're (so) Sack aren't they
 ⌐
F: ⌊but I don' think these are

F: mmh

A: or whatever (0.2) I think (.) are n't (.) they?
 ⌐
F: ⌊Yeah
 (0.2)

A: (Freda) are they two (.) are those sorts of jars::
 (0.5) (([F grasps porcelain fragment))

→ A: Y<u>es</u>: all these little bits isn't that fun:?
 ⌐
F: ⌊Yeah

Despite Annie's attempt to have Freda look at some other pots in the far right of the cabinet, it is not by chance that the two friends come instead to inspect the Bellamine jugs. Indeed Freda goes to some trouble to secure Annie's orientation and in so doing creates an opportunity to tell her a story about how some jugs of this type were supposedly a caricature of the face of Cardinal Bellamine. Securing Annie's inspection of the jugs involves the complex interplay of talk and bodily conduct. A second, though simplified, transcript accompanied by a series of pictures may be helpful to give a sense of the emerging action.

As she begins 'I was planning' Freda is looking at the area that contains the jugs and raises her hand to her face as if preparing to point to the objects in question. Almost simultaneously Annie points to a different area of the cabinet, specifying the objects previously referred to in 'I would quite like to look at these'. Freda neither abandons her turn at talk, nor glances at the objects referred to by Annie. Instead she points at the jugs. As Freda's hand begins to move forward and she utters 'to see whether', Annie withdraws her own pointing finger as if deferring to her friend's proposed choice of object.

Transcript 2 of Fragment 5.1

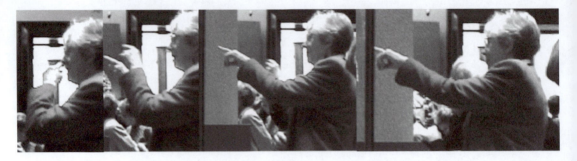

Freda

raises hand and prepares to hand forms thrusts hand jabs hand to
 point point forwards jugs

 ↓ ↓ ↓ ↓ ↓

turns and looks at the Bellamine Jugs

I was planning(g) to see whether the(y'd) (.) <any of these (0.2) we've seen these before called >Bella:mine:

 ↑ ↑ ↑ ↑ ↑ ↑

turns and begins to abandons point, and moves forward accelerates removes glasses
 point to look at the Bellamine Jugs her movement and looks at jugs

Annie

As Freda says 'any of these', Annie begins to move slowly towards the area of the cabinet that Freda is pointing towards and she removes her glasses. Freda then pauses, jabs her pointing hand at the jugs and says 'we've seen these before', and Annie accelerates her postural movement towards the area of the jugs. By the time Freda names the jugs ('called Bellamine') she has encouraged Annie to turn towards, find and look at the jugs in question. Indeed, one suspects that Freda delays naming the object by building an additional component to the turn ('we've seen these before called') until she has secured the appropriate orientation from her friend. Having established their mutual alignment to the jugs, Freda is able to tell the brief story of Cardinal Bellamine.

From the array of objects that pervade the immediate environment therefore, Freda not only encourages Annie to look with her at particular objects, but provides a way of seeing and interpreting those objects. Freda's story is occasioned by, and makes sense by virtue of, their mutual orientation to the specific features of the local environment, namely a collection of jugs with grotesque faces. A fea-

ture of the immediate environment becomes relevant by virtue of one person encouraging a co-participant to look at an object or small collection of objects.

The immediate environment, however, can be rendered relevant to participants in the course of an activity through a range of resources that do not necessarily demand others to turn and look at something. In some instances, people can simply happen to notice another's noticing of an object and in consequence look at that feature for themselves (see Heath and Hindmarsh, 2000a). Indeed, a little later in the same fragment, the two friends are glancing at different exhibits as Annie talks about the jars in the cabinet. Freda grasps one of the porcelain pieces, Annie turns to look at the same piece and remarks 'Yes: all these little bits isn't that fun:?'.

In this example Freda's grasping of the object would appear to be occasioned by a prior action of Annie's. It is not that Annie points or refers to the porcelain. Rather,

FIGURE 5.2 *Freda grasps the object*

immediately before the piece of porcelain is grasped by Freda, Annie reaches forward to place her own hand on the same piece. Annie's hand momentarily hovers over the fragment but then abandons her move, withdrawing her hand and turning towards a different section of the cabinet. As Annie's hand withdraws, Freda grasps the object. Annie immediately turns back and comments on the fragment.

The sequential organisation through which Freda happens to touch the fragment and look at it with Annie is very different from their looking at the jugs together. If we simplify the first instance, we might suggest that Freda's utterance and the accompanying gestures render sequentially relevant her friend's inspec-

tion of the jugs and, in turn, provide the opportunity to tell the story. In the second, the mutual orientation to the piece of porcelain derives from Annie nearly touching it, an action that occasions Freda's grasp but neither encourages nor demands that action. Annie's comment, however, retrospectively acknowledges Freda's action and invokes her own tentative orientation towards the object. In both examples we can see how features of the immediate environment are rendered contingently and momentarily relevant with regard to, and by virtue of, the participants' interaction and in different ways serve to engender comment and remark.

The fragment raises a number of methodological considerations. Firstly, we can begin to consider the ways in which participants themselves invoke features of the physical environment within the course of activity and thereby render a particular object(s) or artefact(s) noticeable. The fragment points to the ways in which the sense and significance of the objects are constituted and shaped within the emerging interaction between the two participants. The mutual 'encounter' with the objects, their looking together and being able to talk about the 'same things', is systematically accomplished in and through their interaction. In other words, the 'meaning' of the jugs or the porcelain fragments is not set once and for all, even within this brief fragment, but rather it is constituted within the interaction. The characterisation of the jugs for this occasion is in relation to the story at hand and not the range of other possible and correct ways of describing the jugs. Similarly, the porcelain pieces are seen as 'fun' not, for example, as instances of the distinct qualities of European and Chinese manufacture. The sense and significance of artefacts could be reshaped in another moment of interaction.

Secondly, we begin to examine how talk can be dependent upon the visible orientation and bodily conduct of the participants. Freda's story of Cardinal Bellamine gains its sense and significance by virtue of the participants' mutual orientation to the grotesque faces found on the jugs in the cabinet. The discussion only makes sense for the participants in relation to the jugs that they are looking at. In a very different way, we find that Annie's remark concerning the porcelain fragments is embedded within and inseparable from their mutual inspection of the objects. In other words, rather than consider the conversation between the participants as somehow independent of the environment in which it occurs, we can explore how talk and bodily conduct not only enable certain things to be seen and seen in certain ways, but provide a resource for discussion. Video enables us to explore these interdependencies and how talk – what is said, how it is said and the sense and sequential import it achieves – can be embodied within, and dependent upon, the participants' orientation to and engagement with features of the immediate environment.

Thirdly, as we began to discuss in the previous chapter, using the video recording to address the social and interactional organisation of the participants' activities enables us to examine the complexity of the action and the gesture(s) that accompany talk. In pointing to the jugs, Freda's gesture consist of a series of components that appear sensitive to the emerging conduct of Annie. For instance, Freda begins to move her hand towards the jugs, as Annie begins to turn from her right to the centre of the cabinet. As Annie moves forward towards the area in question, Freda

thrusts her hand back and forth, delineating the specific location of the jugs in the cabinet. In turn, we can begin to consider how the design of the utterance is sensitive to Annie's progressive orientation to the jugs such that the objects are named just as the recipient leans forward and inspects them. So, we find how a seemingly simple gesture and the accompanying utterance is progressively shaped with regard to the emerging conduct of the co-participant in relation to the immediate, material environment.

> **Tip: Analysing actions in the environment**
>
> Rather than treat the immediate physical environment as an overarching influence on action, examine the ways in which the participants orient to and constitute features of that environment. The analysis should delineate the resources used to accomplish action – it is critical to consider how a range of material and bodily resources might bear upon the action, if only to provide explicit grounds to discount their relevance.

5.3 'Interactive' tools and technologies and transcribing their use

The material environment increasingly includes digital tools and technologies that in many ways are unlike conventional inanimate objects. It is not only the workplace that has been transformed by virtue of the introduction of digital technologies, but the home, and public environments such as museums, train stations and supermarkets. Indeed, almost every site of sociality in contemporary society includes 'interactive' objects and technologies that feature 'input' mechanisms (such as the keyboard and mouse) and 'displays' (such as screens). If we are to take seriously the environment in which action arises and the ways in which participants invoke, appeal and manipulate features of that environment, then we need to consider how we can analyse the use of these systems and the 'interactivity' they afford.

There is a tradition of using video to examine 'human–computer interaction', but it is largely experimental, and rarely examines the use of complex systems in naturally occurring everyday environments. Indeed, the methodological resources on which they rely, including techniques to code, count or log the actions of the user, are largely inappropriate for the qualitative analysis of the use of systems in everyday settings. However video-based studies do lend themselves to the qualitative study of technology in action (see also Heath and Luff, 2000).

Consider the following example. It is drawn from a study of the control room of the Docklands Light Railway in East London. The rail network is computerised and uses automatic, driverless trains. Its operation is overseen by two controllers who sit alongside each other and intervene in the operation of the system where necessary. One controller (he is nearest to us in the images) is the 'God of the Line', the principal controller, who operates the radio to talk to train captains (who accompany vehicles and can operate them manually if necessary). He is responsible for the

rescheduling of the traffic. The second controller ordinarily deals with problems that arise in the depot where the trains are kept and maintained when not in service. However, as we will see, the actual division of labour is organised with regard to the contingencies that arise in dealing with the numerous problems faced by the service.

Both controllers have an Automatic Train Supervision (ATS) monitor that shows traffic movement and a keyboard that enables them, where appropriate, to use the ATS system to reschedule the path and timing of vehicles. It is the use of this system and the way in which its use is embedded within the interaction of the controllers that interests us here. In the fragment, we join the action as a call is received by the principal controller from a train driving instructor ('driver Ed' or 'driver education') seeking permission to make a change for her train at the upcoming station, Crossharbour. She needs to test the student train captain's ability to manually operate the vehicle. For this she needs the controller to set the system to allow her to run in the Automatic Train Protection (ATP) mode, which will prevent vehicles from approaching her train too closely when it is being manually operated.

As the instructor completes her request to the principal controller, the secondary

Transcript 1 of Fragment 5.2 (simplified)

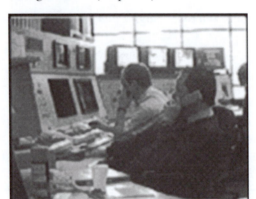

I: request permission to (.) change into A: Tee Pee (0.2) driver (0.3) (Ed)
 at Crosshar:bour: (0.4) over.
 (2.9)

controller (Cii) begins to enter a command into the computer using his keyboard; a command that is relevant to the radio conversation.

In transcribing system use we indicate which keys are struck and when; in this case 'HEQ' for the command, number keys by ⑨, the function key by '■', the enter key by '↵' and any unidentified keys by '☐'. The length of pauses and silences between operations is represented by '....' each dot is one tenth of a second, and any key hit with extra force is marked with an underline (see Appendix 1 for further details).

As the instructor gives her location, the second controller begins to enter the

command; he types the location where it will be required ('HEQ' for the Herons Quay station) and then pauses.

The principal controller delays responding to the instructor, and when he does speak, asks her to 'standby'.

His colleague continues to type, entering the function and the section of track,

Transcript 2 of Fragment 5.2

```
I:    (Ed) at Crosshar:bour: ------- over.-     (2.9)
Cii:                              ■....;H E Q....;..
```

a series of numbers that set the appropriate command to enable the train to be operated manually. As the secondary controller enters the instructions, his colleague watches the ATS monitor and is able to see the command being entered. After the second controller hits the return key to submit the command, the principal controller informs the instructor that she may operate manually after arriving at Crossharbour station. The precise instructions he issues to the instructor, to set to manual at routeboard 143, is informed by reading from the screen what has been entered into the system by his colleague.

So the principal controller's reply to the caller is dependent upon the actions of his colleague entering commands into the system. No explicit exchange occurs between the two colleagues. Rather, in overhearing the call, the secondary controller immediately begins to enter relevant commands. Seeing those commands being entered, the principal controller delays granting the request until he knows precisely what to tell the instructor and her student. The use of the system therefore is critical to the way in which the principal controller can respond to the request, just

Transcript 3 of Fragment 5.2

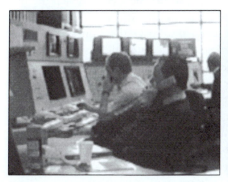

```
                                                              "
_____
   ATS1

Ci:   (I can see) if you could standby and let me get back to you in a mo::-
Cii:       ■        ⑨           ⑨        ⑨       ⑨  ⑨            ⑨ .. ↵
kbd
```

The second controller continues to type

as the system's use enables the principal controller to know that his colleague is dealing with matters that are relevant to the management of the request.

Transcript 4 Fragement 5.2

> ➜ Ci: (That change is fine) that's affirmative when you arrive at Cross-harbour (0.3) (routeboard) <u>one four three</u> (0.4) you may set A: Tee Pee manual (0.2) and proceed (on your section and <u>clear</u>) (0.2) until further notice ↓

In turn, by hearing his colleague delay an immediate response to the request, and in seeing him oriented towards the screen (where the command will appear) the second controller can produce an action knowing his colleague is awaiting its completion. In other words, the system and specific characteristics of its use with regard to the request informs the very ways in which the principal controller interacts with the caller and resolves the issue at hand. The way in which the system is used is sensitive to, indeed dependent upon, the interaction between the two colleagues and the instructor who happened to make the request.

It is worth summarising a number points raised by the fragment. First and foremost, while the system is designed for an individual user to undertake a highly specialised task, we can see how its use is embedded within and sensitive to the actions of the co-participants. The entry of the command is occasioned by the call and the principal controller's initial response to the call. In turn, the completion of the command enables the principal controller to respond to and manage the request. The progressive entry of the command is co-ordinated with components of the principal controller's talk, just as the principal controller's talk is produced, in its course, with regard to the visible entry of the commands into the system. The 'interaction' with the system is accomplished within and with regard to the interaction of the other participants.

Secondly, the use of the system is accomplished within the sequential organisation of the interaction between the participants. There is a sequence of action that involves a request and the granting of the request. Within these two actions, a third participant (the secondary controller) produces an activity that enables the request to be granted and relevant instructions issued. The activity of entering the commands is occasioned by the request, it is intelligible by virtue of its juxtaposition

with the request, but is neither demanded nor invited by the other participants. So, we can begin to see how the system's use arises within, and is occasioned by, the sequential organisation of the interaction between the instructor and the principal controller. Sequence and sequential organisation provide the vehicle in and through which the technology is used.

Thirdly, unlike the previous fragments, the activity is not solely accomplished by virtue of 'mutually focused' interaction. The exchange over the radio simply involves the instructor and the principal controller, but the accomplishment of the activity, the granting of the request involves the action of a third party, the second controller. Interestingly, it may well be the case that the instructor is unaware of the contribution of the second controller. The second controller is neither part of the conversation between the instructor and the controller, nor at any point is he explicitly encouraged to be included. However, the action he produces is key to the activity's accomplishment. The analysis therefore requires attention to the actions of the third party, actions that are produced through the use of the system and rendered visible by virtue of the screen. In gathering data, we can begin to see the importance of recording the actions of the range of participants who may contribute to the activity's accomplishment, and where possible the tools and technologies that enable that contribution. In the next section, we address these more complex forms of participation in interaction in a little more detail.

Box 5.2 System support for transcription and data analysis

The emergence of relatively cheap digital video cameras has heralded a range of software that makes the management and analysis of video much easier. Rather than relying on tapes, multiple video recorders and a word processor, software by Apple, Microsoft, Adobe and others allows for much more sophisticated ways of analysing video data sets. Indeed, as Shrum et al. suggest, '[w]hile tourists, parents and hobbyists were the target markets for manufacturers, professional observers of social life were beneficiaries' (Shrum et al., 2005).

Chapter 6 considers the technologies used to present analyses at some length, for now it is worth highlighting how different aspects of managing and analysing video data sets are supported by a number of existing software packages:

1. For capturing and editing digital videos: Standard video-editing software packages, such as Final Cut, Adobe Premiere, iMovie, and MovieMaker.
2. For cataloguing and managing collections of video fragments drawn from large corpora of video data, without using large amounts of disk space: Professional software such as CatDV.
3. For managing and integrating multiple video views on a single scene: Bespoke software, such as DIVER and CIAO.
4. For transcribing and annotating video streams: Bespoke software, such as InqScribe and ANVIL. InqScribe is particularly useful for adding sub-titles to Quicktime video files, for instance when incorporating translations on foreign language data.

(Continued)

5. For 'coding' video data and transforming raw video materials for quantitative analysis: Packages designed for the social and psychological sciences, such as ObserverPro and Studiocode.
6. For cleaning and enhancing digital audio: Bespoke audio editing packages such as Sound Soap or Soundstudio.
7. For supporting collaborative analysis of video data sets: Bespoke software for asynchronous analyses.
8. For integrating and synchronising multiple digital media types (video, field notes, system logs, text messages, etc.): Digital Replay System (Crabtree et al., 2006) provides opportunities to manipulate and transform combinations of data using various visualisation techniques.

There are a small number of software applications which offer many of these features and are designed exclusively for the video analysis communities of the social sciences: e.g. Transana, DIVER and CLAN. Researchers find solutions or combinations of solutions that best fit the demands of their data set and their individual ways of working.

5.4 Forms of participation

So far we have broadly considered the analysis of two-party interaction. In the last fragment, however, we brought in an additional party to the encounter – namely the instructor connected via the radio link. Furthermore, we have started to show how the material environment can be drawn into and used as a resource by participants in co-ordinating conduct. In this section we aim to extend these issues further by exploring variable 'forms of participation' that arise in encounters. This was originally discussed by Goffman (1981) in his discussion of participation framework.

> 'Participation framework': when a word is spoken all those who happen to be in perceptual range of the event will have some sort of participation status relative to it. The codification of these various positions and the normative specifications of appropriate conduct with each provide an essential background for interaction analysis – whether (I presume) in our own society or any other. (Goffman, 1981: 3)

Participation is a useful resource for the analysis of video data, enabling researchers to consider the ways in which people engage with the actions of others and to address how those forms of engagement are accomplished through sequences of interaction. Even during a single turn at talk, which consists of six or seven words, the form of participation adopted by one participant can be significantly transformed and it is important to note that these shifting forms of participation arise within, and are sustained in and through, sequential organisation. The notion of 'participation' also provides a resource for conceptualising the differential ways in which people, especially 'recipients', engage in the same activity.

Consider the following fragment, which is drawn from a study of pre-operative anaesthesia. There are three people involved in the activity: an anaesthetist, a patient and an assistant (ODA). The fragment begins at the onset of an an aesthetic injection and in the subsequent moments the patient drifts off to sleep. You will notice from the verbal transcript alone that only the anaesthetist and the

patient talk and that the talk of the anaesthetist seems clearly directed to the patient at all times.

Transcript 1 of Fragment 5.3

```
A:   this is the stuff that's going to put you off to sleep. (.)
     now sometimes this stings a little bit as it goes
     up your arm. (.) how does that feel?
     (2.0)
Pt:  °okay.°
     (0.3)
A:   okay?=
Pt:  =hm-hmmm.
     (0.2)
A:   right.
     (6.0)
A:   now in just fifteen or twenty seconds (.)
     you're going to start to feel very very drowsy (.)
     and you'll drift off to sleep (.) and the next thing
     you know it'll all be finished
     (14.5)
A:   there we are. we'll take that for you now. (.) that's good.
```

When looking at the video with the sound turned off, other elements of the action come to the fore. Notably, it is clear that the ODA repeatedly raises and lowers his arm to the mask on the patient's face. The issue for the ODA is this. The patient is holding her own mask. However, when she is fully anaesthetised the patient will not be able to hold her mask any longer. Her hand will drop, the mask will fall, she could injure her arm and the monitoring equipment attached to her arm could be ripped off. As the patient will fall asleep at any moment, the ODA is readying himself to take the mask to avoid these difficulties. However, quite some moments elapse before the patient is fully unconscious, so his problem here is that he is not sure exactly when to take hold of the mask.

Careful consideration of the sequential organisation of the talk and the visible conduct *together* reveals a more interesting account regarding the interactional organisation of the team's work. Indeed, on close inspection of the fragment, it transpires that the talk of the anaesthetist is doing more work than it seems from the transcript alone. He is in fact helping his colleague out.

Let us consider just one moment when the ODA raises his hand to take the mask. Here we find that when the ODA raises his hand to the mask, the anaesthetist says 'now in just fifteen or twenty seconds (.) you're going to start to feel very very drowsy (.) and you'll drift off to sleep (.) and the next thing you know it'll all be finished'. While this is useful information for the ODA, as it gives a sense of when the patient's hand will drop, the utterance seems to be directed to the patient. So one reading could be that its placement is coincidental. However, let us look a little more closely and consider how we might build evidence that there is some 'organisation' at play. There are various types of evidence that we can use to

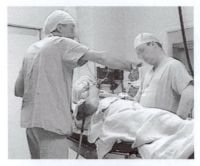

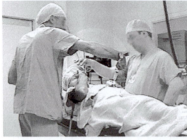

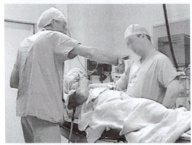

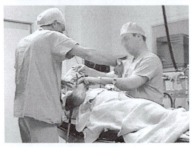

FIGURE 5.3 *Images to accompany Fragment 5.3 (anaesthetist on left, ODA on right)*

suggest that the utterance is occasioned by the ODA's hand movement and is designed for the ODA, as well as, if not more so than, for the patient.

Firstly, the anaesthetist's turn is tagged directly to the ODA's movement to take hold of the mask. This would not be sufficient evidence but it is the first part of a case.

Secondly, the turn starts by detailing the amount of *time* relevant to the drug taking an effect. Then there is a pause before a discussion of the effects that should be experienced in that time. There is no reason, for the patient, why these two elements of information could not be reversed. To prevent an untimely action by the ODA, however, it is the temporal information that is required more immediately and indeed it is provided first.

Thirdly, the anaesthetist appears to look directly at the ODA as he says 'fifteen or twenty seconds', further suggesting that the talk is designed, at least in part, for the ODA. There is no exchange of glances, but the ODA is likely to be aware of the shift in the anaesthetist's gaze.

Fourthly, when the anaesthetist says, 'now in just fifteen or twenty seconds', the ODA immediately retracts his hand. This is critical as it shows how the ODA treats the utterance as relevant for him.

So, there are a number of aspects of the sequential organisation of the vocal and visible conduct of the parties to the event, which suggest that the anaesthetist's utterance is timed and designed to aid the ODA and that the ODA treats it as such. Indeed, it would seem that the anaesthetist's talk with the patient is intimately co-ordinated with these tentative movements and that although the talk is in many ways about and for the patient, it has a 'double duty' (Turner, 1974). The talk is certainly 'to' the patient and works to provide information to the patient about the procedures in hand. However, it also works to support the work of the ODA, to provide a sense of when he should help the patient out.

Tip: Analysing multi-party activities

When analysing a turn at talk or a gesture, consider the involvement of all parties to the event. What is their participation status in relation to the action? Some participants will turn out not to be orienting to the action at all, but the action of others will, on further scrutiny, be seen to be intimately sensitive to, and engaged in, the action. These more subtle forms of participation can be critical to unpacking the organisation of an activity.

This fragment raises a number of methodological issues. Firstly, if we return to Goffman's notion of the participation framework, here we can see that the patient and the ODA can both hear the same utterance from the anaesthetist and yet they have very different ways of engaging with it. Moreover, the anaesthetist designs it delicately to manage these different forms of participation. The same utterance on the same occasion does different work for different parties to the encounter. So the fragment reveals the importance of mapping out the activities of all those in perceptual range of the event. It would be very easy to listen to the talk alone and to consider that the anaesthetist is straightforwardly producing some information for the patient. Only by careful consideration of the data and detailed mapping of the conduct of all parties does a richer picture of the team's work emerge. In looking at video data of multi-party encounters it is therefore useful to consider how all those in perceptual range of the event are orienting to the turn and indeed whether the turn may be occasioned or designed with regard to the visible participation of others.

Secondly, forms of participation are not static. Over the course of the fragment, or the encounter more generally, the anaesthetist, the patient and the ODA do not have 'fixed' forms of participation. Even in the course of the short utterance that we analysed in a little more depth, the active participation of the ODA is transformed. His engagement in the work and his relationship to the anaesthetist's utterance shifts once the information about the time that the drug will take to have an effect is produced. While he continues to be sensitive to the talk of the anaesthetist, its direct relevance for his conduct is lessened, his participation with regard to the turn is different. Transformations in participation are organised in and through sequential organisation.

Thirdly, the fragment raises issues about warranting analytic claims and particularly claims about the relationships between actions. We have discussed at some length the importance of transcribing talk and mapping out visible conduct in order to identify the temporal organisation of action. However, a claim to sequential organisation cannot rest solely on the fact that two actions are immediately juxtaposed. To build a robust analysis it is necessary to try to consider how an action can be seen, in and through its design, to display an orientation, an attentiveness, to the prior. Such displays may be found in talk or in visible conduct. So in this case we looked at how the utterance was ordered to provide some information first, we looked at how the anaesthetist looked at the ODA during the turn, and so forth. Most importantly, we considered how the ODA responded to the turn and how he could be seen to treat it as relevant to his work. Therefore in building claims about episodes of social interaction

it is fundamental to build a case that draws in all the resources that participants them-selves are using to make sense of conduct. Therefore in transcribing data it is impor-tant to look closely at whatever could be relevant to the interaction's organisation. Given the complexity involved, it is sometimes useful to have colleagues analyse the data with you and to assess your analytic claims (see Tip below).

Tip: Data sessions (see also Appendix 3)

The 'data session' has become a standard arrangement for the collaborative analysis of recorded materials in video-based studies of interaction. These data sessions essentially involve a number of individuals viewing, commenting on and analysing video data together. Thus, they facilitate collaborative interrogation of short stretches of recorded data and enable participants to receive immediate comment, contribution and feedback from colleagues in relation to those data.

The value of data sessions cannot be underestimated. They provide opportunities for a number of researchers to spend time examining extracts from the video record-ings, to make observations and discuss insights and even preliminary analyses. They can also be used to introduce new members of a team or research group into a par-ticular project and can be very important for training students in video-based analy-sis. On occasions it can also be helpful to have 'practitioners', personnel from the research domain, participate in data sessions, as they can provide distinctive insights, and can often help to clarify events that have proved difficult to understand.

In data sessions it is important to avoid overwhelming participants with too much material. A small number of brief extracts of, say, no more than 20 seconds or so is fine. It is also helpful to provide transcripts of the talk as well as any other materials that may be useful for understanding the extracts in question.

Other benefits of data sessions can include:

- helping to identify candidate phenomena worthy of more detailed analysis;
- enforcing rigour in analysis as you attempt to provide evidence for analytic claims;
- revealing the difficulties that can arise in presenting data and in having people understanding your observations and analysis;
- introducing alternative perspectives on the materials and activities in which you are interested; and
- generating new paths to pursue in your analysis, including, for example, (i) addressing issues that might have passed unnoticed; (ii) identifying related fragments and building collections; (ii) identifying further informa-tion needed in future interviews with members of the setting; and (iv) reflecting on better ways of collecting further data so that you can more properly address particular phenomena.

Participation in data sessions provides an important opportunity to work on other people's data and to become more sensitive to the problems and issues that arise in analysing materials drawn from a range of different settings.

Two further important points are as follows:

- Data sessions are not where the principal analytic work is undertaken. That is undertaken by individual researchers in transcribing and scrutinising the video recording.

- Data sessions are a collegial activity and are based on mutual trust. They should be treated as such and discussions of Intellectual Property and the like should be avoided. It is up to individual participants to reveal or with-hold ideas that they have, if they do or do not want others use those ideas in future analytic work.

5.5 Institutions and institutional 'roles'

In recent years we have witnessed the emergence of a growing body of research concerned with talk and interaction in institutional settings. These studies have addressed the organisation of talk in interaction in a range of environments includ-ing courts of law, medical consultations, clinics, classrooms, news interviews, coun-selling sessions and business meetings (see, for example, Atkinson and Drew, 1980; Boden and Zimmerman, 1991; Clayman and Heritage, 2002; Drew and Heritage, 1992; Maynard, 2003; Mehan, 1985; Peräkylä, 1995; Silverman, 1997). They have demonstrated the ways in which institutional identities are constituted in and through talk and provide a template for the distinctive forms of participation that arise within these specialised environments. As Heritage (1997) points out, the sequential and turn organisation of talk has proved a critical resource for these stud-ies. In particular, highly specialised forms of activity embody a transformation of conversational organisation. These transformations reveal aspects of 'institutionality'.

Video can provide the resources to build upon these studies to consider how the visible, material, as well as spoken, aspects of interaction contribute to specialised forms of participation that arise in organisational settings. For example, in Chapter 4 we discussed how patients may orient to the reading of the medical records at the beginning of the consultation and delay responding until the doctor is ready and willing to listen. We have also considered how the abilities of colleagues to monitor the visible as well as the spoken activities of others can enable the delicate co-ordination of complex activities. It is worthwhile considering a further exam-ple in a little more detail. It is drawn from an auction of fine art and antiques.

The example provides an opportunity to explore how visible conduct plays an important part in the organisation of turn-taking and the ordering of participa-tion. In this way it reveals distinctive characteristics of the auction as an institu-tional activity. The fragment is an extract from the sale of a small Egyptian figure. For convenience we have abbreviated the fragment and described bidders in terms of the order in which they first enter the bidding (e.g. [B.1 bids]).

Transcript 3 of Fragment 5.4.

 A: Lot one hundred and six. There it is lot one hundred and six Eighty
 Six A: (.) Fi<u>ve</u>: <u>hun</u>dred please::.

 .

 A: Eight fifty
 [B.1 bids]
 A: Nine hundred

```
      [B.2 bids]
A:    Nine fifty madam thank you
      [B.1 bids]
A:    A thousand there:
      (0.4) [B.2 bids]
A:    Eleven here
      (.) [B.2 bids]
A:    Twelve hundred
      [B.1 bids]
A:    Thirteen hundred
      [B.2 bids]
A:    Fourteen hundred
      [B.1 bids]
A:    Fifteen hundred

A:    Two two:: the standing bidder (0.2) last chance [glances at B.3]
      (0.2) two thousand two hundred pounds:::
      (0.6)
      ((knock))
```

From the transcript we can see that there are various characteristics of the event that differ markedly from other forms of institutional interaction. There is only one speaker, the auctioneer (A), and the talk consists largely of numbers, namely price increments. These increments remain stable at £50 up until £1000 and then the increment changes to £100. Once begun, the incremental structure projects the series of prices at which people bid irrespective of the values they may have in mind. Moreover, it can be seen that bidding alternates between two principal protagonists, B.1 and B.2. When B.1 withdraws at £1800, the auctioneer finds a new bidder and alternates the bidding between B.2 and B.3. This ordering principal is know as the 'run' and is used within almost all auctions of fine art and antiques. The auctioneer establishes two bidders and no more than two bidders at any one time.

It is apparent from the transcript that visible conduct plays an important part in the organisation of the event. First and foremost, 'turns' at bidding are accomplished through gestures (e.g. a nod or a wave) rather than through talk. The participation of potential buyers is largely limited to agreeing or declining to bid at a price. Secondly, given that there may be up to 100 or so people in the sale room, and a number of people eager to bid, it is clear that the visible conduct of the auctioneer may play an important part in enabling individuals to know when they are allowed to bid. Thirdly, bidders and all those present need to know when a bid has been successful and who, at any moment, has bid the highest price. In other words, the organisation of participation during the event, the distribution of opportunities to bid and the rapid escalation of price, rest upon the visible conduct of the auctioneer and potential buyers. To explore this further it is worthwhile considering a section of the run. Take, for example, the announcement of the increment 'Twelve hundred'.

From the images, one can see that the auctioneer alternates between gestures with his right hand and gestures with his left. The gestures are accompanied by shifts in

Transcript 2 of Fragment 5.4

gesture at B.2 begins to gesture and turns B.1 gestures and acknowledges bid

Eleven here (.) Twelve hundred Thirteen hundred Four.

B.2 nods

his visual alignment in which he turns successively from the bidder on his right (B.1) to the bidder on his left (B.2). As he begins to announce 'Eleven here' (bid by B.1), he turns towards B.2. His gaze arrives with the word 'here'. He withdraws his right hand and starts to raise his left to gesture towards B.2. The moment he looks at and gestures towards B.2, she nods, agreeing to the projected next increment. The visible realignment and the gesture, coupled with the announcement, enables the buyer to know when it is her turn, and the price that they are expected to bid. It also enables the bid to be accomplished through the most minimal of actions – a head nod.

As B.2 bids, the auctioneer immediately turns away from her and towards B.1, simultaneously announcing the price that she has bid. Before he withdraws his pointing hand however, he transforms the gesture, flipping the hand up and down. The flip of the hand follows the buyer's head nod, and with the announcement of the increment, displays acknowledgement of the bid.

The visible conduct of the auctioneer serves with the announcement of the increment to invite a person to bid and to bid with dispatch. The transformation of the gesture, the flip of the hand, coupled with turning to the other buyer and announcing the next increment serves to display and acknowledge the bid. The gesture works both prospectively, in inviting the bid, and retrospectively, acknowledging the bid. So the auctioneer's talk and bodily conduct create and sustain an alternating sequential organisation in and though which participants are successively invited to bid and bids are acknowledged.

The run is dependent upon, and accomplished through, a social and interactional organisation that selectively and successively places particular participants under the obligation to respond to an invitation to bid. This invitation is produced through the simple announcement of a figure accompanied by a gesture that establishes the relevance of specific actions by specific bidders. In this way, an extraordinary economy of behaviour enables a form of limited participation that serves to rapidly establish the value and secure the exchange of goods (see Heath and Luff, 2007).

FIGURE 5.9 *The auctioneer acknowledges the bid*

Heritage (1997) describes six basic dimensions of talk-in-interaction that can be used to examine the institutional character of an encounter. These are: (i) the turn-taking organisation; (ii) the overall structural organisation; (iii) sequence organisation; (iv) turn design; (v) lexical choice; and (vi) forms of asymmetry. It is not possible to discuss these in detail, but we can begin to see how the analysis of video can begin to build upon our understanding of institutional talk and interaction. Taking the auction example, we might suggest the following:

- The characteristic turn organisation in auctions relies upon the ability of auction-eers to use gesture and other forms of bodily conduct to select particular partici-pants and successively establish bidding and competition between two and no more than two buyers at any one time.
- Auctions rely upon a sequential organisation through which the auctioneer successively invites bids from specific individuals and acknowledges those bids. Both the invitation and acknowledgement rely upon the visible conduct that accompanies the successive announcement of increments.
- The alternating sequence that invites and acknowledges bids from two and no more than two parties at any one time, coupled with incremental structure, enables 'turns', that is bids, to be produced and recognised using minimal visible actions – head nods, waves and the like. This enables an economy of action and the rapid pace and rhythm that is characteristic of auctions.
- Auctions reveal distinctive asymmetries and symmetries – the auctioneer has the principal responsibility deploying an organisation that orders the contributions of participants, but in creating those opportunities active participants are provided with equivalent opportunities for action.

The ways in which visible conduct features with, and within, talk in institutional environments have perhaps received less attention than one might have expected. Video, however, does provide an important resource with which to draw upon and develop the rich corpus of studies that addresses language use in organisational settings. Indeed, one suspects that many of the organisational settings that have been subject to the analysis of talk, in areas such as health care, the news media, and the law, provide exciting opportunities for video-based analyses. These studies can draw on our understanding of talk within these work settings to address the ways in which the visible and the material feature in the interactional accomplishment of highly specialised tasks and activities.

5.6 The analytic primacy of the recording

In this chapter we have demonstrated how aspects of context and setting can be directly considered in adopting this analytic approach. In particular, and in contrast to some approaches in the social sciences, it does not involve seeing the interaction as determined by contextual variables (environment, participation, institution) but rather requires we explore and demonstrate the ways in which the participants themselves render relevant features of context in the accomplishment of action. Sometimes, however, it is important to take into account information about the interaction that is not derived directly from the recordings and that is drawn instead from fieldwork, interviews and so forth. There is some debate concerning the extent to which ethnographic materials, field observations and the like may be invoked in Conversation Analysis (see, for example, the contrasting articles by Cicourel, 1992 and Schegloff, 1992) and similarly in video-based studies. In discussing the analysis of talk in interaction, Schegloff (1997) characterises the problem as the 'paradox of proximateness'. Essentially, if participants orient in their talk to issues of context (for example, status, gender, role, setting and the like) then the analyst can tell from the talk that they are relevant, so they do not need to gain external validation of it. However, if participants do not orient in their talk or action, be it visible or material conduct, to some aspects of context, then it is not clear that there are grounds to claim that they are relevant to the accomplishment of the activity. So the question becomes, when are ethnographic materials relevant?

There are, of course, pragmatic judgments to be made regarding the collection and use of ethnographic materials. As we discussed in Chapter 3, there are numerous reasons for undertaking fieldwork in video-based research, not simply to enable appropriate camera positions to be identified and to establish trust with participants, but to come to terms with some of the complexities of the tasks in which people engage and the technologies that they use. In at least some settings it would be difficult to analyse the conduct of participants without this background knowledge. That said, how this data informs investigation of the recordings and is appealed to in analysis remains an important issue.

If, like many qualitative research approaches, we wish to prioritise the 'perspective of the actor' then we need to consider the ways in which participants themselves orient to features of context in the practical accomplishment of their activities. We have seen how that commitment is reflected in the situated and sequential analysis of action and warranting our observations with regard to the ways in which participants themselves demonstrably orient to some action, object, ecology, procedure, role or whatever. As we have suggested, interaction provides both a topic and resource in this regard; it forms the focus of our analysis whilst enabling us to examine how participants themselves respond to each other's actions. It offers a 'proof procedure' where participants can be shown to be orienting to particular features of context in the very ways in which they produce and co-ordinate their actions.

Underlying our own approach therefore is an analytic commitment both to interaction, for both methodological and substantive purposes, and to the *primacy of recorded data*, the video recordings of everyday activities. Observations and ideas gathered through ethnography and fieldwork are informative, and sometimes highly insightful, but their relevance to analysis has to be shown within the situated and interactional accomplishment of the participants' actions.

Key points

- Features of context are constituted in and through the action and interaction of the participants.
- In part, action can gain sense and significance by virtue of its relationship to specific features of that environment.
- It is useful to examine how the design of a gesture, a turn at talk, or computer use might be shaped within its course, with regard to the conduct of others in the scene.
- Transcriptions of fragments should be sensitive to the conduct of all participants in perceptual range of the event and any use of tools, systems or other objects relevant to the activity at hand.
- Aspects of interaction in institutions are often designed differently to informal conversation. It is useful to unpack these differences in order to further understand the distinctive demands and characteristics of the work involved.
- While it may be necessary to draw on field observations and other materials, there is a requirement to demonstrate how participants themselves, in the practical accomplishment of particular activities, orient to features invoked in the analytic description.

RECOMMENDED READING

- A number of recent studies have considered the ways in which the material environment features as a resource in the organisation of interaction (see, for example, Goodwin, 1995; Heath and Hindmarsh, 2000b; LeBaron and Jones, 2002).
- Goffman (1981) discusses the notion of 'participation framework' and 'footing' at length.
- Heritage (1997) provides a very useful overview of how 'institutionality' can be addressed in interaction in organisational settings.
- There are some highly illuminating debates about the value of 'external' contextual factors in the analysis of talk-in-interaction between Schegloff (1992) and Cicourel (1992) and also between Schegloff (1997; 1998) and Wetherell (1998).

EXERCISE

Select a fragment from your corpus of video recordings that preferably involves talk and the participation of three or more participants. Transcribe the talk that arises within no more than 20 seconds of the data and undertake a preliminary analysis of the sequential organisation of a particular action or activity. Continue the analysis by examining the visible as well as spoken aspects of the fragment. How does this change your preliminary analysis? What needs to be added to the transcript? What additional elements of embodied conduct and tool use are significant to the organisation of the talk?

6

PREPARING PRESENTATIONS AND PUBLICATIONS

Contents

6.1 Introduction

Video can prove highly engaging to an audience. In giving talks at conferences and colloquia, even relatively brief fragments taken from the original recordings can give an audience a clear sense of the setting and the activities in which people are engaged. A brief fragment of video can also allow a speaker to reveal succinctly the methodological commitments that inform the study. Perhaps most importantly, video fragments provide evidence for analytic insights into particular phenomena and aspects of the social organisation of everyday activities. In publications, an image or a series of images can powerfully serve to illuminate analyses of conduct and co-participation as well as the material resources on which participants rely when accomplishing activities.

Unlike more traditional forms of qualitative data, such as field notes or interviews, video enables the researcher to show and to share the data on which the analysis is based and to subject observations and insights to more general scrutiny. However,

selecting and organising fragments for presentations, editing and presenting images for publication, can prove challenging even for the most experienced researcher.

In this chapter we provide guidance on how to present video materials to different types of audience. We provide advice on how to report analyses in live presentations, within written texts and through digital media. There are currently a large number of tools that can help in the preparation of video, ranging from simple presentation tools to systems that have been designed for professional movie editors and web designers. Whether these are appropriate will depend on the kind of presentation that you wish to give, the circumstances under which it is being given, the time you have to prepare for the presentation, and perhaps most fundamentally, the form of analysis that is being presented.

Whereas ethnographic research may demand the use of longer, more illustrative fragments in presentations, research that draws on conversation analysis will require detailed scrutiny of fragments of video that are often less than ten seconds or so in length. Similarly, publications that draw on video-based research vary significantly depending on the analytic framework that has informed the original research and the type of insights and findings that are revealed. In other words, whether publishing or presenting, there is no one convention that fits all. However, we can provide a range of considerations, recommendations and guidance that can help with disseminating video-based research.

6.2 Live presentations

Planning the presentation

Given the richness of audio-visual recordings it can be tempting to believe that an extract 'speaks for itself' and requires little in the way of introduction or background information. This is a mistake. In the first place most materials will require an introduction to the setting and the key activities involved. Secondly, almost all presentations are concerned with providing both insights into particular phenomena as well as an argument that raises analytic or substantive issues. Therefore the introduction to the data needs to be tailored to these issues and should highlight what the audience needs to know in order to discover the insights and observations that are critical to the overall argument.

However there is a danger of providing too much background information at the beginning of a presentation. It can detract from the underlying argument and provide information that is long forgotten before its relevance to the specific part of the talk arises. This problem becomes particularly pertinent when presenting studies of highly complex settings with which the audience may be unfamiliar. For example, when we first prepared talks concerning the Line Control Room on London Underground, it proved difficult to avoid spending the first ten minutes or so describing the nature of the participants' day-to-day work, the routine problems they faced, the solutions they deployed to solve them and the array of tools and technologies that were used in their work. We soon found, however, that this introductory information was a time-consuming distraction. Instead we started to work

through a series of brief fragments that revealed specific aspects of organisational practice, and at pertinent moments we provided details of, say, the use of particular displays and computer systems, as and when necessary.

The presentation of video recordings requires a stringent *economy of description*. This should allow the audience to see and discover for themselves the characteristics of the setting, the activities and phenomena that are relevant to the overarching analytic argument. The temptation is to give too much away too early and thereby to undermine the focus of the presentation and the richness of the phenomena being presented. The presentation demands a careful balance that provides enough background information without overwhelming the audience or undermining the analytic thrust of the paper.

Selecting data extracts

Different forms of video analysis have different conventions for presenting recordings, but there are a number of rules of thumb that can be used for reporting studies concerned with the details of interactional phenomena.

In the first place, an initial fragment or fragments should be selected to enable the speaker to provide the audience with a clear sense of the actions or activity that will form the focus of the presentation. Where possible these should provide a preliminary sense of the organisation or practice that will be addressed. This may well involve selecting one or two simple, straightforward, examples; that is, examples where the audience can readily recover the phenomena of interest. Secondly, it can be helpful to select fragments that *progressively* reveal key aspects of the action(s) or practices under consideration. This may also involve demonstrating how they are organised in different occasions or circumstances. Thirdly, a practice that is common in conversation analysis is to present a fragment towards the end of the presentation that might be seen as constituting a 'deviant case'. The deviant case can then be subject to more detailed analysis to demonstrate how it develops an understanding of the issue or activity at hand.

As you build an argument the analysis should be progressively revealed and emerge by virtue of the presentation of each successive extract. Furthermore the fragments should become more delicate and complex such that the audience can learn how to see the phenomena and can follow the argument as it unfolds.

Structuring the presentation

In introducing the background to the themes and motivations of the research, it may be useful to play a brief video clip depicting the setting or at least to show a number of images or photographs. In this way, the audience can become familiar with the setting and find it easier to attune to the video fragments when you play them later.

It may be best to structure the empirical material according to a small number, maybe two or three, analytic themes that help to unpack the phenomena of interest. Clearly the time you have for the presentation will determine the depth of analysis that you can reveal for each theme. It will also limit the number of fragments that

FIGURE 6.1 *Sample background slides. These are taken from a presentation on interaction in surgical operations. The talk commenced with some general discussion of issues accompanied by a general fragment showing all participants (played alongside the introduction with no sound). Later fragments, such as those shown on the slide on the right, were cropped using Apple's iMovie to focus on the gestures of the surgeons and the instruments they were using*

can be shown and discussed. A standard conference presentation is likely to last 20 to 30 minutes, so even if you use very short fragments, it may only be possible to include one for each section. Even with an hour available it can be very hard to present more than nine fragments, particularly if you wish to develop an argument which relies on the audience seeing the fine details in the data. When presenting fragments you need to consider that each fragment needs some introduction and a discussion of its contribution to and implications for the overall argument.

While the early 'simple' fragments may only require playing once, later on the fragments and the points of relevance may well be more complex and delicate. In these cases it is important that the fragment is shown at least a second time so that the audience can see the relevant features for themselves. It may also be useful to play in slow motion or to crop the video in order to highlight a key gesture or action. The specific means for replaying the video will be determined by the phenomena of interest. Thus the discussion of each fragment might best follow this general format: (i) introduction to the extract; (ii) initial playback; (iii) discussion of the key points to notice; (iv) repeat playback; and (v) summary of the contribution of the fragment to the overarching argument.

If the presentation of extracts clearly helps to build the argument, then the concluding remarks can focus on the contribution of the analysis say to contemporary research in the field rather than simply summarise the findings.

Box 6.1 Tips for presenting video data

Do not use fragments that are too long

Be careful when using fragments that are longer than 15 seconds. There may be times when long fragments can help to provide background information or

unpack a complex case, but it can prove difficult for an audience to identify the key features in lengthy fragments.

Avoid using too many clips

It is hard to maintain the audience's attention if they have to view a succession of fragments, particularly if each adds little to the overall argument.

Take time to set up and discuss fragments

Make sure you properly introduce a fragment, provide the audience with a sense of why it is being shown and even what they should look and listen out for. When it has been played, clearly draw out the issues that it raises. Do not distract the audience with irrelevant information.

Do not use fragments as illustrations

Show how a fragment contributes to the overall argument you are making. It should advance the argument rather than simply illustrate a point that has already been made.

Avoid forms of presentation that are visually complex

Computer-editing and presentation systems offer significant opportunities for manipulating clips and showing video alongside other materials. Carefully consider any changes or additions you make to the original footage since it can confuse and overwhelm the extract. In some cases, it can be helpful to provide additional resources such as transcripts and handouts on paper to avoid presenting too much information on-screen.

Using presentation tools: Videotapes

Until the last decade or so, video was most commonly presented using a video player and a conventional monitor. The use of reel-to-reel tapes that emerged in the late 1960s was superseded in the early 1980s by successive types of cassette, the most recent instantiation of which are High Definition Digital Video (HDDV) tapes. These have many advantages when used for presentations. They are portable and can be played through a conventional monitor or projector. They are agile to use, enabling a speaker to play and replay fragments with ease. They have stable still-frame and slow-motion facilities allowing a speaker to hold images on a display and discuss sequences of action in some detail. With most DV recorders it is also possible to add text or to manipulate the images, though we suggest that such techniques can prove a distraction to, rather than enhance, a presentation.

In editing a collection of fragments on DV tape it is worthwhile considering a few issues. In the first place, it is best not to edit a fragment so that key features appear too early in a fragment. An audience often needs lead time, of three seconds or more, in order to attune to the image and be able to notice key actions and details. Secondly, it is worthwhile placing short breaks of a second or so

between fragments to help you to find and identify different extracts in a series. Thirdly, it can be helpful to record each fragment twice, so that when it is played for a second time, the tape does not need to be rewound. It is also worthwhile making a copy of your collection just in case the tape gets trapped and becomes unusable. Also, if the first fragment appears too soon on the tape, the first few seconds can sometimes be skipped when the player begins playing it; therefore, always start recording some seconds into the blank tape.

Using presentation tools: Computer software

It is increasingly common to use computer systems and data projectors when giving talks. Widely available applications like Microsoft's PowerPoint or Apple's Keynote help to structure a talk, allow the speaker to illustrate points with graphics, and show associated transcripts and other materials. However, they do have their drawbacks.

As Edward Tufte (2003), Max Atkinson (2004) and others have suggested, despite their enormous potential, the use of these software packages can undermine rather than enhance a presentation. It is not unusual, for example, for speakers to place an inordinate amount of information on a slide and to find themselves reading the slide out-loud to the audience. Or, speakers will present a series of bullet points that summarise their observations or argument, thus enabling the audience to read them before they are spoken. This can undermine the motivation for listening. Furthermore, computer slide presentations can impose a rigid structure on a talk and undermine the speaker's ability to adjust and tailor the presentation to the participation of the audience. Both Tufte and Atkinson argue that presenters should use such software for what they are most appropriate – the presentation of visual materials.

Some presenters like to strip down the presentation to simply focus on the data fragments, as in many ways they stand as sufficient and powerful visual materials. Some will use a basic editing package like Apple's iMovie to work through collections of fragments. Other presenters work with computer packages more commonly used by graphic and web designers or by movie editors. For example, Macromedia Director can allow a presenter to be much more flexible in when and how to display clips and offers an extraordinary range of ways to present text and animations alongside moving images. This can be visually appealing, however highly demanding as it can take time to learn to use these tools effectively.

More commonly used packages like PowerPoint and Keynote have a number of sophisticated functions that can allow quite complex presentations to be developed. Most auditoria and classrooms typically have facilities to connect laptops into their projection systems and technical support staff now tend to be more familiar with this kind of presentation software. Furthermore, it is possible to construct computer-based presentations that enable you to assemble collections, repeat fragments and even tailor the talk for different audiences. It is also relatively straightforward to import clips from editing packages such as Apple's iMovie from most kinds of camcorders and in most video formats.

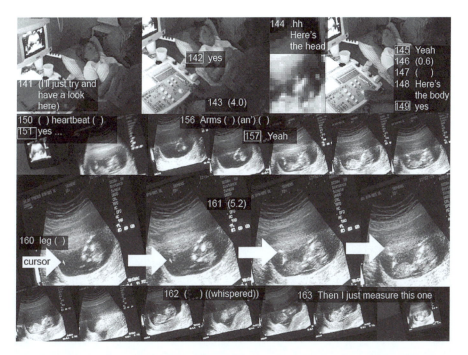

FIGURE 6.2 *A presentation using Macromedia Director. In this case Macromedia Director has been used to augment a video image of an object being viewed by the participants (an ultrasound display of a pregnant woman). As the presentation developed the author focused on the details of the talk in relation to the moving image. Reproduced courtesy of Monika Büscher*

Box 6.2 Assembling video fragments using iMovie

There are numerous video-editing packages available; some are for professional and semi-professional editors such as Adobe's Premiere and Apple's Final Cut. However, even applications designed for simple domestic movie editing, like Apple's iMovie, offer a wide range of features that help tailor a presentation. As applications change regularly it is hard to give advice about using particular packages, but some pointers to how one popular system is used to do certain activities might be helpful.

Importing fragments from a camcorder

A package like iMovie offers an easy way to build a collection of fragments. The package also supports analysis by allowing you to switch easily between clips and playing these back immediately. In iMovie, importing fragments usually only requires a lead (usually a FireWire 4 pin to 6 pin or a USB 2.0 cable) and selecting 'record' or 'Import from Camera' when the program recognises the camera is connected.

(Continued)

Editing clips

You may wish to use clips of different lengths in the presentation. Cutting clips can be done by making a copy of the fragment and trimming it from either end. You can also set the playback speed to slow motion or 'crop' the image to zoom into a portion of the fragment. You can apply more than one of these effects to a fragment, but it is important to note that some effects like 'zooming in' will reduce the quality of the image.

Special effects

It is possible, either by using the special effects, or 'plug-ins' provided by other companies, to do more complex manipulations. For example, a useful feature is 'picture-in-picture'. This can be particularly useful when you have images from more than one camera and wish to play them at the same time. Normally you will need the inset to be a quarter of the size of the main image as this maintains the shape (or 'aspect-ratio') of the image. You will need to decide which of the images should serve as the principal image. It is also worth noting that synchronising fragments using picture-in-picture can be difficult and may require numerous attempts to get the necessary precision.

Playing fragments simultaneously

An alternative approach is to use the animations available in PowerPoint and Keynote that enable you to play clips alongside each other. You have less control but, with some practice, adequate synchronisation is possible. This approach has the advantage of providing more flexibility both in the number of images and how the images are presented. The limitation of the approach is that it requires a powerful laptop to ensure more than one clip is played at the same time without stuttering.

Exporting fragments to a presentation program

To use the fragments in PowerPoint or Keynote you need to 'export' the clips from the application that holds your collection. This can be as simple as 'dragging' the clip from iMovie into Keynote, but usually requires saving copies, particularly if you wish to present copies with different framings or with different lengths. You may also need to change the format of the video. Even if you are using your own machine or laptop for the presentation, do test it beforehand. Some formats can appear quite different when projected on a large display.

Transferring material to other workstations or laptops

If you save the clips on a disk or CD and then transfer them to another machine there is no guarantee that the video will play, especially if you happen to switch between Macs and PCs, which may have different operating systems. It is a recurrent problem when presenting video, that the format you use is incompatible with that required by the venue's computer. This can result in an error message appearing saying something like 'No Codec available on this computer' instead of the fragment. In an emergency and with the right software available

(e.g. QuickTime) it can be possible to reformat and re-import all your frag-
ments. A safer option is to use your own machine, even when the venue or the
organisers explicitly state otherwise. If you do have to use the machine at the
venue, give yourself plenty of time to check it will work, for example, by send-
ing a copy of your presentation to the organisers beforehand.

FIGURE 6.3 *An example re-framing of a video fragment. An original framing from the
video recording on the left and the framing used in a presentation when showing the
production of the gesture*

There are a number of ways to present individual fragments. After you have set up
the issue you are concerned with (and given a brief description about the particular
fragment) you can present the video with an accompanying transcript, with annota-
tions and labels, or simply on its own. If there is a feature that is hard to see then this
may need to be pointed out and if the talk on the recording is hard to hear (or make
sense of) then a transcript will help. It may help to zoom in on particular features of
a fragment (see Figure 6.3). Using a tool like Adobe Premiere or Apple's iMovie it is
possible to add subtitles and choose when text and labels appear in the course of pre-
senting a fragment. Indeed, many people find InQscribe an extremely useful tool for
inserting 'subtitles' to present the talk in the data – for instance, when presenting for-
eign language data to a predominantly English-speaking audience or *vice versa*.

However, it is easy to overwhelm the original images and sound with textual
materials, labels, subtitles, diagrams and the like, thereby undermining the very
material that gives strength to the argument. It is important to remember that the
presenter's talk is the most flexible, powerful and engaging vehicle for revealing
the sense and significance of fragments of video recordings.

This is why, when presenting to a small audience (of up to 50 people), it can be
more useful to provide a data handout which includes relevant transcripts and
maybe some images that are key to the analysis. This means that the screen does
not have to be overloaded. However, with larger audiences this is less feasible. Here,
you have to consider the most economic use of on-screen information. For exam-
ple, in terms of presenting transcripts, you can choose amongst many different ways
of presenting a single transcript, particularly when you repeat a fragment. The first
time through it may be useful to have an accompanying transcript and in later
showings you can just show the video fragment on its own and maybe even zoom
in on a particular area of the image.

FIGURE 6.4 *Example slides featuring video fragments. On the top left is an introductory slide where four repeated moving fragments (with sound) are used to give an impression of the settings and activities of interest. On the top right is a slide for a fragment accompanied by a transcript of talk. On the bottom left is a picture-in-picture image where a zoomed-in image of the gavel is shown inside an image of the auctioneer. On the bottom right the slide is accompanied by stills showing key features of the analysis*

Box 6.3 Preparing video clips for live presentations

It is best to avoid the need to select or manipulate fragments during a presentation. Applications such as PowerPoint and Keynote have a number of functions that support the smooth presentation of video.

For example, with PowerPoint once the movie has been inserted you have an opportunity to resize the clip and make it play automatically when the slide appears. In many cases, this is all you will need. However, you may wish to introduce the fragment with a still image on the screen. In this case, you can play the movie by clicking on the image. These 'effects' can be changed by selecting the 'custom animation' options on the 'Tools' menu.

Alternatively, you can use custom animation to make movies (and other graphics) appear when required. One animation sequence that can be useful is to present a still frame from a movie with associated text and then when you require it (when you click the mouse) the moving image appears larger than the still. These, and other effects, can be produced by changing when images appear, disappear, fade or zoom on your command ('On Click'), automatically after a previous effect ('After Previous') or at the same time as another effect

('With Previous'). Some presenters like to keep control of everything that happens on the screen so all changes happen after the click of a mouse; others prefer short sequences of animations to avoid intervention. When you wish to play two extracts at the same time, the 'With previous' option can be used so that fragments play simultaneously. Use the sound from the fragment with the best audio to resolve the minor synchronisation problems that will emerge when trying to play two or more video clips at the same time.

The same effects can be achieved in Apple's Keynote using Builds (accessible through the 'Build Inspector') and constructing sequences of effects either 'with' or 'after' one another. The 'QuickTime Inspector' allows quite simple manipulation of movies including, for example, looping clips and selecting a still image to display before a fragment is played (a so called 'poster frame').

Another clip manipulation that may be required is to focus on a particular area of an image. Doing this smoothly and without too much degradation can require quite sophisticated movie-editing packages like Adobe Premiere or Apple's Final Cut. However, the iMovie package provides a simple crop effect that allows you to zoom into a part of an image, for example, if you want to avoid distracting parts of the image or to focus on a detail that you consider important. iMovie also provides ways of trimming clips, playing them in slow motion, adding subtitles and exporting them in a range of video formats.

Common problems and difficulties

Even with forethought and careful preparation, problems do arise when using video as part of a presentation at a conference, colloquium or seminar. Ironically, difficulties often emerge at venues that have sophisticated video and computing facilities. As a rule it is best to assume that problems will arise and, as far as one is able, be prepared to have to deal with a range of difficulties. It is good practice to test out the equipment well in advance of your talk to identify and resolve any problems. It can be most unsettling to begin a presentation only to find that clips are not playing or not playing in the way that you had expected. The following list includes many of the problems that we and colleagues have faced when attempting to show video as part of a presentation.

Problem: The technology provided by the venue fails to work. It is not unusual for laptops to crash, especially when handling the burden of numerous video clips. Video players can snag tapes, TV monitors can fail to hold a stable image and the bulbs in projectors can blow.

Solution: If you plan to show video, take your own equipment, not only your own laptop or DV player but on occasions (and for smaller audiences) your own projector. Some new projectors are quite portable.

Problem: The technology you take to the venue fails to work. The system fails, your power adaptor is incorrect, your player snags your tapes, monitors have unusual or archaic inputs, etc.

Solution: Take copies of your presentation and, in particular, the video fragments both in the same and other formats, for example, on DV, CD, DVD or hard disk. Take a range of cables that enable you to link into different equipment as well as spare parts. Take power conversion plugs if you travel abroad.

Problem: You can open your PowerPoint application but the video does not seem to work.

Solution: Apart from problems caused by trying to play a presentation on someone else's computer, the most common reason is that you have simply forgotten to copy the video clips you require. To save disk space, most versions of PowerPoint do not save the media associated with the presentation in the same file as the slides. This can mean that when you copy a file the movies are left on the original computer. A simple practice is to always save the completed talk as a PowerPoint 'Package' which saves the whole presentation as a folder with copies of the files used in the slides. Even when the media are available, it is not uncommon for the link to be lost from the presentation to the media. To solve this problem you will need to re-import the files into the presentation. These difficulties are not so common in Keynote as this application always saves presentations as a package. Test all the slides on the machine you are going to use during the presentation well in advance of the talk.

Problem: The images appear but there is no sound. In many of the venues you will find there are no external speakers linked to the projector. Even in places where sound equipment is provided it can be difficult to link it into your equipment.

Solution: Always take a pair of portable speakers that can be directly connected to the laptop or player that you plan to use. Portable speakers are now commonly available and provide adequate sound for audiences of up to 50 participants. When audio equipment is available at the venue, check sound levels in different parts of the room before you begin your talk. Also, be wary of mono systems, either on your own equipment or the equipment at the venue; you can find there is no sound because the audio is being played through the channel where no sound was recorded.

Problem: You cannot stand near to your equipment to operate it – either because of the layout of the auditoria or the infrastructure. Some venues have audio-visual infrastructures operated by specialist staff. It can be very disruptive, in some cases impossible, to present video clips through an intermediary.

Solution: Insist that you have control of your system, even if this requires rewiring, or even bypassing, the established set-up. If this is not possible ask a colleague to assist and practise your presentation with them.

In sum:

- do not rely on the equipment provided by the venue;
- do not expect technicians or other staff to understand why their system is inappropriate or to be able to help you resolve your problems;

- do take your own equipment including copies of your materials and cables, connectors, plugs, batteries and the like;
- test your presentation and equipment before leaving for the venue and once again well in advance of your talk; and
- ensure that you have control over your equipment throughout your talk.

6.3 Presenting video in written texts

The act of preparing and presenting a talk is extremely useful in developing associated written articles. It helps to clarify the argument, to structure the paper and to identify the fragments that best exemplify the themes and issues you wish to address. Moreover, the response of the audience and the comments that you receive can help you reflect on how best to position and organise the analytic argument. In the social sciences, text remains the principal vehicle for the dissemination of empirical work. Transposing and, in a sense, translating video into text is problematic. Indeed, observations, insights and arguments that prove persuasive to a live audience can be difficult to deliver in textual form. There are also technical, practical and ethical difficulties that arise.

Describing data extracts

For the time being, still images coupled with descriptions, transcripts, drawings and various forms of annotation remain the pervasive resources for referencing and presenting video data in articles and papers. It can be useful to use images to illustrate background information about the setting. However, the most significant use of images from the video data will relate to the more detailed discussion of action within a number of fragments of data.

Although the reader should be made familiar with the general character of the setting, each of the fragments will require a short introductory paragraph to introduce the reader to the participants involved in the scene and the specific activity in which they are engaged. Indeed, it is often useful to mention the events that have led up to a fragment.

In presenting the fragment, a transcript of the talk can be used prior to or alongside the relevant images. The presentation of the extract progressively introduces the reader to the complexity and richness of the fragment. It may be valuable to use successive transcripts or images to highlight different aspects of particular activities. These should be highly selective in order to bring the reader's attention to specific features of conduct. The presentation of examples is not an attempt to provide an overall characterization of all that is happening within a fragment, but rather to give a selective impression of relevant aspects of the setting, the action or the activity at hand.

Once again, the textual account of the extract should employ an *economy of description*, enabling the reader to gain a sense of the relevant phenomena and how they bear upon the observations, insights and arguments that are being

presented. It should also clearly articulate how they relate to the paper's overall argument.

Integrating images and transcripts

If you are presenting a particularly fine aspect of conduct it is worth considering how this can best be done for a reader to see the necessary detail. Showing the images alongside the corresponding talk, like in a filmstrip, can help give a sense of the emerging nature of the visible conduct with respect to the talk. You can also consider how many images are necessary and how to lay these out. Apart from the difficulty of viewing a large number of images alongside each other, if there are too many to fit on a page each may be too small to see the relevant detail.

As well as the size and number of images you wish to present for any fragment, it is good to consider the orientation will best reveal the features you are focusing on (see Figure 6.5). For example, an upward movement of a hand becomes more apparent through a horizontal series of images; a movement across an image is clearer if the images run down the page. Cropping each image so that it is framed in a similar way can help the reader see distinctions between images. It is also easier if there are not too many changes of scale and framing within a series. You should frame images to make sure that features that are key to the analysis are most apparent. So, if you wish to convey for example how people alter the ways they are looking at a computer screen, it helps if the screen and the person are both within the frame.

By annotating the images, or at least the first in a sequence, you can identify the principal participants and any key features of the environment like tools and technologies that might be referred to in the main text. Although it is possible to use a range of devices, like arrows, titles, transparent and overlaid shapes, it is best not to have too many additional design features interfering with the image.

Developing from this relatively simple approach, it is possible to create more complex ways of presenting the images. For example, pictures may be: cropped; partially overlaid to reveal a sequence of emerging action; fragmented to exaggerate specific detail; or merged to demonstrate how the actions of participants recorded by different cameras are subtly interrelated. At one point in a paper on medical interaction we were concerned in showing slight changes in the conduct of the patient. For the purposes of the description, it was not necessary to repeat the doctor's image in each frame (see Figure 6.6).

Despite this array of techniques, it is often best simply to use a single image. In the past we have made the mistake of trying to represent very subtle movements across multiple frames, and readers (or reviewers) have sometimes reported that they cannot tell the difference between the images. If this arises you may have to consider using annotations to highlight difference. Charles Goodwin (1995), for example, has developed a range of techniques that help emphasise when particular details occur. These highlight the critical features relevant to the analysis and their temporal organisation. When necessary he also adds graphics and annotations to

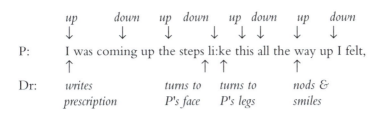

FIGURE 6.5 *Cropping images in a series. Example that aims to bring the reader's attention to a subtle change in the bodily conduct of the patient. Taken from Heath (2000)*

the transcript to reveal the interrelationships between the talk and the visual conduct (see Figure 6.7). If it is hard to develop such a way of presenting fragments you may simply have to rely on good quality transcripts and descriptions in the text.

Images and ethical issues

The ethical strictures that apply to the collection and use of audio-visual data may constrain whether and how an image is included within a publication (see Chapter 2 for further details). For example, in video recordings of medical consultations, it may not be possible to show the face of the patient in the image or even other aspects of the image that may threaten the anonymity of the participants. It may be necessary, on occasions, to rework or replace images to conceal the identity of the participants or the setting in which the data was collected. For example, pictures may be faded, blurred or selectively 'pixellated' to preserve confidentiality. This can prove challenging in cases where the analysis rests upon for example the facial orientation or expression of an individual.

In these and related circumstances it is not unusual to substitute the original image with drawings or tracings (see Figure 6.8). In some cases these are drawn free hand either by the authors or professional artists (for example, see Goodwin (1981) and Heath (1986)) or by using software packages such as Adobe Photoshop and hardware, such as graphic tablets, to help draw the outline of the relevant features of the scene and action. Alternatively there are

Set 1

SA: (Three two) to Ba<u>se</u> ↑
 (1.2)
SS: Yes er(m)::: (0.4) the
 supervisor's coming <u>now.</u>

 (1.2)
SA: Thanks Michael could you just keep
 an eye on the Westbound for us? We
 might need (to/some) erm: (0.4) sta-
 tion control if it goes on much longer:.

 (1.2)
SS: Alright then.
 (1.0)

SA: (Thank you)

Set 2

SA:	(Three two) to Base↑ (1.2)	SA:	(1.2) Thanks Michael could you just keep an eye on the Westbound for us? We might need (to/some) erm: (0.4) station control if it goes on much longer:.		
SS:	Yes er(m)::: (0.4) the supervisor's coming <u>now.</u>			SS:	(1.2) Alright then. (1.0)
				SA:	(Thank you)

FIGURE 6.6 *Using horizontal and vertical image layouts. Two ways of presenting the same fragment. The first set emphasises the movement in towards the screens by the participant. The second set helps make apparent the less obvious shift in gaze direction particularly between the first and third frames*

software packages that can automatically convert video images into line drawings (see Figure 6.9). Again when using advanced techniques it is important to bear in mind the analytic points that you wish to convey. It is pointless spending a

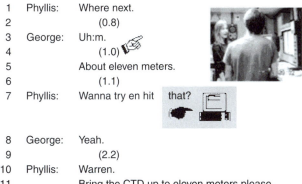

```
 1   Phyllis:    Where next.
 2                   (0.8)
 3   George:    Uh:m.
 4                   (1.0)
 5               About eleven meters.
 6                   (1.1)
 7   Phyllis:    Wanna try en hit   that?
```

```
 8   George:    Yeah.
 9                   (2.2)
10   Phyllis:    Warren.
11               Bring the CTD up to eleven meters please.
```

FIGURE 6.7 *Embedding images in transcripts. From Goodwin, 1995. Reproduced by kind permission of Charles Goodwin*

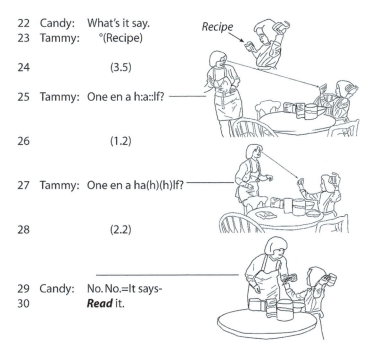

```
22  Candy:   What's it say.        Recipe
23  Tammy:     °(Recipe)

24                  (3.5)

25  Tammy:  One en a h:a::lf?

26                  (1.2)

27  Tammy:  One en a ha(h)(h)lf?

28                  (2.2)

29  Candy:   No. No.=It says-
30            **Read** it.
```

FIGURE 6.8 *Using line drawings in publications. From Goodwin, 2009. Reproduced by kind permission of Charles Goodwin.*

lot of time producing complex graphical effects, if they fail to add to the analytic description. Whatever approach you adopt, using images requires careful selection and framing to enable the principal features of the action to be accessible to the reader.

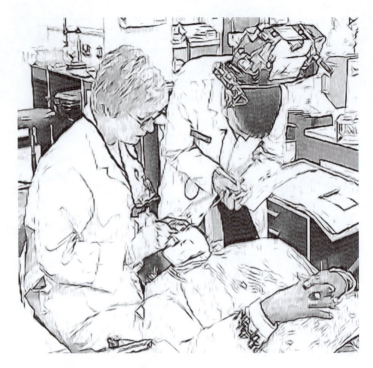

FIGURE 6.9 *Using automatically-generated line drawings. These images have been converted to line drawings using AKVIS Sketch. Taken from Hindmarsh 2010.*

Box 6.4 How to anonymise video data

If you have to anonymise your visual material it can be done fairly easily with most image-editing packages (like Adobe Photoshop). All you need is to select a portion of the image and blur it.

For video fragments this is more difficult, as each frame needs to be changed. There are packages that you can purchase to help you do this. For example, in a widely-used older version of iMovie (iMovie HD), Virtix's witness protection plug-in allows you to select an area of an image and for a specified duration, blur or pixellate it.

In the latest version of iMovie and other video-editing packages you will need to create what is called a mask. This is an image, usually created using a image-editing package, consisting of an area which will cover the face, eyes or a name. The easiest way to create a mask is to grab and manipulate an image from the video so it consists of only the blur or mask. Once you have this, in iMovie, you can just drop this over the clip you want to mask.

The whole process can require you to set various properties on the application that can involve quite sophisticated editing. It is a lot simpler if you have a

still image. It can be very difficult if the person or object you want to obscure is continually changing position within the frame.

The complexity of the process, and the problem that it can obscure the very things you want to present (e.g. gaze direction or the co-ordination of writing or typing), suggests that it is well worth considering the issues that will arise in presenting this data when you negotiate access and permission to record.

Preparing images for publication

Publishers are becoming increasingly concerned with the costs of production and in some cases severely limit the number of images that can be included in an article or chapter. One simple solution is to combine different frames relating to a fragment into a single image file. This will reduce the overall number of images. It is also important to recognise that publishers may have very specific requirements for, and constraints on, the reproduction of images. Apart from limiting the number of images, they may have constraints on the quality of the images that can be reproduced and will often only print in black and white. Some publications have standard ways of setting images, for example, by placing them towards the top of a page, regardless of what is written in the text. You need to be aware of these constraints when preparing the article and be sensitive to the ways in which seemingly innocuous strictures or conventions can have severe implications for the ways in which you present material.

Publishers will often set standards for the quality of the image they print that are based on what can be obtained from photographs. Even when using high definition video, the resolution you can get from a still frame taken from a video image is unlikely to match that of a photograph, particularly if you had to cope with problems with poor lighting, focusing and framing that typically occur when collecting naturally occurring materials. However, it is possible to improve the quality of images by subtly altering the contrast, the sharpness and the brightness of each image. You can also change the tonal quality of the colours, or more typically the shades of grey.

At a very early stage in the publishing process, it can be worth making the editor aware that your article may require special attention and even arranging to contact the printers so that you can ascertain their requirements for image quality and printing. Except for some specialist journals, editors, and even some publishers, are not usually familiar with the distinct requirements of printing images taken from video. It is not uncommon for images to be printed that are too dark, have no contrast or appear in the wrong location or order. In some cases we have found that publishers will attempt to de-blur faces to improve image quality – failing to realise that they were blurred deliberately to preserve anonymity. When relying on electronic submission and proofing, these problems can sometimes only become apparent after the article is printed.

Box 6.5 How to manipulate an image using Adobe Photoshop

Import the frame using the highest resolution possible. For convenience and compatibility with other systems it is usually best to use JPEG or TIFF formats.

'**Deinterlace'** the image – this removes effects from being taken from a video image.

Change the image to **Grayscale.**

Set the **Image Size** to the required resolution (if this is known). In Adobe Photoshop you can set the image size in terms of file size: the higher the resolution the larger the file size. Working with very large images not only takes up storage space but also increases processing time and is slower.

Crop the image using the editing tool. It is usually best to use the rulers so you crop each image exactly in the same way.

Apply necessary image effects: these might include changing the brightness and contrast, sharpening the image and using the Variations tool to change the grey tones. Note: how the image appears on the screen is not the same as it appears when printed and images print differently on different printing devices. Using a high quality laser printer can help.

Save each image in a separate file in the required format (e.g. JPEG). This may require first 'flattening' the image. It is advisable to label each image carefully. For example, include the number of the fragment and details of the precise location of the particular image in a sequence.

6.4 Publishing and presenting video using digital media

There are growing opportunities to publish video-based articles using the Web, CDs or DVDs which can overcome some of the limitations of paper. In particular these media, whether online journals or bespoke DVDs, enable the reader to see the video fragment in full, rather than simply relying on the impoverished representations of a series of still images. To use these opportunities to the full may require developing skills more commonly associated with designers or electronic publishers. One of the first serious attempts to exploit opportunities for digital dissemination in video-based research was by Leslie Jarmon (1996). She was the first person to produce her PhD thesis on CD-ROM and she fully exploited emerging opportunities with digital media to interlink text with transcripts, images and video clips (see Figure 6.10). Her study was well suited to this form of presentation as it was concerned with the delicate co-ordination of talk and bodily conduct in face-to-face interaction. In order to accomplish this, however, she was required to become somewhat of an expert in computer programming. More recently, software packages are becoming commonly available that make web design and DVD production relatively straightforward, without the need to learn special computer languages or techniques. There are also simple ways of producing electronic materials that principally use conventional word-processing and presentation packages.

The ease of copying digital materials can make it a useful way of disseminating research, however, this can have less desirable consequences. As we discussed in

FIGURE 6.10 *A screenshot from the world's first multimedia PhD thesis. The CD-ROM,*
produced by Leslie Jarmon (1996), incorporates video clips, text and navigation menus.
Image reproduced courtesy of Leslie Jarmon

Chapter 2, the digital distribution of video files does raise serious ethical issues for data that was gathered for limited research purposes. It may be possible to secure a more open agreement on how to disseminate materials, but it can be unwise to attempt to secure blanket agreement since neither you nor the participants can know all the circumstances under which the data could then be used. If you are still in contact with the participants it may be possible to secure their consent to distribute a particular clip or set of clips.

If you do secure agreement to disseminate data electronically or to distribute data amongst your colleagues, this can be done quite quickly from either a presentation you have made or using your original video fragments. Most word-processing packages allow you to include video fragments in a document (e.g. the 'Insert Movie…' command in Microsoft Word). Alternatively you can distribute presentations as PowerPoint or Keynote packages or as an electronic movie (e.g. as a QuickTime file). Although this can make the files very large, they can be easily transferred to a website or onto a CD, DVD or another electronic storage device.

With most video-editing systems it is also possible to create DVDs directly from your video data. If you have used Apple's iMovie, for example, you can use the associated iDVD package to assemble a DVD that can be played by most domestic players. iMovie provides templates to construct the menus and forms of

presentation that are familiar to anyone who has played a DVD. This can involve little more than dragging the movies into a template and adding some titles. If you wish to design something more specific, then this will require designing a template for each of the DVD's menus and deciding how the viewer will access the media on the disk. With a little effort it can be possible to design DVDs that present collections of fragments grouped into appropriate themes, with accompanying texts and diagrams. Such collections can allow others to search and explore your data in a more systematic way rather than simply as a collection of files. This can prove an innovative way of presenting your research and provide the resources with which to develop teaching and training materials.

The opportunities for using video fragments in journal articles are emerging rapidly. On the one hand print journals are increasingly providing web space to store multimedia files for readers to access. On the other hand, there are a growing number of online journals who actively encourage articles that feature video clips and the like. For instance, in recent years, *Sociological Research Online* has published a series of papers that have included video fragments. These articles have examined issues as diverse as the work of midwives (Lomax and Casey, 1998), landscape architects (Büscher, 2005) and the management and organisation of customer behaviour (Brown, 2004). These types of journal largely support the presentation of low quality clips and provide few restrictions on how they can be accessed. Nevertheless, they do give the reader immediate access to the very data on which the analytic argument is based.

If you have a location on the web where you can place materials securely, more innovative ways of presenting data are also possible. Through hyperlinks, viewers or readers have a familiar set of resources for exploring a collection of video clips. Using one of the many web design tools that are available you can start to develop novel ways of presenting your analyses. One simple use of hyperlinks is just to tie fragments to objects like images or pieces of text. In this way it is possible to animate an electronic document by providing links to the video clips where the still images would appear in the paper equivalent. This approach provides a simple way for readers to see the fragments of data referred to in the text. Although one can facilitate linear progression through written articles, a series of research projects at Cardiff University have considered the potential to explore new forms of ethnographic writing. The use of hypermedia technologies enables multiple routes through a network of multimedia data, raising some interesting opportunities for ethnographic accounts (Dicks et al., 2005).

Once again, care needs to be taken to make sure that the forms of presentation do not overwhelm the analytic thrust of the argument. What underlies the web is quite a simple relationship – the link between one item and another. If this is used effectively it can be a powerful way of associating texts with visual (and audio) materials. However, it cannot be expected that such relationships can convey all you might wish to present in an analysis. For most purposes, written texts are the clearest ways of communicating complex relationships and themes. They remain the most prevalent of media. They also are very easy to read.

From the initial tape machines to more modern digital formats, presenting moving images has always relied on some form of technology, technology that has rapidly

FIGURE 6.11 *Using websites to disseminate video materials. Some video fragments are made available by selecting the appropriate locations in the text (at the top is an introductory tutorial in Conversation Analysis available online at* http://www-staff.lboro.ac.uk/~ssca1/sitemenu.htm *courtesy of Charles Antaki. At the bottom is the 'Patterns of Home Life' website with kind permission from Andy Crabtre; see* http://www.mrl.nott.ac.uk/~axc/patterns_of_home_life/ *(accessed April 2009))*

changed over the last four decades. New formats and systems will undoubtedly emerge over the coming years and provide new and innovative ways of editing and presenting higher fidelity images both alone and in combination with a range of other visual and textual resources. Whatever the technology, it is critical that the form of presentation resonates with, reveals, even evokes the analytic thrust of the research. For qualitative research it is critical that the form of presentation first and foremost serves to enable the revelation of the practices and reasoning, the social organisation in and through which participants themselves make sense of and accomplish their everyday activities.

Key points

- The use of video clips should be used selectively to reveal key insights and arguments.
- When presenting video to live audiences never make assumptions about the systems that will be available and the support you will be given. Take control and know how to use your own equipment.
- In presentations and publications, an economy of description is invaluable in introducing research settings and summarising fragments.
- Image and movie-editing techniques can be used to good effect to clarify and focus on key details and if necessary to mask or conceal the identity of participants.
- New media provide interesting and innovative opportunities to interconnect text, transcripts and video clips.

RECOMMENDED READING

- Max Atkinson (2004) delivers a very useful practical guide to the art of public speaking. Interestingly, many of his tips are based upon conversation analytic studies of political oratory and public speakers.
- Edward Tufte (2003) warns of the dangers of 'allowing' PowerPoint to structure and shape the delivery of your argument, while Bernt Schnettler (2006) begins to unpack the communicative genre of the PowerPoint presentation.
- Monika Büscher (2005) demonstrates a variety of innovative ways in which video fragments can be integrated into online journal articles.
- Bella Dicks, Bruce Mason, Amanda Coffey and Paul Atkinson (2005) explore the potential of technologies that link digital documents to transform the nature and organisation of ethnographic accounts.
- Jon Hindmarsh (2008) considers a range of ethical and practical issues concerned with the distribution and dissemination of digital video among research groups and beyond.

EXERCISES

1 Prepare a short presentation lasting no more than ten minutes. The presentation should include an introduction in which you establish the problem or issue you will address, brief background, for example, describing data collection, followed by presentation and analysis of at least one fragment of video data. The conclusion should summarise the key issue(s) and implications of the presentation.
2 Write a report of no more than ten pages in which you present a detailed analysis of a single fragment. Consider the best combination of images to reveal the analytic points being made. Also experiment with alternative layouts for the images and transcripts.

7

IMPLICATIONS, APPLICATIONS
AND NEW DEVELOPMENTS

Contents

7.1 Introduction

Over the last two or three decades, research that draws upon video has generated a substantial corpus of observations and findings. As we discussed in Chapter 1, these studies have contributed to research and debates within a wide variety of fields and disciplines, including the sociology of health and illness, work and organisational analysis, science and technology studies, and more generally, our understanding of interpersonal communication, language use and social interaction. These studies have also contributed to more applied concerns and in some cases formed the basis to interventions and training in industry and the public services. We cannot hope to do justice to such a wide range of studies and concerns, so instead we will briefly discuss three areas to give a flavour of the contributions that these studies can make.

We will use three examples from our own work where the research has had more applied concerns. These relate to the analysis of surveillance technologies, doctor–patient interaction, and the interactional organisation of the museum visit. For each we outline the study's implications for debates in the social sciences and how they can inform more practical concerns, and how they relate to the wider

programmes of work to which they belong. We will also consider how video analysis has been utilised for business concerns and in the professions. We conclude the discussion by considering some current developments in video analysis, suggesting ways in which it may be applied to the exploration of new sites of sociality and to more mundane settings to explicate quite fundamental, yet largely uncharted, features of social interaction.

Case 1: Technology in action – Surveillance technologies in use

Over the last couple of decades there has been growing interest in the ways in which tools and technologies, objects and artefacts, feature in work and organisational practice. In part, this interest has arisen because of the problems that frequently occur when deploying technologies that fail to resonate with work and organisational arrangements. Indeed, a liturgy of costly technological failures has revealed how little we understand about how technology is used in everyday settings. Video-based studies have begun to play an important role in the analysis of technology-in-use and emerging interdisciplinary fields that inform the design, development and deployment of new technologies; fields such as HCI (Human-Computer Interaction), CSCW (Computer-Supported Co-operative Work) and Ubiquitous Computing.

Technology developers have turned to social scientists to gain detailed understanding of the social and interactional organisation of the circumstances for which systems are designed and deployed. Numerous approaches have emerged in sociology to consider how technology shapes society, how societal forces shape the development of technologies and how we construct and negotiate the meanings of technologies. However, as Button (1993) argues, in such analyses the technologies in question frequently vanish from view. Instead, the focus of the analysis tends to be concerned with more traditional sociological concerns – class, gender, power and so forth.

In contrast, a corpus of 'workplace studies' has emerged (see Heath and Button, 2002a; Luff et al., 2000b) that considers the very ways in which people '…recognisably and accountably orientate to technology in the course of its design, construction, development, implementation, its use, and in talking and writing about it' (Button, 1993: 25). Video-based studies of work practice stand firmly within this approach. They examine the detailed co-ordination of verbal, visual and material conduct through which technology is used. As an example, we briefly describe one of our recent studies of the use of a particular technology: CCTV (or Close-Circuit Television).

Surveillance technologies are widely and increasingly deployed throughout major cities in the UK, mainland Europe and North America. This has led to a corresponding emergence of a particular work setting – the 'surveillance centre' as a workplace. Here, personnel use CCTV technologies to analyse, assess and, where relevant, manage behaviour in public places. Despite the burgeoning body of research concerning the sociological and political implications of surveillance technologies and the 'surveillance society', the ways in which personnel skilfully

FIGURE 7.1 *CCTV in use in different station operation rooms on the London Underground*

use these technologies to oversee, and intervene in, public behaviours, the practices and reasoning that underpin the deployment of these CCTV systems, have received less attention.

As part of a pan-European project concerned with developing security systems for stations on urban transport networks, we undertook a video-based study of the use of surveillance technologies on London Underground (Heath et al., 2002; Luff et al., 2000a). In each of the major stations on the network, the CCTV system provides personnel with access, through a small number of (six to eight) monitors, to anything between 60 to 150 cameras that provide multiple views of the station (see Figure 7.1). Our studies addressed the ways in which personnel use the system both to identify problems and events – overcrowding, passenger accidents, suspect packages, pick-pocketing, illegal busking, fare dodging, physical attacks and the like – and to deploy a co-ordinated solution to these events.

Our video-based studies reveal the ways in which personnel configure the system, select a combination of scenes (cameras), with regard to their practical knowledge of the temporal and local geographical organisation of routine problems and events. So, for example, a particular combination of views will be selected during the rush hour to prospectively identify when platforms may become 'over-crowded' rather than simply crowded. Personnel used the CCTV system in combination with other technologies, such as monitors giving details of train times, to assess over-crowding, how to manage it and intervene.

These studies point to the ways in which the skilful use of CCTV is inextricably embedded within the operators' practical knowledge of the station: its local ecology, the activities in which people, both staff and passengers, engage, and the patterns of human conduct and navigation that arise. For example, staff use the cameras to 'see' problems and events that are, in their words, 'off the world', out of sight of the CCTV cameras, where people engage in illegal or untoward activities. Their ability to notice and identify problems is dependent upon a detailed, practical understanding of normal ways of behaving – of walking, standing, passing through ticket barriers, etc.; knowledge that forms background expectancies that enable the identification of the peculiar, the unusual

and the dangerous. The studies show how the identification of problems using the technology is tied to the routine and accountable practices through which they are managed.

These studies, like many other video-based studies of technology-in-use, provide a fresh perspective on technology. Technology does not simply engender change or simply reflect wider social and cultural values. Rather these studies of its deployment have a concern with '…locating technologies within the socially organized activities and settings of their production and use' (Suchman, 1997: 42). They reveal the ways in which participants assemble technological and material resources to make sense of, and contribute to, the activities of colleagues. The studies recurrently show how the sense and significance of modern technologies is constituted in and through social interaction in the workplace (see Goodwin and Goodwin, 1996; Heath and Luff, 2000a; Hindmarsh and Heath, 2000).

These observations and findings not only contribute to debates concerning technology and materiality in social interaction, but also to the design, development and deployment of new systems. In the case of our studies of the real-time use of CCTV, they informed the technical development of novel image processing systems that were being designed to identify problems automatically (see Khoudour et al., 2001; Norris et al., 1998; Velastin and Remagnino, 2006). The ways that personnel identify incidents that require intervention provided criteria to inform the development of the system. The studies also suggested ways in which the system needed to be configured, or tailored, to solve regularly occurring problems and how the system could be integrated with other systems, say, for automatic recording, making announcements or monitoring traffic. Perhaps more importantly, they also suggested challenges that needed to be overcome if the automated image recognition system was deployed, particularly how to present the problems that the system identified and how to practically manage the many problematic events potentially identified by an automated system.

The programme of studies of technology in action, of which our study of CCTV is only one example, was initiated by Lucy Suchman's groundbreaking video-based study (1987; 2007) of users attempting to make sense of an 'intelligent' photocopier. That work not only raised questions about contemporary cognitive models of human-conduct, but also informed a range of studies that revealed the importance of understanding how artefacts, whether they be computers or more mundane tools, were situated in sequences of social interaction. Subsequent workplace studies have reflected on the uses of tools such as paper (Luff et al., 1992); blackboards (Greiffenhagen and Sharrock, 2005) and order forms (Moore, Whalen and Gathman, 2010); as well as technologies such as mobile devices (Brown et al., 2005; Luff and Heath, 1998); expert systems (Whalen, 1995b; Whalen and Vinkhuyzen, 2000) and ubiquitous computing (Crabtree et al., 2007). What binds these diverse studies together is a broad recognition that, as John Hughes and colleagues (1994 p. 438) suggest, '…even though design may be concerned with developing a completely new system, understanding the context, the people, the skills they possess are all important matters for designers to reflect upon'.

Case 2: Health care communication – Doctor–patient interaction

In this book we have considered a number of cases that have been drawn from medical settings, particularly the interactions that arise between doctors and patients. For many decades the relationship between doctors and patients has been a significant concern for sociological inquiry. Indeed, some of the finest ethnographic studies of work and organisation address health care and the cultures that underpin and enable professional, medical practice. Alongside that research, a burgeoning corpus of research has considered the interactional accomplishment of the consultation and more generally encounters between health care professionals and their patients or clients (see, for example, Heritage and Maynard, 2006; Maynard, 2003; Peräkylä, 1995; Silverman, 1990; Stivers, 2007; West, 1985). In this regard, the asymmetries of knowledge and expertise that arise in medical encounters have proved of particular interest and a range of studies have examined the ways in which these asymmetries are created, oriented and reproduced in and through the interaction of doctor and patient.

While the visible aspects of medical encounters have received less attention than the spoken, video provides the resources with which to consider how asymmetries in the interaction between doctor and patient are embedded in and sustained through bodily conduct with and within talk. Our early work revealed the delicate ways in which patients, through various forms of bodily comportment, attempt to encourage particular forms of participation from doctors, especially to encourage doctors to display attention as they disclose their symptoms. The very ways in which patients attempt to transform the participation of the doctor reveals a deference, subtly encouraging but not demanding reorientation (see Heath, 1986). Consider, for example, the extract discussed in Chapter 4, where we found the patient withholding a response to the doctor's invitation to present his difficulties until the doctor appeared to have finished reading the medical records.

More recent research has addressed similar issues when considering the introduction of information technology into the medical consultation. This has revealed how patients are highly sensitive to the use of the computer and, for example, use bodily conduct in an attempt to encourage the doctor to orient, or orient visually, to what they are saying (see Greatbatch et al., 1993; Heath and Luff, 2000a). This work resonates with other studies of medical interaction where there is concern to explore and demonstrate the agency of the patient and the collaborative character of the medical encounter (e.g. Heritage and Maynard, 2006; Silverman, 1997; Strong, 1978).

These issues also relate to studies where we have examined how patients present their symptoms and attempt to justify seeking professional medical help (Heath, 2002). In the fragment discussed in Chapter 4, the patient has a visible problem (a 'bad eye') which he encourages the doctor to inspect. However, in other consultations patients suffer from symptoms that may not be visible, or may be episodic, and thus not present during the consultation. This raises a distinctive practical problem for many patients – how to demonstrate the pain and suffering associated with symptoms that are neither present in the moment nor visible to the doctor. Such symptoms can include headaches, chest pains, stomach aches,

even coughs, breathlessness and the like. Video provides the opportunity to examine the ways in which patients use bodily expression to render visible their difficulties; to (re)embody their pain and suffering for the doctor during the course of medical consultation. These practices enable and encourage doctors to see for themselves, to witness, the very pain and suffering experienced by patients. In this way patients not only (re)embody and animate their symptoms but reveal their unique or distinctive qualities that help to underscore the severity of their difficulties. In terms of the sociology of health and illness they reveal an orientation by the patient to the demands of the 'sick role' (Parsons, 1951) in the practical and interactional business of the medical encounter.

These kinds of issues and studies not only contribute to core concerns and debates in the sociology of health and illness, but also point towards practical implications. There is a long-standing recognition that communication skills are critical to the successful diagnosis and management of illness, and that encounters between medical practitioners and patients form the sites in which success and satisfaction with health care reside. Diagnosis rests on the abilities of doctors to glean adequate information from patients. Compliance with the treatment and the safety of medication depends in part upon instructions being understood by patients. Communication skills training traditionally discusses how doctors should design conduct to deliver better quality care, however, the interactional or collaborative elements of the encounter can be overlooked.

Analyses that take account of the visual and bodily conduct of the co-participants can reveal the practical or communication problems faced by patients and, in fine detail, how aspects of the conduct of medical practitioners can encourage, or even undermine, the disclosure and discussion of symptoms, illness and treatment. In a sense, these studies provide a foundation upon which to understand and assess the differing communication strategies we find within the medical consultation. Building on Drew et al. (2001: 59), who consider the potential contributions of conversation analytic research to medical practice and the consultation, we might suggest that these studies:

- identify common patterns of interaction, which health care students, supervisors and practitioners might more consciously take into account;
- identify interactional strategies that can facilitate patient involvement in decisions about health care;
- explore the association between different interactional 'styles' and key outcomes (e.g. patient satisfaction, patient resistance, etc.);
- inform the design of new tools for health care training and practice that resonate with the key elements of existing practice; and
- reflect on the impact of new policies, procedures or technologies on the form and style of interaction in health care encounters.

The consultation has formed the principal focus of studies of medical communication. In recent years, however, there has been a growing interest in the analysis of work and interaction in a broad range of additional health care settings. Video has proved particularly important in this regard, since it has enabled research into

activities that are more explicitly 'physical' or 'manual' in character, and in some cases activities that are accomplished in highly complex technological environments. Moreover, they often move beyond the doctor–patient consultation to consider other health care practitioners and carers, as well as exploring the interactional organisation of teamwork and training in health care. Consider, for example, recent video-based studies concerned with surgery (Koschmann et al., 2007; Mondada, 2003; Sanchez Svensson et al., 2007), anaesthesia (Hindmarsh & Pilnick, 2002, 2007), physiotherapy (Parry, 2004), dentistry (Becvar, 2008; Hindmarsh et al., 2010), psychiatry (McCabe et al., 2002) and the like. A further body of work that bears upon health care considers how brain damage impacts on the interactional organisation of conversation (for example see Goodwin, 2004). These studies reveal the bodily and vocal skills and competencies brought to bear by individuals with brain damage (and their interlocutors), rather than simply, as is often the case, undermining their status as communicators.

In sum, these studies comprise a significant and wide-ranging body of literature that is taking seriously the embodied and interactional organisation of health care work and delivery, the ways in which an activity's accomplishment is dependent upon the interplay of talk, embodied conduct and material resources.

Case 3: Visitor behaviour in museums and galleries

Members of our research group have been conducting video-based studies of visitor behaviour in museums and galleries over the last ten years or more. These studies have involved the collection and analysis of naturalistic video materials in a large number of institutions, primarily in London, but also in regional museums and others around the world. These wide-ranging studies have explored the ways in which people approach, view, explore, inspect and appreciate exhibits of various kinds ranging from paintings to scientific interactives and from art installations to aquaria.

As with the extract discussed in Chapter 5, the analysis has focused on the spoken, bodily and material resources that people bring to bear in organising their action and interaction in exhibition spaces and in particular around exhibits. In most studies of visitor behaviour, the details of action and interaction at the exhibit are rarely considered. Visitors tend to be interviewed before they enter a museum and after they have visited a gallery. Our studies seek to understand how people constitute the sense and significance of exhibits in and through their interaction with others, both those they are with and those others who happen to be in the same space.

These studies suggest a rethinking of how the very idea of the 'visitor' is conceived in analyses of visitor behaviour and related concepts such as response and reception, interaction and interactivity. Our studies of museum visitors demonstrate the fundamentally social and interactional organisation of 'the visit', considering how individuals co-ordinate their approach to an exhibit; how they learn to use those exhibits; and how they learn to display appreciation of artefacts, all by virtue of their sensitivity to the conduct of others who happen to be in the same space (see vom Lehn et al., 2001).

These studies have been undertaken in close collaboration with curators, edu-cationalists, designers and artists. As in other practical applications of video, the recorded materials can be invaluable when disseminating findings and presenting analysis. Detailed viewings of how people approach, discuss and in other ways engage with an exhibit can quickly reveal, to curators and other professionals, the problems and difficulties faced by visitors, whether the exhibit is a complex inter-active or a simple artefact.

In taking seriously the social and the collaborative nature of the museum visit there are potentially significant implications for the evaluation and design of museum exhibits and exhibitions. For example, there is often a clear contradiction between the notions of the visitor invoked in designing exhibits and the ways in which visi-tors actually encounter, explore and appreciate exhibits. Museum curators, designers and evaluators tend to focus on the organisation of exhibits and exhibitions on the *individual* visitor encountering exhibits *in isolation*. Even when exhibits are explicitly designed for multiple visitors, they often emphasise simultaneous and independent use, rather than supporting or enhancing collaboration between visitors.

Thus the idea of 'interactivity' that informs the design and development of many computer-based exhibits and resources in museums and galleries is often conflated with social interaction. Two of the most common emerging 'interactive' technologies in museums, touch screens and PDAs, seem to offer resources for the visitor that can be rich and dynamic, tailored to particular locations and even cus-tomised for different kinds of visitors. However, they can simultaneously under-mine interaction and collaboration. So a focus on the interactivity between a

FIGURE 7.2 *Exhibits developed by Jason Cleverly arising out of studies of visitor behaviour (Top line: Deus Oculi and Ghost Ship; bottom line Keepsake, and The Universal Curator)*

device and a user can neglect, or even undermine, the social interaction between visitors (Heath and vom Lehn, 2008).

Drawing on our studies of interaction within museums we considered how 'interactives' could be developed that might support, or even enhance, interaction between visitors. With agreement from a number of museums, galleries and fairs we were able to deploy these exhibits for extended periods and then record how visitors encountered them (see Figure 7.2). Through these 'naturalistic experiments', and our associated analyses, we were able to suggest some *design sensitivities* to inform the design of exhibits seeking to support social interaction. They have been used to inform the design of a number of interactive artworks (Hindmarsh et al., 2005).

Our work on visitor behaviour can be seen to resonate with a much wider body of video-based studies that explore issues of learning and indeed education. Although primarily concerned with language use and talk, a corpus of research has emerged that has become increasingly committed to using video to examine the visual and material as well as vocal features of interaction and learning in the classroom (see, for example, Hemmings et al., 2000; Matusov et al., 2002). More specifically they relate to studies that delineate the forms of participation and engagement that enable, enhance and embody learning in informal environments (see, for example, Meisner et al., 2007a).

7.2 Applications in services and industry

There is a growing recognition amongst personnel within industry and services of the potential value of video-based studies to the more practical problems they face. Indeed, ironically they can be more open to using video for their own research and training purposes than some within the social sciences. The practitioners recognise the importance of the tacit, the ordinary, the 'seen but unnoticed' to their practical concerns.

One area where video has been seen to have practical value has been among major companies concerned with the design and development of new technologies. The seminal studies by Lucy Suchman and colleagues emerged within the Xerox research laboratories. Researchers in organisations such as Xerox, Hewlett Packard, Intel, Nokia and Microsoft have had a concern with understanding how people use existing systems and services when considering how to develop innovative technologies. Video is now seen as a tool, often used in association with conventional fieldwork, that can help identify the requirements for new technologies, clarifying the concepts that inform system design, as well as informing the evaluation criteria and the strategy through which a new system or service will be deployed.

Although such studies have to be undertaken in less time and depth than academic research, video does allow a design team to view, scrutinise and analyse details of situated action that may be otherwise inaccessible. Unlike other forms of data used to develop requirements for new technologies, video recordings enable members of design teams to see and judge for themselves the quality of insights emerging from an analysis. They also offer a way of maintaining a 'trace' through the design process, to keep track of the relationship between the design decisions that are made and the original studies. Interestingly these approaches are no longer

confined to research laboratories within organisations. Development, product design and marketing divisions have also begun to use these methods to support their work.

A related development is the growing trend towards 'corporate' video-based ethnographies, found within market and consumer research companies, as well as multi-nationals. Large organisations have begun to undertake field research with customers or partners to better understand their needs, processes and practices (Ikeya et al., 2007). Furthermore, agencies such as InUse, Everyday Lives and Naked Eye are using video to record the behaviour of consumers in everyday settings such as supermarkets, shopping malls and even in the home. They recognise the power of video to support analyses of how consumers choose and use goods and services, as well as to provide a highly persuasive resource with which to convince companies that they should explore and adopt particular strategies or innovations. On their website, Everyday Lives, one of the leading agencies engaged in this type of consumer research, outlines their motivation for using video:

> We share a curiosity for the extraordinariness of everyday happenings which people take for granted. We slow them down and speed them up in order to see them with fresh eyes. We then ask subjects to provide their own perspectives before working with our clients to map out insights, opportunities and implications … There is an added advantage. Because we video people, our ethnographic research is transparent to clients. You see and hear what we see and hear. So you can challenge our analysis, make your own judgements. (Everyday Lives: http://www.everydaylives.com/ Accessed 6 March 2007)

While the interest in video, and the approach that has been adopted by these companies, draws from academic studies of interaction, they have developed distinctive and highly sophisticated methods to undertake intensive, applied analysis of video materials, interweaving a range of qualitative and quantitative techniques.

Despite its uses in system development, product design and consumer research, perhaps the most common use of video within organisations is in training, particularly in the training of communications skills. Even before the introduction of cheap domestic equipment, the potential of video for training was recognised by leading professional associations, particularly in medicine. Patrick Byrne, then the Chairman of the Royal College of General Practitioners, began using video in GP training in 1974 and by the early 1980s many medical schools in the UK had adopted a similar approach.

The commitment to skills training and communication in both medicine and other professions provided a momentum to academic research in the field; research that not infrequently involved close collaboration between clinicians and social scientists. However, increasingly we are witnessing the emergence of video-based studies of interpersonal communication within health care and other services that is undertaken by clinicians and has, as its primary purpose, a training application. In some cases, these studies lead to highly engaging and insightful analyses, akin to more conventional research in the social sciences. In general, however, these studies are primarily concerned with informing and enabling intervention strategies to provide resources for trainees to examine, assess and improve their own skills and practices. Increasingly we may find that practitioners in various fields will not only

use video in training but also as a resource to develop insights that will enrich their practical understanding of the activities in which they and their colleagues engage.

7.3 Emerging areas of interest

We turn now to two areas of research that use video and that raise distinctive challenges to its use and indeed its focus.

Mediated communication

There is one use of technology that has particular resonance for researchers who deal with video materials, and that is the potential of video itself to support communication. This is an application with a long history. Ever since the emergence of television in the 1920s and 1930s, there has been an interest in using video to enhance communication between individuals who are separated by great distances (Harrison, 2009). With recent innovations like web-cameras, and the common availability of broadband internet connections and free applications like Skype, it is only now that the vision of widespread video-mediated communication is being realised. Alongside these developments, researchers have sought to identify the unique characteristics of video-mediated communication that might explain some of the failures and successes deploying the technology. Drawing upon insights in social psychology in particular, researchers have considered how gestures, emotions, facial and body movement are preserved or transformed when mediated through a video technology (see, as examples, Finn et al., 1997; Short et al., 1976).

In one attempt to support video-mediated communication in the 1980s and 1990s, extensive infrastructures, called media spaces, were developed in a number of major research laboratories like Xerox, Hewlett Packard and Bell Laboratories and within a number of university research groups. These media spaces (see Figure 7.3) provided audio-visual access; the video image typically showing a head and shoulders view of the remote participant. Although there were some enthusiasts, the systems were under-utilised and later abandoned.

When considering the details of interaction mediated by these systems, it became apparent that the technology transformed the impact of visible conduct (Heath and Luff, 1992). When mediated through video, it was found for example that a gesture, a turn towards another person, a glance towards an object, does not have the performative and interactional impact of co-present conduct. So participants did not seem to notice particular gestures or aspects of visible conduct, and colleagues would reformulate and upgrade their attempts, exaggerating their gestures and their bodily conduct. There is an asymmetry between how actions are produced and seen when mediated through video.

By attempting to reproduce literally face-to-face interaction, the potential utility of video to support collaborative work was undermined. Support for the discussion of documents, materials and objects is rather primitive in most media spaces. When only the face of the colleague or the document can be seen, referential practice becomes problematic, as the body of the speaker is fractured from

FIGURE 7.3 *An early example of video-mediated communication through a desktop media space. Image reproduced courtesy of Bill Buxton*

the object referred to. Opportunities to gesture over and around the documents, whether local or remote, are denied to the participants. Recent attempts to address those problems (e.g. Luff et al., 2006) have tried to enhance access to bodily orientation, gestures and remote objects in order to re-embody the gesture and re-connect it to the point of reference. However, it turns out that supporting something like pointing and referencing in media space remains a significant problem.

Studies of these technologies raise two challenges for video-based research that we would like to highlight.

Firstly, they raise some interesting challenges for method and methodology. As many of these systems are under-developed and in prototype form, it is rare to be able to study them in the midst of naturally occurring interaction. Trying to understand the use of these systems often requires a more experimental approach. In our collaborations with computer scientists and engineers we have frequently developed 'quasi naturalistic' experiments where we gather recordings of people undertaking simple tasks within a circumscribed domain with limited resources. The tasks are designed to seem natural, open-ended and familiar to the participants, and not to require intervention from the researchers. Unlike standard experimental methods, the participants' abilities to complete the task are of little interest. Rather, the video recordings are analysed with regard to interactional organisations through which the participants accomplish particular activities.

A second challenge highlighted by studies of media space relates to the ways in which they reveal our limited understanding of rather basic features of social interaction. Whatever our sensitivities about using 'quasi-experimental' data, they

FIGURE 7.4 *The Agora system developed by Tsukuba and Saitama Universities in Japan. The engineers who developed this drew from detailed studies of interaction to provide a more embodied kind of mediated communication. It is possible to see in the image the hands of the remote participant (actually in a room 500m away) projected onto the surface of the desk and pointing to a feature on a document (which happens to be a map)*

provide, as Garfinkel (1967) suggests, 'aids to a sluggish imagination'. They can dramatically reveal the pre-suppositions and resources, which often remain unexplicated in more conventional studies of the workplace. What becomes apparent through these more experimental studies is how little we know about the most seemingly simple everyday actions and the competencies and skills that people bring to bear in their accomplishment. The issues that arise in mediated communication are not confined to media space. The emergence of a variety of virtual reality environments from lab-based prototypes through to 'worlds' like 'There', 'Second Life' and 'World of Warcraft' offer rich opportunities for remote interaction and collaboration. It might be fair to assume that such shared worlds would resolve problems of, for example, referential practice found in more traditional media space – after all the avatars share the same resources in the digital domain. However, a series of studies have revealed that these problems persist (Brown and Bell, 2004; Hindmarsh et al., 2000; Moore et al., 2007). So an interesting result from these studies of new and innovative sites of sociality is that they highlight the importance of taking the everyday seriously and of using video along with other methodological resources to explore the social and interactional organisation of seemingly simple activities.

Taking 'materiality' seriously

It is interesting to consider that despite the widespread deployment of computer systems in the workplace, paper, pen and pencil remain some of the most pervasive and important resources through which work is accomplished. Or consider how life in the home rests upon our abilities to use a range of familiar artefacts both alone and in collaboration with others, artefacts that seem of little significance but underpin our ability to prepare food, to plan and structure the day, and to choose and enjoy whatever entertainment comes in the evening. It is almost the very commonality and simplicity of these objects and artefacts that render them unnoticeable, unworthy of academic attention, and yet they inform the concerted accomplishment of many of our ordinary activities. In some cases, they form the basis to interpersonal relations and forms of sociability.

Harvey Sacks (1992) once suggested that we should reflect on the ways in which the new and the innovative are 'made at home' in our ordinary lives, and his advice perhaps serves as a lesson to encourage us to pay analytic attention to the ordinary, to take the mundane seriously and explore the complex array of resources, knowledge, practice and social organisation, that underpin the use of the most ordinary of objects and artefacts. In doing so, we may well be in a better position to inform future developments.

The challenge then is to prioritise the material, to give ordinary objects and artefacts the analytic attention normally afforded to the major topics addressed by the social sciences. The ways in which the immediate ecology features in the accomplishment of social action form the foundation to the ways in which we organise our conduct and make sense of the activities of others. Consider for example how navigation through public space is dependent upon our abilities not simply to anticipate the course and trajectory of the actions of others, but to make sense of those activities by virtue of the ways in which they relate, if only momentarily, to relevant features of the environment. Conduct renders relevant particular aspects of that ecology, and thereby constitutes a certain order and significance. While it is important to consider the ways in which people use and manipulate objects and artefacts, both alone and in collaboration with others, social action is continually and unavoidably constituted through the immediate ecology. This in turn provides the resources for others to make sense of the activity at hand and, where relevant, to contribute. Video-based studies can provide the practical and methodological resources through which we can begin to counter the 'linguistic turn' and to take seriously the ways in which social action is produced as intelligible by virtue of the interplay of the spoken, the visible and the material.

It is worth mentioning one further point. The emergence of video in the early 1970s enabled a number of researchers from various disciplines to begin to use recordings to examine social interaction in 'naturally occurring' settings. With a few notable exceptions (see, for example, Kendon, 1972), film was considered prohibitively expensive and difficult to use unobtrusively in non-experimental situations. Despite the idiosyncrasies of the various formats, early reel-to-reel videotape recorders did provide the opportunity to examine relatively fine-grained details of social action, including aspects of bodily comportment, gaze and even facial

expression. The emergence of digital sound and vision recording over the past decade or so, and the quality of data that is now produced using even relatively cheap domestic camcorders, have transformed our access to conduct and interaction. Video recordings using contemporary equipment enable us to see and analyse aspects of social action and activity that were hitherto inaccessible to enquiry. Moreover, the size of equipment and the ability to combine and edit images and sound recordings using digital technology provide the opportunity to capture and encompass aspects of activities within everyday settings that would have proven problematic even a decade or so ago. If we take our plea to prioritise the material and ecological in social science inquiry, whether the setting is the home, a museum, or a workplace, then we have equipment available that can now provide immensely rich and powerful resources to underpin data collection and analysis.

7.4 End note

In the history of the natural sciences, it is not unusual for a technology to have a radical impact on the way in which investigation is conducted and to inspire empirical and theoretical contributions to particular disciplines. It is less recognised perhaps in the social sciences, but it is only necessary to consider the impact of audio recording on our understanding of language use, or the way in which data management has been supported by the computer, to realise how the investigation of human behaviour has transformed in the last few decades. It is perhaps all the more surprising therefore that the use of video in research, particularly qualitative research, remains relatively neglected despite the unique opportunities that it offers for both the analysis of conduct and interaction and the dissemination of insights, observations and findings.

However, like any technology, the use of video for social science research relies upon our ability to deploy and exploit its functionality, to have methods and methodological commitments that enable us to use the technology to enrich our analysis and understanding of the social world. One suspects that the time that it has taken to begin to exploit the opportunities afforded by first film and then video within certain fields of the social sciences reflects the ways more traditional methodological and theoretical commitments fail to resonate with a technology that enables the detailed and repeated scrutiny of fragments of everyday life.

The burgeoning corpus of video-based research has begun to demonstrate the enormous potential of the technology and the range of different analytic and methodological commitments that can be brought to bear in using video to explore human conduct and experience. The diversity of these commitments reveal the very different ways in which video can contribute to our understanding of culture and social organisation and, one suspects, form the background to the emergence of new and distinctive ways of using digital media to support social science research.

If we stand now at an early stage of these developments then it is pleasing to note that video-based research has begun to make an important contribution to

our understanding of human conduct and experience, in particular, perhaps, our understanding of social interaction and everyday life. We have witnessed the emergence of a broad range of video-based studies; studies that emerged within various disciplines and contributed to diverse fields and areas of interest – health and illness, work and organisation, interpersonal communication, learning, human–computer interaction, the family and the home, and professional practice. The empirical contribution of these studies is distinctive and insightful but perhaps more importantly they also begin to provide the resources to reconsider, perhaps respecify, some of the key concepts that underpin our understanding of interaction and social organisation. We hope that this brief guide provides a useful introduction to using video and will encourage students, scholars and practitioners alike to exploit its enormous potential for research in the social sciences.

Key points

- The approach outlined in this book encourages a distinctive treatment of 'interaction', 'embodiment' and 'materiality' which has led to distinctive contributions to the social sciences and beyond.
- Video-based studies of interaction have had a wide-ranging impact across the social, cognitive and computing sciences.
- These studies have a number of applications for practitioners in a range of domains, including technology design, consumer research and communication skills training.
- Aside from the value of this approach to studying social interaction, the medium itself can be used in organisational domains as it provides opportunities to show, share and trace evidence.
- Video is increasingly used to analyse social interaction in new 'online' sites of sociality. These developments pose new and distinct challenges to method and methodology.

RECOMMENDED READING

Dedicated reviews or collections of video-based studies are rare. They are more usually reported with other kinds of research, especially ethnographic and conversation analytic research. However, there are a number of monographs, edited collections and special issues that include video-based studies in the fields of health care (Heritage and Maynard, 2006; Maynard, 2003; Pilnick et al., forthcoming), studies of technology-in-use (Heath and Button, 2002b; Heath et al., 2000; Heath and Luff, 2000b; Luff et al., 2000b), communication (dis)orders (Goodwin, 2003), organisation studies (Llewellyn and Hindmarsh, 2010), learning and education (Goldman et al., 2007), childhood (Goodwin, 2006) and everyday conversation (Goodwin, 1981).

EXERCISE

Consider how you might draw on your analyses of video recordings to identify more applied implications or recommendations of your study. These may be relevant to the setting that you studied, the participants, the organisation in question, or relevant policy-makers. Alternatively they may be developed with regard to a very different practical problem such as the structure of an environment or the design of new technology.

Consider the opportunities and challenges of presenting video based research to practitioners.

APPENDIX 1: TRANSCRIPTION NOTATIONS

Transcription notation for talk

Described below are the conventions used to transcribe the sequential organisation of talk, and the production of such features as pauses, loud or soft speech, quickening and slowing of pace, and where particular aspects are unclear. The orthography was developed by Gail Jefferson and adapted from published descriptions (e.g. Atkinson and Heritage, 1984).

Intervals between utterances

When there are intervals in a stream of talk, they are timed in tenths of a second and inserted within parentheses, either within an utterance:

Rod: this ehm (1.0) this (0.3) line almost could start within the case

or between utterances:

P: he's going down the dumps
 (0.2)
Dr: Yeah
 (1.5)
P: Because I have some of the homemade stuff you know

A dot in parentheses (.) indicates a gap of less than two tenths of a second:

A: now in just fifteen or twenty seconds (.) you're going to start to feel very very drowsy (.) and you'll drift off to sleep (.) and the next thing you know it'll all be finished

Characteristics of speech delivery

Punctuation is used to capture various characteristics of speech delivery. For example, extensions of sounds or syllables are indicated by placing a colon (:) after the relevant syllable.

C: if you could standby and let me get back to you in a mo:

More colons prolong the stretch; one colon for each tenth of a second:

A: last chance (0.2) two thousand two hundred pounds:::

Other punctuation marks are used as follows:

? A question mark for rising intonation.

. A full-stop (or period) for a fall in tone (not necessarily at the end of a sentence).

, A comma for continuing intonation.

! An exclamation mark indicates an animated tone.

– A single dash is used when the utterance is cut off.

Rising or falling shifts in intonation are indicated by up- and down-pointing arrows:

 S: thank you very much (0.8) very kind of you you are going redder ↑ and redder↓ by the moment

Underlining shows where an utterance, or part of an utterance, is emphasised:

 A: A thousand <u>there</u>:

Capital letters are used when part of an utterance is spoken much louder than the rest:

 A: Yeah ladies and gentlemen we're asking you to pl:ease remain behind the barriers (0.4) REMAIN BEHIND THE BARRIERS↑ Thank you

A degree sign is used when a passage of talk is quieter:

 S: Ang' on a minute (0.2) there's only °four° (1.0) There's only four quarters

Audible aspirations (hhh) and inhalations ('hhh) are inserted in speech where they occur:

 P: Thank you very much
 (0.3)
 P: °hhtha(h)nk y(hh)ou. Ooh::(er)
 (0.3)
 P: Did you see? just when I got up.

Double parentheses are used to enclose a description of something that is hard to transcribe:

 Dr: there you are ((cough)) °hh one lot of tablets at a time ((folds paper))

When part of an utterance is delivered at a pace quicker than the surrounding talk, it is indicated by being enclosed between 'greater than' signs (>):

 John: yeah, that's what I'm saying <exactly> this place here

Transcription doubt

When it is unclear what is being said, single parentheses mark the phrase which is in doubt:

 SA: There's a passenger just complained. There's somebody down the south-bound platform. He got some megaphone like, (running up) to people and (blowing) it at them and (things) frightening them and like

When it is impossible to hear an utterance or phrase, the parentheses are left empty. The space between the parentheses provides an indication of the length of the unheard utterance:

> SS: Is the Northern Line (.) run:ning southbound between (0.8) Charing
> Cross and ()?

Simultaneous and overlapping utterances

When two speakers start talking at the same time, a square bracket ([) is used to denote synchronisation:

> CRA: How long are you going to keep that train ?
> (0.3)
> C: ⌈ What?
> CRA: ⌊ How long are you keeping that A: Tee Pee train there

When utterances overlap a square bracket is used when the overlap begins:

> F: there was a Cardinal Bellamine whose face was meant to be rather like this
> A: Oh really:: But the⌈↑y're (so) Sack aren't they
> F: ⌊but I don' think these are

Contiguous utterances

When there is no interval between adjacent utterances, they are 'latched'. This is indicated using equals signs (=):

> T: That one there: (.) Chris, that's: one- you- decided not to (.) bother
> putting in the log, is(n) it, (now)=
> C: =Yeah that's right.

Marking interesting parts of the transcript

An arrow (➔) in the left-hand margin can be used to mark parts of the transcript that are being discussed.

> A: I am very keen on pot(s). I was te(lling)
> F: Yes
> A: I would quite like to look at these.
> ➔F: I was planning(g) to see whether they'd (.) <any of these (0.2) we've
> seen these before called >Bella:mine: jugs

Transcription of visual conduct

The transcription system we use for capturing aspects of visual conduct involves mapping, or charting, the visual and vocal conduct of the participants, so that the researcher can see where the various actions within a particular fragment occur

in relation to each other. It provides a rough and ready guide to the interaction within a particular fragment which is used alongside the actual data, the video recording, to facilitate analysis.

The following transcript is a simplified map of part of one video fragment.

Fragment 1

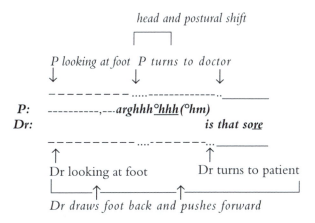

This transcript captures some aspects of the participants' conduct surrounding the initial cry of pain. Talk is transcribed using the system above. However, the talk is laid out across the page, so that each speaker's contribution follows on horizontally from the prior. In the example, the participants' talk has been presented in the centre of the page, but in multiparty interactions it will be necessary to divide the page vertically so that space is left to transcribe each participant's visual conduct either above or below their talk. So that silences or pauses are represented spatially as well as descriptively, a gap is transcribed by dashes '-'; a single dash is a tenth of a second, so that in the gap of (1.3) prior to the patient's pain cry, we find 13 dashes. In cases where there is no talk occurring within the interaction, a timescale in tenths of a second may be drawn at the bottom of the page.

The visual conduct of the participants is then located in relation to the talk and/or the timescale. Gaze is transcribed using a system developed by Goodwin (1981). A continuous line indicates that the participant is gazing at the co-participant, a series of dots ('.....') indicates that one party is turning towards another, and a series of commas (',,,,,') indicates that one party is turning away from the other. In the transcript we find the patient turning towards the doctor on completion of her pain cry and immediately following the onset of his shift of gaze towards her. In certain circumstances it may be helpful to use a series of spaced dashes ('_ _ _') to indicate gaze is directed towards an object. Other features of the participants' visual conduct are then indicated on the transcript according to where they occur within the talk or timescale. The researcher should at least indicate the onset and completion

of particular movements, such as gestures, postural movements, and in the case at hand, the manipulations by the doctor, and perhaps also mark any critical junctures within the development of a particular movement. Movements are represented by a continuous line, although *ad hoc* signs and symbols are often used to represent particular aspects of the movements.

Transcription of Human Computer Interaction

In some analyses it may be important to map out in more detail the 'interaction' with complex artefacts like computer systems. A simple way to do this is to develop a transcription notation for simple keyboard activity, drawing upon that for visual conduct. For example:

- ❑ Indicates a keystroke.
- ❑ Indicates that a key is pressed with greater force than normal.
- ⏎ Indicates a carriage return keystroke.

For some analyses more detail may be required. For example, different kinds of typing of particular keys are distinguished. So function keys could be indicated by '■', number keys by '◉', letter keys 9 by '**A B C**...'. and other unidentified keys by ' ❑'. Again, keys that are struck with some force are underlined and pauses between characters are indicated by '...', each '.' representing one tenth of a second. For example:

Fragment 2

```
          command                        command
          initiator        function      completer
             ↓                ↓              ↓
    Cii:   ■ D E R . ■ .   . ◉ ◉ ◉ ◉ ◉ ◉ . ⏎
```

APPENDIX 2: EXAMPLE OF AN INTRODUCTORY LETTER SEEKING ACCESS TO RECORD

The following is an example of a letter that could be used when seeking to gain access to a setting, in this case for undertaking a workplace study that involves video recording in a call centre. It is more likely to be successful if such a letter follows an initial enquiry, phone call or meeting with someone from the setting.

<researcher's name, institution, and contact details>

Dear <contact name>

Following our recent discussion you asked for more details about our research.

The overall objective of the study is to explore the use of new technologies in call centres. We are particularly interested in the ways in which staff manage to use the call-taking system whilst talking with customers on the phone.

Our work consists of a mixture of fieldwork and video recording. Initially we would hope to come for around three days at the beginning of May. If you are happy with this, then we would like to focus on particular uses of the call-taking system and return to record for short periods during the summer.

This project contributes to a wider research project funded by <name of company or funding body> which is looking at future technologies for call centres. As well as making an academic contribution, an aim of our study is to inform the development of new services and new technologies by observing a range of call centres. We would be happy to provide copies of our reports for the project and present preliminary findings in the course of the project.

We realise this is a very brief summary of the study, but would be happy to answer any questions you or your colleagues have in relation to it. I would be happy to visit you at your convenience to discuss our research in more detail. If you would like to talk please do not hesitate to contact me using the details above.

Yours faithfully

<Researcher's name>

APPENDIX 3: TIPS FOR DATA SESSIONS

Video is a resource that can be subjected to repeated viewings and can be seen by many people at the same time. This means that, at times, data analysis can be supported and assisted by colleagues. It is not uncommon for researchers who undertake video analysis to organise data sessions or data workshops where tentative and emerging analyses can be discussed, either amongst colleagues in a research team or with people who come from outside and who can offer new perspectives on the data.

Data sessions come in many forms. They can be similar to a workshop where successive people present data from their studies or they can be more informal and focused on one person's data. Although each group develops their own ways of carrying out data sessions, there are some things to bear in mind that can help participants focus on the data and the analysis being presented.

- Carefully consider how many people can usefully attend. Even with big screens it is hard for large groups to discuss the details of a particular analysis. Formal sessions can involve quite a number of people, maybe up to 20, but it can be hard to discuss the details of an analysis when more than ten attend.
- Even if the person bringing the data has only just started analysing the data, they should have some idea where they would like to start. They should select a few (say, three to six) short fragments, each of 30 seconds duration at most, preferably shorter.
- It is also very helpful if at least the talk has been transcribed. There will inevitably be places where people hear the data differently – this is part of the value of having data sessions – but having even a rough transcript saves the participants in the data session from having to try to work out all that is being said. Transcripts also help focus on the details of the data.
- If there are accompanying materials: images, background shots, glossaries of terms, examples of objects and texts that are being discussed in the data then bring these along and, if possible, give copies to the participants. For complex settings, such materials can help those unfamiliar with a setting have a better sense of what the participants are doing and attending to.
- When looking at data, try to concentrate on one fragment for a while, even one small portion of a fragment. It can be tempting to move on to other examples which seem interesting, or go on to a later section to try to discover more about a fragment. One of the great values of video is being able to scrutinise data in detail. This can require some patience even to try and work out what is happening. It can be well worth spending 20 minutes, half an hour or even longer on a fragment lasting no longer than five seconds or so.

- Bear in mind the sequential, unfolding nature of the conduct. When possible, try not to draw too heavily on what you know occurs later on in a fragment or extraneous details that you have gathered in fieldwork. Try to consider fragments from the participants' perspective, from when and where they were undertaking the action.
- Conclude the data session with a brief summary of any issues that have arisen. Although there is seldom any need to keep a formal record of the meeting, it can be useful for all participants to have a time where they reflect more generally on the issues that have been discussed and the potential implications this may have.

APPENDIX 4: SELECTED REFERENCES TO OUR RESEARCH STUDIES

Throughout the book we illustrate issues in video-based research by recounting our experiences in undertaking a number of studies. For the reader interested in finding out more about the findings from these studies, we include a small number of key references organised by domain.

Control rooms (London Underground, Docklands Light Railway and telecommunications)

Heath, C. and Luff, P. (1996) 'Convergent activities: collaborative work and multimedia technology in London Underground Line Control Rooms', in D. Middleton and Y. Engeström (eds.), *Cognition and Communication at Work*. Cambridge: Cambridge University Press, pp. 96–130.

Heath, C., Luff, P. and Sanchez Svensson, M. (2002) 'Overseeing organisations'. *British Journal of Sociology*, 53(2): 181–203.

Luff, P. and Heath, C. (2000) 'The Collaborative Production of Computer Commands in Command and Control'. *International Journal of Human-Computer Studies*, 52: 669–99.

Luff, P., Heath, C., and Jirotka, M. (2000) 'Surveying the Scene: Technologies for Everyday Awareness and Monitoring in Control Rooms'. *Interacting With Computers*, 13: 193–228.

Hindmarsh, J. and Heath, C. (2000) 'Sharing the Tools of the Trade: The interactional constitution of workplace objects'. *Journal of Contemporary Ethnography*, 29(5): 523–62.

Health care (general practice, anaesthesia, surgery, dentistry)

Heath, C. (1986) *Body Movement and Speech in Medical Interaction*. Cambridge: Cambridge University Press.

Hindmarsh, J. (2010) 'Peripherality, Participation and Communities of Practice: Examining the patient in dental training'. In N. Llewellyn and J. Hindmarsh (eds.), *Organisation, Interaction and Practice: Studies in ethnomethodology and conversation analysis*. Cambridge: Cambridge University Press. pp. 218–40.

Hindmarsh, J. and Pilnick, A. (2002) 'The Tacit Order of Teamwork: Collaboration and embodied conduct in anaesthesia'. *The Sociological Quarterly*, 43(2): 139–64.

Sanchez Svensson, M., Heath, C. and Luff, P. (2007, 25–28 September). 'Instrumental action: the timely exchange of implements during surgical operations'. *Proceedings of the European Conference on Computer-Supported Collaborative Work*. pp. 41–60.

Museums, galleries and science centres

Heath, C., Luff, P., vom Lehn, D., Hindmarsh, J. and Cleverly, J. (2002) 'Crafting Participation: Designing ecologies, configuring experience'. *Visual Communication*, 1(1): 9–34.

Heath, C. and vom Lehn, D. (2004) 'Configuring Reception: Looking at exhibits in museums and galleries'. *Theory, Culture and Society*, 21(6): 45–63.

Heath, C. and vom Lehn, D. (2008) 'Construing Interactivity: Enhancing engagement and new technologies in science centres and museums'. *Social Studies of Science*, 38(1): 63–91.

vom Lehn, D., Heath, C. and Hindmarsh, J. (2001) 'Exhibiting Interaction: Conduct and collaboration in museums and galleries'. *Symbolic Interaction*, 24(2): 189–216.

Markets, sales and auctions

Heath, C.C., Jirotka, M., Luff, P. and Hindmarsh, J. (1995) 'Unpacking Collaboration: Interactional organisation in a city trading room'. *Journal of Computer Supported Cooperative Work*, 3(1): 147–65.

Heath, C. and Luff, P. (2007) 'Ordering Competition: The interactional accomplishment of the sale of fine art and antiques at auction'. *British Journal of Sociology*, 58(1): 63–85.

Heath, C. and Luff, P. (2007) 'Gesture and institutional interaction: Figuring bids in auctions of fine art and antiques'. *Gesture*, 7(2): 215–41.

Classrooms

Luff, P., Adams, G., Bock, W., Drazin, A., Frohlich, D.M., Heath, C., Herdman, P., King, H., Linketscher, N., Murphy, R., Norrie, M., Sellen, A., Tallyn, E. and Zeller, E. (2007) 'Augmented paper: Developing relationships between digital content and paper'. In N. Streitz, P. Nixon, A. Kameas and I. Mavrommati (eds.), *The disappearing computer: Selected papers from the projects of the disappearing computer initiative*. Springer Verlag, pp. 275–98.

Design and architecture

Luff, P., Heath, C. and Greatbatch, D. (1992) 'Tasks-in-interaction: Paper and screen-based activity in collaborative work'. *Proceedings of the Conference on Computer Supported Cooperative Work*, pp.163–70.

Luff, P., Heath, C. and Pitsch, K. (2009) 'Indefinite precision: The use of artefacts-in-interaction in design work'. In C. Jewitt (ed.), *Routledge Handbook of Multimodal Analysis*. London: Routledge, pp. 213–22.

Media spaces and virtual environments

Heath, C. and Luff, P. (1992) 'Media space and communicative asymmetries'. *Human–Computer Interaction*, 7: 315–46.

Hindmarsh, J., Fraser, M., Heath, C., Benford, S. and Greenhalgh, C. (2000) 'Object-Focused Interaction in Collaborative Virtual Environments'. *ACM Transactions on Computer–Human Interaction (ToCHI)*, 7(4): 477–509.

Luff, P., Heath, C., Kuzuoka, H., Hindmarsh, J., Yamazaki, K. and Oyama, S. (2003) 'Fractured ecologies: Creating environments for collaboration'. *Human–Computer Interaction*, 18(1–2): 51–84.

REFERENCES

Agar, M. (1991) 'The Right Brain Strikes Back'. In N. Fielding & R.M. Lee (eds.), *Using Computers in Qualitative Research* (pp. 181–94). London: Sage.

Asch, T. (Director) (1975) *The Ax Fight* (Film: Collaborating anthropologist – Napoleon Chagnon): Pennsylvania State University. 30 minutes.

Ash, D. (2007) 'Using video data to capture discontinuous science meaning making in nonschool settings'. In R. Goldman et al. (eds.), *Video Research in the Learning Sciences.* New Jersey: Lawrence Erlbaum.

Atkinson, J.M. (2004) *Lend Me Your Ears: All You Need to Know about Making Speeches and Presentations*: Ebury Press/Vermillion: Oxford.

Atkinson, J.M. and Drew, P. (1980) *Order in Court: The Organisation of Verbal Interaction in Judicial Settings.* London: Macmillan.

Atkinson, J.M. and Heritage, J.C. (eds.) (1984) *Structures of Social Action: Studies in Conversation Analysis.* Cambridge: Cambridge University Press.

Banks, M. (2001) *Visual Methods in Social Research.* London: Sage.

Barley, S.R. and Kunda, G. (2001) 'Bringing work back in'. *Organization Science*, 12(1): 76–95.

Bateson, G. and Mead, M. (1942) *Balinese character: A photographic analysis.* New York: New York Academy of Sciences.

Becvar, A. (2008) *An Ethnographic Investigation of the Evolving Dynamics of a Learning Ecology.* Unpublished PhD Thesis.

Benford, S., Crabtree, A., Flintham, M., Drozd, A., Anastasi, R., Paxton, M., et al. (2006) 'Can You See Me Now?' *ACM Transactions on Computer–Human Interaction*, 13(1): 100–33.

Birdwhistell, R.L. (1970) *Kinesics and Context: Essays on Body Motion Communication.* London: Allen Lane.

Boden, D. and Zimmerman, D.H. (eds.), (1991) *Talk And Social Structure: Studies in Ethnomethodology and Conversation Analysis.* Cambridge: Polity Press.

Brand, S.B. (1976) 'For God's Sake, Margaret: Conversation with Gregory Bateson and Margaret Mead'. *CoEvolutionary Quarterly*, 10: 32–44.

Braune, W. and Fischer, O. (1895) *The Human Gait* (reprinted 1987). Berlin: Springer-Verlag.

Brown, B. (2004) 'The Order of Service: The practical management of customer interaction'. *Sociological Research Online*, 9.

Brown, B. and Bell, M. (2004) CSCW at play: 'There' as a collaborative virtual environment. *Proceedings of CSCW 2004.* New York: ACM Press. pp. 350–59.

Brown, B., Chalmers, M., Bell, M., MacColl, I., Hall, M., Rudman, P. (2005) 'Sharing the square: collaborative leisure in the city streets'. Paper presented at the ECCSCW 2005. Paris, France.

Brown, B. and Randell, R. (2004) 'Building a Context Sensitive Telephone: Some Hopes and Pitfalls for Context Sensitive Computing'. *Computer Supported Cooperative Work*, 13(3–4): 329–45.

Büscher, M. (2005) 'Social Life Under the Microscope'. *Sociological Research Online*, 10.

Button, G. (1993) 'The Curious Case of the Disappearing Technology'. In G. Button (ed.), *Technology in Working Order* (pp. 10–28). London: Routledge.

Callanan, M., Valle, A. and Azmitia, M. (2007) 'Expanding studies of family conversations about science through video analysis'. In R. Goldman, R. Pea, B. Barron and S.J. Derry (eds.), *Video Research in the Learning Sciences*. New Jersey: Lawrence Erlbaum.

Cassell, J. (1998) 'The relationship of observer to observed when studying up'. In R.G. Burgess (ed.), *Studies in Qualitative Methodology* (pp. 89–108). London: JAI Press.

Cicourel, A.V. (1992) 'The Interpretation of Communicative Contexts: Examples from Medical Encounters'. In A. Duranti and C. Goodwin (eds.), *Rethinking Context: Language as an Interactive Phenomenon* (pp. 291–310). Cambridge: Cambridge University Press.

Clark, C. and Pinch, T. (1995) *The Hard Sell: The Language and Lessons of Street-wise Marketing*. Hammersmith: HarperCollins.

Clayman, S. and Heritage, J.C. (2002) *The News Interview: The History and Dynamics of a Social Form*. London: Sage.

Condon, W.S. and Ogston, W.D. (1966) 'Sound Film Analysis of Normal and Pathological Behavior Patterns'. *Journal of Nervous and Mental Disease*, 143: 338–47.

Corti, L., Day, A. and Backhouse, G. (2000) 'Confidentiality and Informed Consent: Issues for consideration in the preservation of and provision for access to qualitative data archives'. *Qualitative Social Research*, 1(3): Art. 7. Online at: http://www.qualitative-research.net.

Crabtree, A., Benford, S., Capra, M., Flintham, M., Drozd, A., Tandavanitj, N., Adams, M. and Row Farr, J. (2007) 'The cooperative work of gaming: orchestrating a mobile SMS game'. *Computer Supported Cooperative Work: The Journal of Collaborative Computing*, 16(1&2): 167–98.

Crabtree, A., French, A., Greenhalgh, C., Benford, S., Cheverst, K., Fitton, D., Rouncefield, M. and Graham, C. (2006) 'Developing digital records: early experiences of record and replay'. *Computer Supported Cooperative Work: The Journal of Collaborative Computing*, 15(4): 281–319.

Dant, T. (2004) 'Recording the "Habitus"'. In C. Pole. (ed.), *'Seeing is believing? Approaches to Visual Methodology', Studies in Qualitative Methodology* (Vol. 7, pp. 43–63). Amsterdam: Elsevier.

Darwin, C. (1872) *The Expression of Emotions in Man and Animals*. London.

Derry, S.J.E. (2007) 'Guidelines for Video Research in Education: Recommendations from an expert panel'. Report for the Data Research and Development Center, Online at: http://drdc.uchicago.edu/what/video-research.html: University of Chicago.

Dicks, B., Mason, B., Coffey, A. and Atkinson, P. (2005) *Qualitative Research and Hypermedia: Ethnography for the digital age*. London: Sage.

Drew, P., Chatwin, J. and Collins, S. (2001) 'Conversation Analysis: A method for research into interactions between patients and heath-care professionals'. *Health Expectations*, 4: 58–70.

Drew, P. and Heritage, J.C. (eds.) (1992) *Talk at Work: Interaction in institutional settings*. Cambridge: Cambridge University Press.

Duchenne (de Boulogne), G.-B. (1862) *Mécanisme de Physionomie Humaine: Analyse Électro-Physiologique de L'expression des Passions*. Paris: Librairie J-B Baillière et Fils.

Efron, D. (1941) *Gesture and Environment*. New York: King's Crown Press.

Engeström, Y. and Middleton, D. (eds.), (1996) *Cognition and Communication at Work*. Cambridge: Cambridge University Press.

Erickson, F. and Schultz, J. (1982) *The Counsellor as Gatekeeper*. London and New York: Academic Press.

Finn, K.E., Sellen, A.J. and Wilbur, S.B. (eds.) (1997) *Video-Mediated Communication*. Mahwah, NJ: Lawrence Erlbaum Associates.

Flewitt, R. (2006) 'Using Video to Investigate Preschool Classroom Interaction: Education research assumptions and methodological practices'. *Visual Communication*, 5(1): 25–50.

Garfinkel, H. (1967) *Studies in Ethnomethodology*. Englewood Cliffs, NJ: Prentice-Hall.

Garfinkel, H. (1992) *Ethnomethodology's Program: Working Out Durkheim's Aphorism*. Lanham, MD: Rowman & Littlefield Publishers.

Gilbreth, F.B. (1911) *Motion Study: a method for increasing the efficiency of the workman*. New York: D. Van Nostrand.

Goffman, E. (1981) *Forms of Talk*. Oxford: Blackwell.

Goldman, R., Pea, R., Barron, B. and Derry, S.J. (eds.), (2007) *Video Research in the Learning Sciences*. London: Routledge.

Goodwin, C. (1981) *Conversational Organisation: Interaction between Speakers and Hearers*. London: Academic Press.

Goodwin, C. (1993) 'Recording Interaction in Natural Settings'. *Pragmatics*, 3(2): 181–209.

Goodwin, C. (1995) 'Seeing in Depth'. *Social Studies of Science*, 25(2): 237–74, (May).

Goodwin, C. (ed.) (2003) *Conversation and Brain Damage*. Oxford: Oxford University Press.

Goodwin, C. (2004) 'A Competent Speaker who Can't Speak: The Social Life of Aphasia'. *Journal of Linguistic Anthropology*, 14(2): 151–70.

Goodwin, C. (2009) 'Embodied Hearers and Speakers Constructing Talk and Action in Interaction'. *Cognitive Studies*, 16(1): 1–14, (March).

Goodwin, C. and Goodwin, M.H. (1996) 'Seeing as a Situated Activity: Formulating Planes'. In Y. Engeström and D. Middleton (eds.) *Cognition and Communication at Work* (pp. 61–95). Cambridge: Cambridge University Press.

Goodwin, M.H. (1990) *He-Said-She-Said: Talk as Social Organisation Among Black Children*. Indiana University Press.

Goodwin, M.H. (2006) *The Hidden Life of Girls: Games of Stance, Status and Exclusion*. Oxford: Blackwell.

Greatbatch, D., Hanlon, G., Goode, J., O'Cathain, A., Strangleman, T. and Luff, D. (2005) 'Telephone Triage, Expert Systems and Clinical Expertise'. *Sociology of Health & Illness*, 27(6): 802–30.

Greatbatch, D., Luff, P., Heath, C.C. and Campion, P. (1993) 'Interpersonal Communication and Human–Computer Interaction: an examination of the use of computers in medical consultations'. *Interacting With Computers*, 5(2): 193–216.

Greiffenhagen, C. and Sharrock, W. (2005, 15–18 June) 'Gestures in the blackboard work of mathematics instruction'. Paper presented at the 2nd Conference of the International Society for Gesture Studies, Lyon, France.

Gutwill, J.P. (2003) 'Gaining visitor consent for research II: Improving the posted-sign method'. *Curator*, 46(2): 228–35.

Hall, R. (2000) 'Video Recording as Theory'. In D. Lesh and A. Kelley (eds.) *Handbook of Research Design in Mathematics and Science Education* (pp. 647–64). Mahweh, NJ: Lawrence Erlbaum.

Hammersley, M. and Atkinson, P. (1983) *Ethnography: Principles in Practice*. London: Tavistock.

Harper, D. (1988) 'Visual Culture; Expanding Sociological Vision'. *The American Sociologist*, 23(1): 54–70.

Harrison, S. (2009) 'A Brief History of Media Space Research and Mediated Life'. In S. Harrison (ed.) *Media Space 20+ Years of Mediated Life* (pp. 9–16). London: Springer-Verlag.

Haviland, J.B. (1993) 'Anchoring, iconicity, and orientation in Guugu Yimidhirr pointing gestures'. *Journal of Linguistic Anthropology*, 3(1): 3–45.

Heath, C.C. (1986) *Body movement and speech in medical interaction*. Cambridge: Cambridge University Press.

Heath, C.C. (2002) 'Demonstrative suffering: the gestural (re)embodiment of symptoms'. *Journal of Communication*, 52(3): 597–61.

Heath, C.C. and Button, G. (eds.) (2002) *Special Issue on Workplace Studies* (53).

Heath, C.C. and Hindmarsh, J. (2000a) 'Configuring Actions in Objects: From Mutual Space to Media Space'. *Mind, Culture, and Activity*, 7(1&2): 81–104.

Heath, C.C. and Hindmarsh, J. (2000b) 'Configuring Actions in Objects: From Mutual Space to Media Space'. *Mind, Culture, and Activity*, 7(1&2): 81–104.

Heath, C.C., Knoblauch, H. and Luff, P. (2000) 'Technology and social interaction: the emergence of "workplace studies"'. *British Journal of Sociology*, 51(2): 299–320.

Heath, C.C. and Luff, P. (2007) Ordering competition: the interactional accomplishment of the sale of fine art and antiques at auction. *British Journal of Sociology*, 58(2): 63–85.

Heath, C.C. and Luff, P. (1992) 'Media Space and Communicative Asymmetries: Preliminary Observations of Video Mediated Interaction'. *Human–Computer Interaction*, 7: 315–46.

Heath, C.C. and Luff, P. (2000) *Technology in Action*. Cambridge: Cambridge University Press.

Heath, C.C., Luff, P. and Sanchez Svensson, M. (2002) 'Overseeing organisations: configuring the environment of action'. *British Journal of Sociology*, 53(2): 181–203.

Heath, C.C. and vom Lehn, D. (2004) 'Configuring Reception: Looking at exhibits in museums and galleries'. *Theory, Culture and Society*, 21(6): 43–65.

Heath, C.C. and vom Lehn, D. (2008) 'Construing interactivity: enhancing engagement with new technologies in science centres and museums'. *Social Studies of Science*, 38: 63–96.

Hemmings, T., Randall, D., Marr, L. and Francis, D. (2000) 'Talk, task and closure: situated learning and working with an 'interactive' museum artefact'. In S. Hester and D. Francis (eds.) *Local Educational Order: Ethnomethodological studies of knowledge in action* (pp. 223–44). Amsterdam and Philadelphia: John Benjamins.

Heritage, J.C. (1984) *Garfinkel and Ethnomethodology*. Cambridge: Polity Press.

Heritage, J.C. (1997) 'Conversation Analysis and Institutional Talk: Analysing Data'. In D. Silverman, (ed.) *Qualitative Research: Theory, Method and Practice*, (pp. 161–82). London: Sage.

Heritage, J.C. and Maynard, D.W. (eds.) (2006) *Communication in Medical Care: Interaction Between Primary Care Physicians and Patients*. New York and Cambridge: Cambridge University Press.

Hester, S. and Francis, D. (eds.) (2000) *Local Educational Order: Ethnomethodological studies of knowledge in action.* Amsterdam and Philadelphia: John Benjamins.

Hindmarsh, J. (2008) 'Distributed Video Analysis in Social Research'. In N. Fielding, R.M. Lee and G. Blank (eds.) *The SAGE Handbook of Online Research Methods.* (pp. 343–61). London: Sage.

Hindmarsh, J. (2010) 'Peripherality, Participation and Communities of Practice: Examining the patient in dental training'. In N. Llewellyn and J. Hindmarsh (eds.) *Organisation, Interaction and Practice: Studies in ethnomethodology and conversation analysis.* Cambridge: Cambridge University Press. pp. 218–40.

Hindmarsh, J., Fraser, M., Heath, C.C. and Benford, S. (2000) 'Object-Focused Interaction in Collaborative Virtual Environments'. *ACM Transactions on Computer–Human Interaction (ToCHI),* 7(4): 477–509.

Hindmarsh, J. and Heath, C.C. (2000) 'Embodied Reference: A Study of Deixis in Workplace Interaction'. *Journal of Pragmatics,* 32(12): 1855–78.

Hindmarsh, J., Heath, C.C., vom Lehn, D. and Cleverly, J. (2005) 'Creating Assemblies in Public Environments: Social interaction, interactive exhibits and CSCW'. *Computer Supported Cooperative Work: The Journal of Collaborative Computing,* 14(1): 1–41.

Hindmarsh, J. and Pilnick, A. (2002) 'The Tacit Order of Teamwork: Collaboration and embodied conduct in anaesthesia'. *The Sociological Quarterly,* 43(2): 139–64.

Hindmarsh, J. and Pilnick, A. (2007) 'Knowing Bodies at Work: Embodiment and ephemeral teamwork in anaesthesia'. *Organization Studies,* 28(9): 1395–416.

Hindmarsh, J., Reynolds, P. and Dunne, S. (2010) 'Exhibiting Understanding: The body in apprenticeship'. *Journal of Pragmatics.*

Hockings, P. (1995 (1974)) *Principles of Visual Anthropology* (2nd Edition). Berlin and New York: Mouton de Gruyter.

Homan, R. (1991) *The Ethics of Social Research.* London: Longman.

Hornsby-Smith, M. (1993) 'Gaining Access'. In G.N. Gilbert (ed.) *Researching Social Life* (pp. 52–67). London: Sage.

Hughes, E.C. (1958) *Men and their Work.* Glencoe: Free Press.

Hughes, J.A., King, V., Rodden, T. and Andersen, H. (1994, 22–26 Oct.). 'Moving out of the Control Room: Ethnography in System Design'. Paper presented at the CSCW '94, Chapel Hill, North Carolina.

Ikeya, N., Vinkhuyzen, E., Whalen, J. and Yamauchi, Y. (2007) 'Teaching organizational ethnography'. Paper presented at the EPIC.

Jarmon, L.H. (1996) 'An Ecology of Embodied Interaction: Turn-taking and interactional syntax in face-to-face encounters'. Unpublished PhD Dissertation, University of Texas at Austin.

Jefferson, G. (1984) 'Transcript Notation'. In J.M. Atkinson and J.C. Heritage (eds.) *The Structures of Social Action: Studies in Conversation Analysis* (pp. ix–xvi). Cambridge: Cambridge University Press.

Jirotka, M., Luff, P. and Heath, C.C. (1993) 'Requirements for Technology in Complex Environments: Tasks and Interaction in a City Dealing Room'. *SIGOIS Bulletin (Special Issue) Do users get what they want?* (DUG '93), 14(2–December): 17–23.

Joseph, I. (1998) *La Ville Sans Qualities.* Paris: L'Aude.

Kendon, A. (1972) 'Some relationships between body motion and speech. An analysis of an example'. In A. Siegman and B. Pope (eds.) *Studies in Dyadic Communication* (pp. 177–210). Elmsford, New York: Pergamon Press.

Kendon, A. (1990) *Conducting interaction: Studies in the Behaviour of Social Interaction*. Cambridge: Cambridge University Press.

Khoudour, L., Hindmarsh, J., Aubert, D., Velastin, S. and Heath, C.C. (2001, 14–16 May) 'Enhancing Security Management in Public Transport using Automatic Incident Detection'. Paper presented at the Urban Transport VII Seventh International Conference on Urban Transport and the Environment for the 21st Century, Lemnos Island, Greece.

Kissmann, U.T. (ed.) (2009) *Video Interaction Analysis: Methods and Methodology*. Frankfurt am Main: Peter Lang.

Knoblauch, H., Schnettler, B., Raab, J. and Söffner, H.-G. (eds.) (2006) *Video-Analysis: Methodology and Methods*. Frankfurt am Main: Lang-Verlag.

Koschmann, T., LeBaron, C., Goodwin, C., Zemel, A. and Dunnington, G. (2007) 'Formulating the "Triangle of Doom"'. *Gesture*, 7(1): 97–118.

Lajard, J. and Regnault, F. L. (1985) *Poeterie Crue et Origine du Tour Bulletin de as Societe d'Anthropologie de Paris*, 6: 734–39.

Laurier, E., Lorimer, H., Brown, B., Jones, O., Juhlin, O., Noble, A., et al. (2008) 'Driving and passengering: notes on the ordinary organization of ordinary car travel'. *Mobilities*, 3(1): 1–23.

Laurier, E. and Philo, C. (2006) 'Natural Problems of Naturalistic Video Data'. In H. Knoblauch, J. Raab, H.-G. Soefnner and B. Schnettler (eds.) *Video Analysis: Methodology and Methods* (pp. 181–90). Frankfurt: Peter Lang.

Lave, J. and Wenger, E. (1991) *Situated Learning: Legitimate Peripheral Participation*. Cambridge: Cambridge University Press.

LeBaron, C. and Jones, S. (2002) 'Closing up closings: Showing the relevance of the social and material surround to the completion of an interaction'. *Journal of Communication*, 52(3): 542–65.

Leeds-Hurwitz, W. (1987) 'The social history of the Natural History of an Interview: A multidisciplinary investigation of social communication'. *Research on Language and Social Interaction*, 20: 1–51.

Lewin, K. (Director) (1932) *Das Kind unde die Welt*. [Film].

Llewellyn, N. and Hindmarsh, J. (eds.) (2010) *Organisation, Interaction and Practice: Studies in ethnomethodology and conversation analysis*. Cambridge: Cambridge University Press.

Lomax, H. and Casey, N.J. (1998) 'Recording Social Life: Reflexivity and video methodology'. *Sociological Research Online* (3).

Luff, P., Adams, G., Bock, W., Drazin, A., Frohlich, D., Heath, C.C., et al. (2007) 'Augmented Paper: Developing Relationships between Digital Content and Paper'. In I. Mavrommati and N. Streitz (eds.) *The Disappearing Computer* (pp. 275–98). Springer Verlag.

Luff, P. and Heath, C.C. (1998, 14–18 November) 'Mobility in Collaboration'. Paper presented at the CSCW '98, Seattle, WA.

Luff, P., Heath, C.C. and Greatbatch, D. (1992) 'Tasks-in-interaction: Paper and screen-based documentation in collaborative activity'. Paper presented at the CSCW '92, Toronto, Canada.

Luff, P., Heath, C.C. and Jirotka, M. (2000a) 'Surveying the Scene: Technologies for Everyday Awareness and Monitoring in Control Rooms'. *Interacting With Computers*, 13: 193–228.

Luff, P., Heath, C.C., Kuzuoka, H., Yamazaki, K. and Yamashita, J. (2006) 'Handling Documents and Discriminating Objects in Hybrid Spaces'. Paper presented at the CHI 2006, Montreal.

Luff, P., Hindmarsh, J. and Heath, C.C. (eds.) (2000b) *Workplace Studies: Recovering Work Practice and Informing System Design*. Cambridge: Cambridge University Press.

MacBeth, D. (1999) 'Glances, trances and their relevance for a visual sociology'. In P.L. Jalbert (ed.) *Media Studies: Ethnomethodological Approaches* (pp. 135–70). Washington: University Press of America.

Malinowski, B. (1930) 'The problem of meaning in primitive languages'. In C.K. Ogden and I.A. Richards (eds.) *The Meaning of Meaning* (pp. 296–336). London: Kegan Paul, Trench, Trubner & Co.

Marey, E.-J. (1895) *Movement* (Translated by Eric Pritchard). London: Heinemann Press.

Marrow, A.F. (1969) *The Practical Theorist: The life and work of Kurt Lewin*. New York: Basic Books.

Matusov, E., Bell, N. and Rogoff, B. (2002) 'Schooling as cultural process: Shared thinking and guidance by children from schools differing in collaborative practices'. In R. Kail and H. Reese (eds.) *Advances in Child Development and Behavior* (pp. 129–60). Cambridge: Cambridge University Press.

Mauthier, M., Birch, M., Jessop, J. and Miller, T. (eds.) (2002) *Ethics in Qualitative Research*. London: Sage.

Maynard, D.W. (2003) *Bad News, Good News: Conversational Order in Everyday Talk and Clinical Settings*. Chicago: University of Chicago Press.

McCabe, R., Heath, C.C., Burns, T. and Priebe, S. (2002) 'Engagement of patients with psychosis in the medical consultation: A conversation analytic study'. *British Medical Journal*, 325: 1148–51.

McDermott, R.P. (1976) 'Kids make sense'. Unpublished PhD Dissertation, Stanford University.

McNeill, D. (1992) *Hand and Mind*. Chicago: University of Chicago Press.

Mead, M. (1995 (1974)) 'Visual Anthropology and the Discipline of Words'. In P. Hockings (ed.) *Principles of Visual Anthropology* (2nd Edition) (pp. 3–10). Berlin and New York: Mouton de Gruyter.

Mehan, H. (1979) *Learning Lessons: Social Organization in the Classroom*. Cambridge, Mass.: Harvard University Press.

Mehan, H. (1985) 'The Structure of Classroom Discourse'. In T.A. van Dijk (ed.) *Handbook Of Discourse Analysis*. New York: Academic Press.

Meisner, R., vom Lehn, D., Heath, C.C., Burch, A., Gammon, B. and Reisman, M. (2007) 'Exhibiting Performance: Co-participation in Science Centres and Museums'. *International Journal of Science Education*, 29(12): 1531–55.

Mondada, L. (2003) 'Working with video: how surgeons produce video records of their actions'. *Visual Studies*, 18: 58–73.

Mondada, L. (2007) 'Operating together through videoconference: Members' procedures for accomplishing a common space of action'. In S. Hester and D. Francis (eds.) *Orders of Ordinary Action* (pp. 51–67). Aldershot: Ashgate.

Moore, R.J., Ducheneaut, N. and Nickell, E. (2007) 'Doing Virtually Nothing: Awareness and accountability in massively multiplayer online worlds', *Computer Supported Cooperative Work*, 16: 265–305.

Moore, R.J. (2008) 'When Names Fail: Referential Practice in Face-to-face Service Encounters'. *Language in Society*, 37(3): 385–413.

Moore, R., Whalen, J. and Gathman, E.C.H. (2010) 'The work of the work order: document practice in face-to-face service encounters'. In N. Llewellyn and J. Hindmarsh (eds.) *Organization, Interaction and Practice: studies in ethnomethodology and conversation analysis*. Cambridge University Press. pp. 172–97.

Morphy, H. and Banks, M. (eds.) (1997) *Rethinking Visual Anthropology*. New Haven: Yale University Press.

Norris, C., Moran, J. and Armstrong, G. (1998) 'Algorithmic Surveillance: The Future of Automated Visual Surveillance'. In C. Norris, J. Moran and G. Armstrong (eds.) *Surveillance, Closed Circuit Television and Social Control* (pp. 255–76). Aldershot: Ashgate.

Parry, R. (2004) 'The interactional management of patients' physical incompetence: a conversation analytic study of physiotherapy interactions'. *Sociology of Health & Illness*, 26(7): 976–1007.

Parsons, A.S. (1951) *The Social System*. Glencoe: Free Press.

Peräkylä, A. (1995) *Aids counselling: institutional interaction and clinical practice*. Cambridge: Cambridge University Press.

Peräkylä, A. and Ruusuvuori, J. (2006) 'Facial expression in an assessment'. In H. Knoblauch, J. Raab, H.-G. Soeffner and B. Schnettler (eds.) *Video Analysis: Methodology and Methods* (pp. 127–42). Frankfurt am main: Peter Lang.

Pilnick, A., Hindmarsh, J. and Gill, V.T. (eds.) (2010) *Communication in Healthcare Settings: Policy, participation and new technologies*. Oxford: Blackwell.

Pink, S. (2004) *Home Truths: Changing gender in the sensory home*. Oxford: Berg.

Pink, S. (2006) *Doing Visual Ethnography: Images, Media and Representation in Research* (2nd Edition). London: Sage.

Poech, R. (1907) 'Reisen in Neu-Guinea in den Jahren 1904–1906'. *Zeitschrift fur Ethnologie*, 39: 382–400.

Prodger, P. (2003) *Time Stands Still: Muybridge And The Instantaneous Photography Movement*. Oxford: Oxford University Press.

Prost, J.H. (1974) 'Filming body behaviour'. In P. Hockings (ed.) *Principles of Visual Anthropology* (pp. 285–313). Berlin: Mouton de Gruyter.

Rendle-Short, J. (2006) *The Academic Presentation: Situated talk in action*. Aldershot: Ashgate.

Rogoff, B. (2003) *The Cultural Nature of Human Development*. New York: Oxford University Press.

Rose, G. (2004) *Visual Methodologies: An introduction to the interpretation of visual materials*. London: Sage.

Ruby, J. (1982) *A Crack in the Mirror: Reflexive perspectives in anthropology*. Philadelphia: University of Pennsylvania Press.

Sacks, H. (1992) *Lectures in Conversation: Volumes I and II*. Oxford: Blackwell.

Sacks, H., Schegloff, E.A. and Jefferson, G. (1974) 'A simplest systematics for the organisation of turn-taking for conversation'. *Language*, 50(4): 696–735.

Sanchez Svensson, M., Heath, C.C. and Luff, P. (2007, 25–28 September). 'Instrumental action: the timely exchange of implements during surgical operations'. Proceedings of the Paper Presented at the European Conference on Computer-Supported Collaborative Work.

Sandelowski, M. and Barroso, J. (2003) 'Writing the Proposal for a Qualitative Research Methodology Project'. *Qualitative Health Research*, 13(6): 781–820.

Saunders, M., Lewis, P. and Thornhill, A. (2007) *Research Methods for Business Students* (4th Edition). Harlow: Pearson Education.

Scheflen, A.E. (1973) *Communication Structure: Analysis of a Psychotherapy Transaction*. Bloomington: Indiana University Press.

Schegloff, E.A. (1992) 'In another context'. In A. Duranti and C. Goodwin (eds.) *Rethinking Context: Language as an Interactive Phenomenon* (pp. 193–227). Cambridge: Cambridge University Press.

Schegloff, E.A. (1993) 'Reflections on Quantification in the Study of Conversation'. *Research on Language & Social Interaction,* 26(1): 99–128.

Schegloff, E.A. (1997) 'Whose text? Whose context?'. *Discourse & Society,* 8: 165–87.

Schegloff, E.A. (1998) 'Reply to Wetherell'. *Discourse & Society,* 9: 413–16.

Schegloff, E.A. and Sacks, H. (1973) 'Opening up Closings'. *Semiotica,* 7: 289–327.

Schnettler, B. (2006) 'Orchestrating Bullet Lists and Commentaries: A video performance analysis of computer presentations'. In H. Knoblauch, B. Schnettler, J. Raab & H.-G. Soefnner (eds.) *Video Analysis: Methodology and methods of qualitative audiovisual data analysis in sociology.* (pp. 155–69). Frankurt am Main: Peter Lang.

Short, J., Williams, E. and Christie, B. (1976) *The Social Psychology of Telecommunications*. London: Wiley.

Shrum, W., Duque, R. and Brown, T. (2005) 'Digital Video as Research Practice: Methodology for the millennium'. *Journal of Research Practice,* 1(1): Article M4, pp. 1–19.

Silverman, D. (1970) *The Theory of Organizations*. London: Heinemann.

Silverman, D. (1990) 'The Social Organisation of Aids Counselling Aids: Individual, Cultural and Policy Dimensions'. In P.E.A. Aggleton (ed.) London: Falmer Press.

Silverman, D. (1997) *Discourses of Counseling: HIV Counseling as Social Interaction*. London: Sage.

Speer, S.A. and Hutchby, I. (2003) 'Methodology Needs Analytics: A Rejoinder to Martyn Hammersley'. *Sociology,* 37(2 (May)): 353–9.

Spencer, W.B. and Gillen, F.J. (1899) *The Native Tribes of Central Australia*. London: Macmillan.

Stivers, T. (2007) *Prescribing under pressure: parent–physician conversations and antibiotics*. Oxford: Oxford University Press.

Streeck, J. (1993) 'Gesture as communication I: Its coordination with gaze and speech'. *Communication Monographs,* 60: 275–99.

Strong, P. (1978) *The Ceremonial Order of the Clinic*. London: Routledge Kegan Paul.

Suchman, L.A. (1987) *Plans and Situated Actions: The Problem of Human–Machine Communication*. Cambridge: Cambridge University Press.

Suchman, L.A. (1996) 'Constituting Shared Workspaces'. In Y. Engeström and D. Middleton (eds.) *Cognition and Communication at Work* (pp. 35–60). Cambridge: Cambridge University Press.

Suchman, L.A. (1997) 'Centers of Coordination: A case and some themes'. In L.B. Resnick, R. Säljö, C. Pontecorvo and B. Burge (eds.) *Discourse, Tools, and Reasoning: Essays on Situated Cognition* (pp. 41–62). Berlin: Springer-Verlag.

Suchman, L.A. (2007) *Human–Machine Reconfigurations: Plans and Situated Actions* (2nd Edition). Cambridge: Cambridge University Press.

ten Have, P. (1999) *Doing Conversational Analysis: A Practical Guide*. London: Sage.

Tufte, E.R. (2003) *The Cognitive Style of PowerPoint: Pitching Out Corrupts Within*. Connecticut: Graphics Press.

Turner, R. (1974) 'Words, Utterances and Activities'. pp. 197–215 in *Ethnomethodology: Selected Readings*, edited by R. Turner. Harmondsworth: Penguin.

Velastin, S.A. and Remagnino, P. (2006) *Intelligent Distributed Video Surveillance Systems*. London: IEE Press.

vom Lehn, D., Heath, C.C. and Hindmarsh, J. (2001) 'Exhibiting Interaction: Conduct and collaboration in museums and galleries'. *Symbolic Interaction*, 24(2): 189–216.

Ward, A. (2003) *Is your oral history legal and ethical?* Online at http://www.oral history.org.uk/ethics/.

West, C. (1985) *Routine Complications: Tasks and Troubles in the Medical Consultation*. Bloomington, Indiana: Indiana University Press.

Wetherell, M. (1998) 'Positioning and interpretative repertoires: Conversation analysis and post-structuralism in dialogue'. *Discourse and Society*, 9: 387–412.

Whalen, J. (1995a) 'A Technology of Order Production: Computer-Aided Dispatch in Public Safety Communications'. In P. ten Have and G. Psathas (eds.) *Situated Order: Studies in the Social Organization of Talk and Embodied Activities* (pp. 187–230). Washington: University Press of America.

Whalen, J. (1995b) 'Expert Systems vs. Systems for Experts: Computer-Aided Dispatch as a Support System in Real-world Environments'. In P. Thomas (ed.) *The Social and Interactional Dimensions of Human–Computer Interfaces* (pp. 161–83). Cambridge: Cambridge University Press.

Whalen, J. and Vinkhuyzen, E. (2000) 'Expert Systems in (Inter)Action: Diagnosing Document Machine Problems Over the Telephone'. In P. Luff, J. Hindmarsh and C.C. Heath (eds.) *Workplace Studies: Recovering Work Practice and Informing System Design* (pp. 92–140). Cambridge: Cambridge University Press.

Whalen, M., Whalen, J., Moore, R., Raymond, G., Szymanski, M. and Vinkhuyzen, E. (2004) 'Studying Workscapes as a Natural Observational Discipline'. In P. LeVine and R. Scollon (eds.) *Discourse and Technology: Multimodal discourse analysis* (pp. 208–29). Washington, DC: Georgetown University Press.

Wolcott, H.F. (1995) *The Art of Fieldwork*. Walnut Creek, CA: Alta Mira.

INDEX

Research Methods
Books from SAGE

DISCOVERING STATISTICS USING SPSS THIRD EDITION

ANDY FIELD

THIRD EDITION

RESEARCH DESIGN

Qualitative, Quantitative, and Mixed Methods Approaches

JOHN W. CRESWELL

Robert K. Yin

Case Study Research

Design and Methods

Fourth Edition

APPLIED SOCIAL RESEARCH METHODS SERIES

Second Edition

QUALITATIVE INQUIRY & RESEARCH DESIGN

Choosing Among Five Approaches

John W. Creswell

Doing a Literature Review

Releasing the Social Science Research Imagination

Chris Hart

STATISTICS for People Who (Think They) HATE STATISTICS

3RD EDITION

NEIL J. SALKIND

SECOND EDITION

INTERVIEWS

Learning the Craft of Qualitative Research Interviewing

Steinar Kvale
Svend Brinkmann

THE QUALITATIVE RESEARCHER'S COMPANION

A. MICHAEL HUBERMAN
MATTHEW B. MILES

Basics of QUALITATIVE RESEARCH 3e

Juliet Corbin
Anselm Strauss

www.sagepub.co.uk

SAGE